An American Point of View **The Daniel J. Terra Collection**

Contributors to the Catalogue

Wendy Greenhouse, Ph.D.,
Independent Art Historian
(p. 48, 52, 74, 166)

Debra N. Mancoff
Newberry Library
Scholar in Residence (p. 44, 54,
64, 66, 76, 80, 84, 152, 164)

Stephanie G. Mayer
Adelson Fellow,
Boston University (p. 46, 58,
70, 120)

Julia R. Myers
Professor of Art History,
Eastern Michigan University
(p. 82)

Carmen Niekrasz
Curatorial Intern,
Terra Museum of American Art
(p. 148–150, 156–160)

Lee A. Vedder
Terra Fellow
at the Huntington Library,
Art Collections
(p. 62)

**Terra Museum of American Art,
Chicago**

Elizabeth Kennedy
Shelly Roman
Scott Sikkema
Tom Skwerski
Elizabeth K. Whiting

**Musée d'Art Américain Giverny,
France**

Katherine M. Bourguignon
Hélène Furminieux
Bronwyn Griffith
Claire Guilloteau
Sophie Lévy
Francesca Rose
Veerle Thielemans

An American Point of View
The Daniel J. Terra Collection

Terra Museum of American Art, Chicago
Musée d'Art Américain Giverny, France

Distributed by Hudson Hills Press, New York

Published in conjunction with the
exhibitions organized by Elizabeth
Kennedy, Terra Museum of American Art,
Chicago, and Katherine M. Bourguignon,
Musée d'Art Américain Giverny, France:

D'une colonie à une collection.
Le Musée d'Art Américain Giverny fête
ses dix ans
Musée d'Art Américain Giverny, France
(March 29–June 16, 2002)
and
A Place on the Avenue: Terra Museum
of American Art Celebrates Fifteen Years
in Chicago
Terra Museum of American Art in Chicago
(November 2, 2002–March 2, 2003).

Produced by Musée d'Art
Américain Giverny Publications
99, rue Claude Monet
27620 Giverny, France

Edited by Francesca Rose with the
assistance of Sarah Blackwood in Chicago
and Claire Guilloteau in Giverny

Designed by Frédéric Lemercier

Production by Francesca Rose

Copyediting by Fronia W. Simpson
and Christine Schultz-Touge

Translation from French by
Deke Dusinberre (p. 50, 94–96,
104–108, 116–118, 122–130, 136,
144, 168–174, 186)

First Edition

Copyright © 2002 by Terra Foundation
for the Arts

All rights reserved under International and
Pan-American Copyright Conventions.

Distributed by Hudson Hills Press Inc.,
1133 Broadway, Suite 1301
New York, N.Y., 10010–8001
Editor and Publisher: Paul Anbinder

Distributed in the United States, its
territories and possessions, and Canada
through National Book Network.
Distributed in the United Kingdom,
Eire, and Europe (except France)
through Windsor Books International.

Printed in Italy

ISBN: 0–932171–27–3

Front cover : Arthur Garfield Dove,
A Walk: Poplars, c. 1912–1913.

Contents

Acknowledgements

A publication project of this magnitude, involving two museums in two countries, required excellence and dedication from all those involved. We would like to extend our heart-felt thanks to Elizabeth Glassman, Director of Terra Museum of American Art (TMAA) and Musée d'Art Américain Giverny (MAAG) for her guidance; Judith Terra for sharing her memories; Wanda M. Corn, Professor at Stanford University for her thoughtful introduction; and members of the Board of Terra Foundation for the Arts for their support of this project, especially Marshall Field, Chairman and President of the Board; Recteur Hélène Ahrweiler, Honorary Chairman; and Collections Committee members Kathleen A. Foster and Theodore E. Stebbins, Jr.

We would like to acknowledge all those who kindly shared their remembrances of Daniel J. Terra, his collection, and his museums. Their stories provided a wonderful resource for our project, and we are extremely grateful for their help: Robert McCormick Adams; Stuart P. Feld, Hirschl & Adler Galleries; Martha Fleischman, Kennedy Galleries; James Berry Hill, Berry-Hill Galleries; Cecily Langdale and Roy Davis, Davis and Langdale Company; Florence Robert; Philippe Robert, Reichen et Robert Architectes; Mark Rudkin; Margo Pollins Schab, Margo Pollins Schab, Inc.; and Stephen E. Weil, Emeritus Senior Scholar, Smithsonian Center for Education and Museum Studies. In addition, for their valuable assistance, we would like to thank: Jeffrey Brown, Brown-Corbin Fine Art; Philip Cronenwett, Special Collections Librarian, Dartmouth College Library; Sophie Fourny-Dargère, Curator, Musée Municipal A. G. Poulain, Vernon, France; Nicholas Kilmer; Martine Leclerc and Claire Brossel, Médiathèque Municipale, Vernon, France; Phyllis Robb, The Art Institute of Chicago; David Sellin; Esther Sparks, Visiting Professor of Art, Valparaiso University, Indiana; and librarians and archivists throughout the United States and France, too numerous to mention. We are indebted to Evelyn D. Barriger, a neighbor and friend of Dan Terra and an original TMAA docent for her invaluable contribution to understanding Ambassador Terra in relationship to his friends and community in Kenilworth and Evanston; thank you also to TMAA docent Elaine Bancoff who came to the rescue by lending her preserved set of "Terra Tidings," the TMAA docent newsletter; and we extend our gratitude to the residents of Giverny, especially Mayor Guy Colombel; Mr. and Mrs. Jacques Durand; Daniel Goupil; Christian Jeanney; Marie-Thérèse Jolivet; Mr. and Mrs. Michel Perdrix; Dr. and Mrs. Philippe Perdrix; Mr. and Mrs. André Picard; and Jean-Marie and Claire Joyes Toulgouat, all of whom shared not only memories of Daniel Terra but also stories of the numerous American artists who called Giverny home a century ago.

While time restraints prevented us from interviewing the entire staff of Terra Museum of American Art and Musée d'Art Américain Giverny, we are appreciative of those current and former staff members who generously responded to the request to share their insights, experiences, and memories of the two museums: from TMAA, D. Scott Atkinson, Robert G. Donnelley, Roberta Gray Katz, Judith Russi Kirshner, Ronald McKnight Melvin, John Hallmark Neff, and David Sokol and from MAAG, Jean Bergaust, Marie Bosson, Didier Brunner, Derrick R. Cartwright, Mayalène Crossley, Diana Guillaume, Véréna Herrgott, Maureen Lefèvre, Jacqueline Maimbourg, Stephan Ristich, and Olivier Touren.

Dozens of people contributed generously to the research and writing of the entries as well as to the production of this catalogue, and we would like to thank all of them for their expertise: Kristina Bottomley, Sarah Coffey, Karen Cohodes, Miranda Fontaine, Hélène Furminieux, Wendy Greenhouse, Bronwyn Griffith, Claire Guilloteau, Dori Jacobsohn, Sophie Lévy, Debra N. Mancoff, Stephanie G. Mayer, Julia R. Myers, Carmen Niekrasz, Géraldine Raulot, Steve Reardon, Cathy Ricciardelli, Marie-Cécile Richard, Véronique Roca, Shelly Roman, Scott Sikkema, Tom Skwerski, Tammy Steele, Veerle Thielemans, Lee Vedder, Barbara Voss, Tom Wawzenek, Elizabeth K. Whiting, and Amy Zinck as well as the 2001 summer interns at TMAA Elizabeth Heatwole and Hilary Smith. Special thanks to Janice McNeill, TMAA Librarian, whose research efforts were central to our project; to Laura Kalas, TMAA 2001 Fall Intern, who deserves special recognition for her diligent research on the collection. This book could never have happened without the expert skills of Francesca Rose who juggled authors, translators, copy-editors, and graphic designers in a tight schedule with her usual professionalism and Sarah Blackwood whose organizational capabilities were universally appreciated as was her good-humored insistence on punctuality. Special thanks are extended also to Fronia W. Simpson, English copyediting (Chicago); Christine Schultz-Touge, English copyediting (Giverny); ; Deke Dusinberre, translation from French to English; Jeanne Bouniort, translation from English to French; Dominique Leconte, French copyediting; Frédéric Lemercier, graphic design. This catalogue has been a group project at every step of the way, and we are sincerely grateful for the contributions of all those involved.

Katherine M. Bourguignon and Elizabeth Kennedy

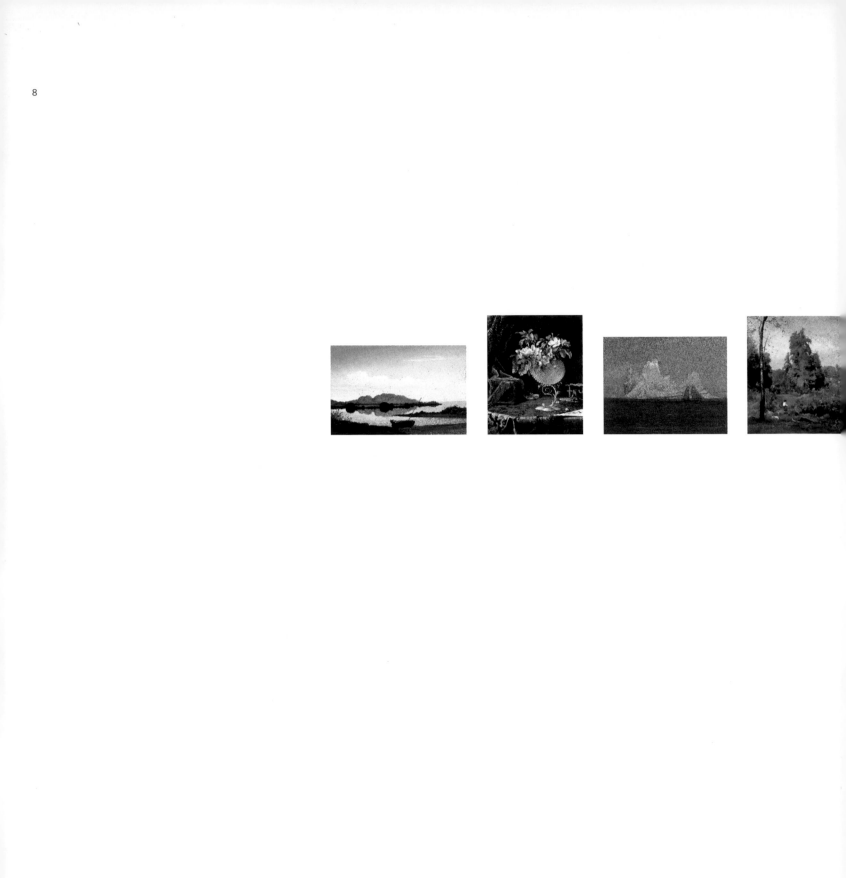

Preface

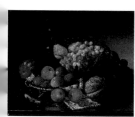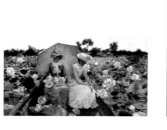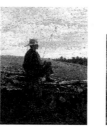

Anniversaries are a time for reflection and consideration, an opportunity simultaneously to look at past accomplishments and to plan for the future. The year 2002 marks two important milestones for the Terra Museums: the tenth anniversary of the opening of the Musée d'Art Américain in Giverny and, in Chicago, fifteen years of the Terra Museum of American Art on Michigan Avenue. Both institutions came to life because of the vision and drive of the founder, Daniel J. Terra. On this significant occasion, the Terra Museums have joined to record their respective histories and to present Terra Foundation for the Arts' distinguished collection of American art.

That Dan Terra was a man of passion is a point of universal agreement. His excitement about America, a country he loved dearly, found outlet in his tireless efforts on behalf of the nation as Ambassador-at-Large for Cultural Affairs. Terra's commitment to civic duty demonstrated his serious dedication to the culture of the United States; the showman in him, most joyfully present when he donned striped trousers and hat to bring the famed American icon Yankee Doodle to life, never tired of using his talent to share his great enthusiasm for this land. Terra found the perfect complement to his love of country in American art, a medium that is often a visual expression of national themes. His ideas about national identity fueled his mission to promote the cultural heritage of America through art: collecting it, exhibiting it, and educating the public about it.

On behalf of the Terra Foundation for the Arts, I am proud to present this volume, which highlights seventy-three masterpieces of the Foundation's collection, including both works acquired by Daniel J. Terra and those added following his death in 1996. The Terra Foundation for the Arts (TFA) oversees the operations of the Terra Museum of American Art (TMAA) and the Musée d'Art Américain Giverny (MAAG), and supports their scholarly publications and educational agendas. The Foundation has embarked on initiatives designed to further scholarship on American art, establishing, for example, the Summer Residency for American and European scholars and artists in Giverny, holding symposia and conferences at both museums, and providing dissertation grants and museum internships. An award-winning educational program at the Terra Museum of American Art in Chicago exemplifies its interdisciplinary and culturally diverse approach to learning from original objects. Bilingual publications and multiple educational activities at the Musée d'Art Américain Giverny enable a wide range of international visitors to maximize their engagement with, and often provide an introduction to, American art. The Musée d'Art Américain Giverny offers Europeans an unprecedented center for research and learning about American art and culture. Both museums organize and host major traveling exhibitions in addition to those that highlight the permanent collection.

Terra opened his first museum in Evanston in 1980 with a collection of about fifty American paintings.

Using as a model important collectors of American art, Terra added works with fervor. Today over seven hundred works of art, including paintings, sculpture, and works on paper, are in the care of the Terra Foundation for the Arts. In general, the collector pursued individual purchases. Twice he bought whole collections: the acquisition in 1983 of the Lano Collection included significant luminist and Hudson River School works; and the purchase of the Weinberg Collection in 1986 contributed important modernist paintings. When possible, Terra acquired in depth, such as his notable holdings of Maurice Prendergast. And at the end of his life, Terra amassed a distinguished collection of works on paper, including pastels, drawings, and prints by Mary Cassatt, Winslow Homer, James McNeill Whistler, William Merritt Chase, Edward Hopper, and John James Audubon. Remarkably, work by American women artists constitutes ten percent of the collection.

In the following pages, Elizabeth Kennedy's history of the Daniel J. Terra Collection draws for us a striking portrait of a patriot, a constant player in the American art scene, and a free-market idealist who thought that the financial support of culture should come from the private sector. A museum on Chicago's busiest retail street speaks to his core values: bring art to the people, make it alive where people work and shop, and promote the rich history of American art through collection building, exhibitions, and dedicated educational programs.

As he began collecting in depth the work of American impressionists and building a transatlantic bridge to Giverny, the place where these artists congregated, Terra revised his mission, determined to present American art to even wider audiences. In Katherine M. Bourguignon's account of the founding of the Musée d'Art Américain Giverny, we glimpse the conviction and persistence that were necessary to establish an American art museum in France. We are prompted to ask what drove this fascinating individual to remain undaunted by obstacles in a country that is skeptical of American patriotism and culture. Terra answered the question himself in the *Chicago Sun Times* in 1987: "The President [Reagan] told me that my biggest job was to bring American art to the world." That he took this assignment to heart is evidenced by his drive to succeed, even as his museum was surrounded by larger state-run institutions in a country that generally questions close links between museums and market forces. Despite all obstacles, in both Chicago and Giverny, Terra's mission was "to provide both pleasure and enlightenment through exhibitions and educational programs," a charge we continue to look to today.

Seminars, lectures, and workshops were instrumental in Terra's original concept for museums in Evanston and Chicago. Roberta Gray Katz, curator of education (1988–1996), recalled that Terra's educational vision encouraged student tours and programs for families as a means to "build the next audience for American art." Terra's first curator (1981–1984) and later director (1985), David Sokol, initiated the successful docent program, in which two of the original docents still participate. In all of these projects, Terra was helped by curators Elizabeth Milroy (1985–1988), Judith Kirshner (1985–1987), and D. Scott Atkinson (1985–1996). In addition, directors of the Terra Museum guided and stimulated the strong-minded founder; among them were Ronald McKnight Melvin (1980–1984), Michael Sanden (1985–1987), Harry P. O'Connell (1988–1991), Robert G. Donnelley (1992–1994), and Stuart Popowcer (1994–1998). Managing the museum in Giverny were Jean Bergaust (1990–1992), Mayalène Crossley (1993–1995), and Robert J. Korengold (1995–1998). Following Terra's death in 1996, John Hallmark Neff, Director, TMAA (1997–2000), and Derrick R. Cartwright, Director, MAAG (1998–2000) provided critical leadership at an important juncture.

To honor the founder's legacy is to be guided by his vision and actions, but it is also to ensure that the Terra Museums continue to flourish. As Wanda M. Corn discusses in her introduction, our current challenge is both to respect the founder's dreams and to move forward, incorporating from the past while preparing for the future. We must grow, not in size but in depth, and forge new solutions to recurring questions.
Most of the progress made by the museums since Terra's death was already envisioned by him, often very early on. In Chicago, Terra imagined a lively exhibition space and educational programs for regular patrons, docents, schoolchildren, the Michigan Avenue visitor, and many others. The charge of the Terra Museum of American Art has remained constant since its founding: to extend and deepen appreciation for our nation's rich and varied cultural heritage. Chicago is often called "the most American of cities." In such a context, a museum dedicated to American art holds an important trust among its colleague museums. By initiating exhibitions, publications, and symposia that extend the boundaries of our current thinking about American art, our center in Chicago will stretch the parameters of discussion. As we enable younger scholars opportunity for study and provide a forum for debate by experts in the field, we frame a dialogue about the evolving interpretation of American art. The Foundation's educational programs will continue to look for ways to bring this rich history to future audiences as we adopt new methodologies and technologies where they can serve our goals.

In Giverny, the extent of the properties Terra acquired demonstrates that he intended to create an exhibition space, a residency for artists and art historians, and a center for the research and study of American art. Further, Terra purchased the Maison

Cannet, formerly the home of the American impressionist Theodore Butler, with the aim of creating a significant library on American art in France. That he intended MAAG to feature American art in its fullest sense needs no further proof than its very name, which extends beyond links with impressionism evoked by its geographic location, beyond even links with its founder. The setting on the site of one of the most active international art colonies of the nineteenth century and the nature of the Foundation's collection point quite naturally to the importance of transatlantic artistic exchanges.

As cultural ambassador and citizen of the world, Dan Terra opened eyes to the rich and complex history of American art. Under the leadership of our board and chairman, and with the support of the dedicated staff, the Foundation and Museums will further this mission. It is my pleasure to be joined by board members and staff in presenting this volume.

The idea to publish a volume on the masterpieces of the Terra Collection began under the directorships of John Hallmark Neff and Derrick R. Cartwright. I thank them both for providing such creative footprints. The book could never have been completed without the dedication and commitment of the entire Terra Museums family. To the officers and directors of the Terra Foundation for the Arts, I express my sincere appreciation for their continued stewardship. Also at the Foundation, Donald H. Ratner, Executive Vice-President and CFO, and Amy Zinck, Assistant Vice-President, work tirelessly to ensure the smooth administration of our activities. From time to time we call on the experience of a distinguished group of advisers. I thank John Wilmerding, Kathleen A. Foster, Franklin Kelly, Marc Simpson, and especially Wanda M. Corn for her thoughts about the past and future of the Foundation. Elizabeth Kennedy's and Katherine M. Bourguignon's illuminating essays record for the first time the history of the museums. I thank Francesca Rose for shepherding this beautiful book to publication. I am especially grateful to Sarah Coffey for her daily assistance. Finally, I extend my great appreciation to the untiring staffs of the Terra Museums and Foundation who, even though separated by an ocean, came together to create this wonderful volume.

Elizabeth Glassman
Director, Terra Museums
Executive Vice-President, Terra Foundation for the Arts

Introduction

The Terra Museums, one in downtown Chicago the other in Giverny, France, are at an important juncture; they are celebrating "big" anniversaries. The Terra in Chicago is fifteen years old, the Musée d'Art Américain Giverny is ten. Relatively speaking, these are young museums and they have reached an important juncture. Their childhood has been spent growing up under the paternal eye and authority of Daniel J. Terra whose idea it was to found in Chicago—and then, in Giverny—a showcase for the study and exhibition of American art. Now these two museums are moving from private, family-controlled museums to autonomous public institutions of distinct identity and offerings.

The essays that follow are the first chapters of an institutional history. As with all museums, questions about the founders always begin the story. How did the patron make his fortune and begin to collect American art? What was his vision for a museum carrying his name? Who were his allies and supporters? How did he engender goodwill as well as controversy—and what were his successes? These are the questions that concern the authors in this volume. The essays are written by two curators, one in Chicago and one in Giverny, neither of whom knew or worked under Terra. They write as professional scholars and historians piecing together Terra's history with the aid of archival museum records, newspaper and magazine criticism, and oral interviews. Their status as newcomers and as outsiders to the first years of the museums' history represents, just as their essays do, the transition

the museums are now making to a post-founder staff and identity.

As a member of the Terra Museum's advisory board of art history scholars, I, too, am part of what will someday be written as the next chapter of Terra's history. In reading these essays, I learned that Daniel Terra was a bold and entrepreneurial man who hated the word "no" and on some days was like a bull in a china shop. That he was optimistic and patriotic, exuded enjoyment in life, and was willing to engage in long-term struggles to fulfill his goals shines through in these accounts. I am impressed, too, by Terra's risk-taking, most of it grounded in generosity and goodwill but with touches of invulnerability and naiveté. When Terra founded his museums, he worked against the status quo and what some would say was financial sense. It is not easy to create successful museums, and Terra seems to have learned as he went.

In 1980 Terra opened his first museum in a former flower shop on Main Street in Evanston. That is where I first saw his collection and remember the space as small and intimate, light and airy, perfect for American impressionist paintings. But it was not easy to get to. A few years later, Terra bought and refurbished a very expensive piece of commercial real estate to house his collection in the downtown business and shopping district of Chicago. He took his collection, in other words, to a space where there was a ready audience. By integrating his collection into the urban fabric rather than isolating it in the suburbs, Terra gave his museum

an identity as a downtown treasure, a jewel box on upper Michigan Avenue. This was daring; Terra traded off the costs to establish a presence for pre-World War II American art in Chicago. He aimed high, wanting to place in the Midwest something like what the Whitney Museum of American Art is for New York City, what the Smithsonian American Art Museum is for Washington, D.C., and what the Amon Carter is for Texas and the West.

Taking yet another risk, Terra decided to found a museum in France—not in Paris—but in the tiny town of Giverny, where many American artists had gone to paint in the milieu of Claude Monet. Terra collected the paintings of these Giverny Amer-impressionists and became driven by the idea that he might be able to show these paintings in the very village where they had been created. This, too, was a risky venture. Though the French are heavy consumers of American popular culture, and regularly import rock music, films, jazz, and blue jeans from the States, they have not shown much interest in American fine arts except those of a very contemporary nature. Terra's drive to establish an American museum in Giverny also raised issues of cultural colonization and commercialization nicely covered in the essays that follow. Despite these challenges, Terra succeeded in building a low-key, white-walled, modern building where art is shown to great advantage.

When first established ten years ago, the Musée d'Art Américain Giverny was dedicated to Franco-

American art and cultural relations. Today, under new leadership, the museum is dedicated not only to impressionism but to all styles of American art. Its mission is to foster learning throughout Europe about American art history and engender research on cross-cultural exchanges. The Terra Museum of American Art in Chicago has similarly broadened its mandate to include the exhibition and interpretation of the entire history of American art. Together the two Terra museums form a unique transatlantic institution, poised to share exhibitions, foster Euro-American scholarship, and open new channels of cultural exchange between this country and Europe. It is an exciting time for the Terra museums. I, for one, look forward to watching the next chapters of the institutions' histories unfold.

Wanda M. Corn, **Ph.D.**
Robert and Ruth Halperin Professor in Art History,
Stanford University
Terra Museums Advisory Board

1

A Patriotic Muse
A History of the Daniel J. Terra Collection
and the Terra Museum of American Art

Elizabeth Kennedy

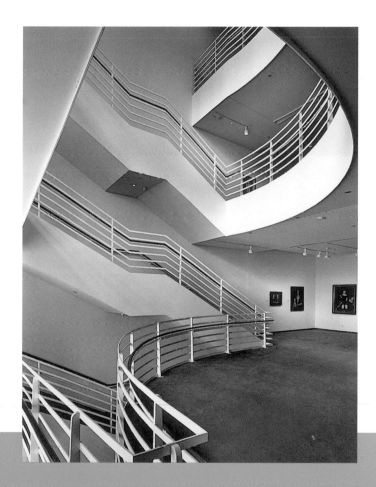

Terra Museum of American Art, Chicago

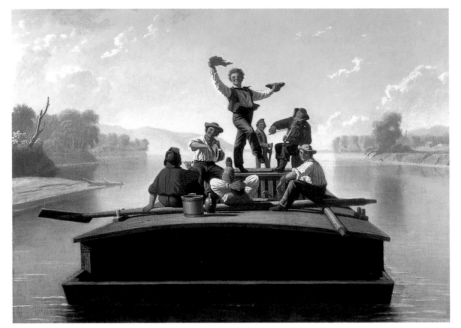

George Caleb Bingham,
The Jolly Flatboatmen,
1877–1878,
oil on canvas,
66.2 x 92.4 cm
(26 1/16 x 36 3/8 in.).
TFA, Daniel J. Terra
Collection 1992.15

History was made at a Sotheby's auction in Los Angeles in 1978 when a painting by George Caleb Bingham (1811–1879) sold for $980,000, triple the price ever paid for a work of art by an American artist. The art world was stunned by the unprecedented sum paid by Hirschl & Adler, Inc., a New York art gallery. For many, the record auction price of *The Jolly Flatboatmen,* 1877–1878 validated American art as collectable. Recognizing the importance of the Midwestern river scene as an early expression of national identity, Daniel J. Terra bought the painting a few months later as a cornerstone for his new entrepreneurial project—an art museum.

In the history of art museums in the United States, Terra Museum of American Art is exceptional for its role in the national discussion of private funding of the arts. Terra's museum not only exemplified his political beliefs but also provided him with a platform from which to express his views. As the two Terra Foundation for the Arts museums, one in Chicago and the other in Giverny, France, celebrate their respective fifteenth and tenth anniversaries, it is appropriate to reflect on the raison d'être of Terra's collection and tell the extraordinary story of his museums.[1]

The Beginnings of an American Art Collection

Born in Bucks County, Pennsylvania, and raised in Philadelphia, Daniel J. Terra (1911–1996) was the son of Italian immigrants. Terra followed in the footsteps of his grandfather and father, who had both managed

printing plants, when he decided to study chemistry at Pennsylvania State University, focusing on the printing process. In the early days of his career, Terra acquired the patent for a chemical that allowed printer's ink to dry in twenty-four rather than ninety-six hours, which revolutionized high-speed offset printing and led to the creation of *Life* magazine, the first news picture magazine. In 1940 Terra coupled his scientific knowledge and entrepreneurial flair. With a loan from a friend, he founded a business, Lawter Chemicals, later Lawter International, Inc., which became a global company with twenty-two branches in twelve countries. In 1960 Terra's profitable company went public. Retaining approximately 25 percent ownership of Lawter, Terra was at midlife on his way to becoming a very wealthy man.

In addition to his business acumen, the multi-talented Terra was briefly a professional song-and-dance man after graduating from college. His interest in the visual arts was developed through the expertise of his first wife, Adeline Evans Richards (1910–1982), who had graduated in 1934 from Northwestern University with a degree in English literature and studied for two years at the School of the Art Institute of Chicago. A few years after they married in 1937, Mrs. Terra, an acknowledged Anglophile, purchased their first work of art, an English landscape painting. Over the next three decades, the couple assembled a collection of English and French eighteenth- and nineteenth-century landscapes, minor old masters,

1. In 1978 Terra formed the first Terra Foundation, a non-profit entity responsible for the oversight and management of his museum and the works of art he gifted to the foundation. In addition to donating art to the foundation, Terra lent works of art from his personal collection to his museums' exhibitions. After his death in 1996 and the settlement of his estate in 1999, his final bequest of works of art entered Terra Foundation for the Arts collection.

Daniel J. Terra,
1984

his eyes to the impressive qualities of late-nineteenth-
and early-twentieth-century American art.
The Metropolitan Museum of Art exhibited the
Horowitz collection in 1973, shortly after the
museum's 1970 landmark exhibition and symposium
Nineteenth-Century America: Paintings and Sculpture,
which began to consider American art as something
more than relics of our colonial ancestors.
Before the 1970s American painting was primarily
an embellishment to American period rooms
or segregated in an "American Wing" in art museums
with a focus on European art.

Also essential to the Terra collection's history
is the influence of the Art Institute of Chicago (AIC).
In 1975 Milo M. Naeve, a decorative arts expert,
became the curator of the museum's newly formed
American Art Department. Two years later Terra was
invited to join the AIC's first American Art Committee
and remained with the group until 1985. During his
tenure, the committee was involved in collection
acquisitions and the development of new gallery
space to be devoted to American painting, sculpture,
and the decorative arts. Undoubtedly, Terra's expertise
as a collector of American art and his knowledge
of museum management increased because of his
involvement on the American Art Committee.

As the United States approached its bicentennial
of 1976, Terra considered the future of his American
art collection. In 1975 he bought the thirty-seven oil
paintings that were reproduced in the illustrated book
Eric Sloane's I Remember America (1971). The images
of Americana so meticulously portrayed in the book
represented Sloane's mission of "reviving or retrieving
worthy things of the American past." Terra exhibited
the paintings at a benefit for the Illinois Republican
Party. Arguably, this is the first event that combined
Terra's love of art and politics. In the 1970s Terra
successfully raised money for the Illinois Republican
Party and was asked to serve as finance chairman for
Ronald Reagan's first presidential bid in 1979–1980.
Terra's endeavors filled the Republican Party's coffers,
earning the gratitude of the newly elected president,
whose appreciation would expand Terra's involvement
in the arts (notably with his appointment as
Ambassador-at-Large for Cultural Affairs in 1982)
and, later, his vision for his art collection.

In 1977 Terra's American art collection was
displayed publicly for the first time. Awarded the

and later, works by secondary French impressionist
artists. Terra described their approach to art collecting
thus: "I have the courage to buy and she has the
great eye."[2]

After thirty years of buying European art, the
Terras' collecting enterprise took a different direction.
On April 17, 1971 at the Parke-Bernet Galleries'
auction, *Important Nineteenth- and Twentieth-Century
American Paintings, Drawings, and Sculpture*, they bid
successfully for two preparatory studies made by John
Singer Sargent for *The Oyster Gatherers of Cancale*,
1878 (p. 94). The Sargent sketches were the genesis
of a twenty-five-year mission by Terra to assemble a
notable collection of American art. Often dramatizing
his anecdotes for effective storytelling, Terra's narrative
of where he acquired his first Sargents—the origin
of his American art collection—is significant because
it was intended to establish his credentials in the
American art market. He repeatedly claimed to have
purchased the Sargent works at an auction in 1955,
a date that would have placed him at the forefront
of collecting American art. Although not in the
vanguard of American art collectors, Terra's initial
transaction did precede the inflated art market of the
late 1980s, warranting him a place in the coterie of
early collectors.[3]

Why did Terra begin to sell his European art and
acquire only American art? He once remarked that
he had visited a New York collection, likely that of
Mr. and Mrs. Raymond J. Horowitz, that opened

2. Quoted in Connie Lauerman,
"Terra Museum's Daniel Terra:
Portrait of an Art Lover
Extraordinaire," *Chicago Tribune*,
August 11, 1981.

3. Lauerman, "Terra Museum's
Daniel Terra." This is the first article
that mentions the purchase of the
Sargents; it is repeated frequently
in interviews over the next few
years. The couple's budget allowed
them to acquire only two of the
designated sketches that evening,
but, characteristically, Terra was not
to be denied. A third sketch was
bought soon after the auction but
the fourth remained elusive,
becoming part of his collection
only on May 20, 1996, just weeks
before he died.

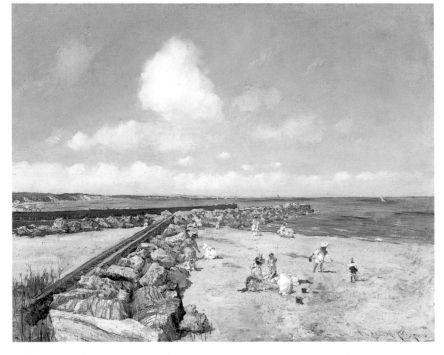

William Merritt Chase,
Morning at Breakwater,
Shinnecock, c. 1897,

oil on canvas,
101.6 x 127 cm
(40 x 50 in.).

TFA, Daniel J. Terra
Collection 1999.30

Distinguished Alumni Medal from Pennsylvania State University the year before, Terra, class of 1931, was asked to lend his collection for a benefit exhibition, which raised two million dollars. Of the twenty paintings that were exhibited from June 5 to July 17, only nine are still in the Terra Foundation for the Arts collection, an indication of the variability of Terra's personal collection over the next twenty years. The exhibit's checklist is the first available record of the collection. Several works by Terra's favorite artists—Sargent (p. 94 a, c), William Merritt Chase, and Maurice Brazil Prendergast (p. 141)—have remained in the collection.

Seeing his paintings on a museum's walls must have been a gratifying experience for Terra. When the university's Museum of Art asked him to donate some paintings to its collection, Terra began to consider the future of the paintings as part of his estate, noting in retrospect that "You get to a point where you have to decide what you're going to do with what you have."[4] When an unnamed dealer suggested that he establish his own museum, Terra demurred: "I said we didn't have enough paintings for a museum, but he said we did. So I began looking into it."[5]

4. Quoted in Lauerman, "Terra Museum's Daniel Terra.".

5. Quoted in Jo Ann Lewis, "Daniel Terra's $35 Million Experiment: In Chicago a New Museum of American Art," *Washington Post,* April 21, 1987, C1-3.

Evanston's Terra Museum of American Art

Terra credited the Whitney Museum of American Art in New York City as an inspiration and a model for his project, suggesting that the Whitney's history was a corollary to his own legacy. Gertrude Vanderbilt Whitney (1875–1942) was one of the wealthiest women in the United States and an accomplished sculptor. Her founding of the Whitney Studio in 1914, later the Whitney Studio Galleries, coincided with her professional and philanthropic interests to encourage living American artists. When the Metropolitan Museum of Art rejected Whitney's proposed gift of her collection, in 1930, she founded a museum of her own dedicated to American art. It is conceivable that Terra identified with her since he, too, was unable to come to an agreement about giving his art to his hometown museum, the Art Institute of Chicago. However, the Metropolitan declined the Whitney collection because the museum deemed her art not to be of high enough quality. Terra, by contrast, did not want to lose control of his collection within a larger institution that had only recently established an American art department. Terra remembered years later, "The hang-up was that I insisted that we have our own board, raise our own money, and make our own decisions."[6] Terra wanted his own museum.

As an experienced and successful entrepreneur, Terra tested his business model by initiating his museum on a small scale. In 1978 Terra chartered a non-profit foundation and began to look for an appropriate site. The first idea was to buy a spacious Victorian house in Evanston's historic district, an hour's drive north of Chicago, where Madeline Richards, his wife's sister, would live as a caretaker. In the first of many zoning problems that plagued Terra's later museums, Evanston's council rejected the notion of showing historic art in a vintage house. Eventually, a remodeled floral shop on a busy thoroughfare in Evanston was transformed into the first Terra Museum of American Art. As plans proceeded, the museum evolved from a house museum to a professionally managed art museum whose exhibitions fulfilled an educational mission.

As the museum was in its early stages of development, Terra quickened his search for outstanding American art. One of the most memorable days in the collection's history was December 12, 1978, when Terra bought both Bingham's riverboat

Ernest Lawson,
Spring Thaw, c. 1910,

oil on canvas,
64.1 x 76.5 cm
(25 1/4 x 30 1/8 in.).

TFA, Daniel J. Terra
Collection 1999.85

Exhibition gallery,
Terra Museum of American
Art in Evanston, c. 1980

6. Quoted in Grace Glueck,
"American-Art Museum Opening
in Chicago," *New York Times*,
April 20, 1987.

7. John I. H. Baur to Daniel J. Terra,
October 4, 1979.

painting and Theodore Robinson's *The Wedding March*, 1892 (p. 121). The acquisition of these two works positioned Terra as a major player in the American art world. The Bingham was at the time historically important for its record-setting price, and the purchase of the Robinson formed an emotional attachment to the American artists' colony in Giverny, France, a tie that would have momentous consequences for Terra's collection and museum.

Skillfully maneuvering between the intersecting worlds of scholarship and display, Terra chose to have a high-profile exhibition organized by the Henry Art Gallery of the University of Washington in Seattle, *American Impressionism*, as the inaugural exhibition at the new museum. Terra focused attention on his growing collection by lending fifteen paintings to the exhibition and underwriting its catalogue. The noted historian of American art William H. Gerdts contributed a scholarly essay to the catalogue, whose cover illustration was Terra's favorite Ernest Lawson (1873–1939) painting, *Spring Thaw*, about 1910.

Terra invited the Whitney's director emeritus John I. H. Baur (1909–1987) to serve as guest curator

for this inaugural exhibition. Terra astutely linked the scholar's credentials to his new museum. Baur's pioneering scholarship and exhibitions of American impressionism made him the perfect consultant for Terra's proposed museum. After visiting the museum in Evanston, Baur remarked, "It will be one of the most attractive museums of its size in the country—and a wonderfully practical one. My only doubt concerns its location."[7] What Baur could not know was that the Evanston location was only the beginning for the museum.

Evanston's Terra Museum of American Art opened to great fanfare on May 16, 1980. Revealing his long-range plans to the *Chicago Tribune* art critic Alan Artner, Terra asserted, "We're committed to a move within five years. I like the idea of going into business. We'll have a bookstore to provide reading materials and reproductions, and it is my hope we can engage specialists to write authoritative pamphlets on each of the painters in the collection. People should be able to take something away with them to help understand the greatness of American achievements." Baur characterized the expansion of the Terra collection, "Our plan is to survey about 130 years

Daniel J. Terra in front of
Samuel F. B. Morse's *Gallery
of the Louvre*, 1982

Daniel J. Terra in the State
Department Office, 1989

8. Quoted in Alan G. Artner,
"Museums and Galleries,"
Chicago Tribune, March 16, 1980.

9. Quoted in Henry Hanson,
"Terra's Americana: A New
Museum in Evanston Champions
the Cause of American
Impressionism," *Chicago*,
May 1980, 197.

10. Franz Schulze, "Terra Incognita:
A New Museum of American Art,"
Artnews 79, no. 10
(December 1980): 84–87.

11. Quoted in Charotte Moser,
"As American as Daniel Terra,"
Artnews 82, no. 5 (May 1983):
106.

12. Quoted in Gary Washburn,
"American Art Museum to Rise
on Boul Mich," *Chicago Tribune*,
April 9, 1982.

of American painting [1800–1930] without a definite cutoff."[8] It was Baur as well who articulated why the country needed a museum devoted to American art: "We're getting over feeling provincial; we finally believe that American art has an identity and a quality of its own. And we're beginning to realize how little we know about our art. . . . Now we're beginning to discover our national heritage. I'd like the museum to expand the definition of American Impressionism."[9] If Terra and Baur were optimistic about the future of the Terra Museum, a writer for *Artnews* listed its liabilities: "no curator, no registrar, no professional staff." The critic hedged his prediction for the museum's uncertain future by proposing that the potential of the collection could overcome these amateurish beginnings.[10]

Unforeseen events began to alter the parameters of Terra's vision for, if not the original premise of, his museum. To reward his staunch supporter for raising the record sum of $21 million for his campaign, President Ronald Reagan created for Terra the post of Ambassador-at-Large for Cultural Affairs, announcing, "I am proud to have Dan Terra on our team. Not only is he a valued friend, but he is making a significant contribution towards the enrichment of society as he works to share culture."[11]

Terra officially began his honorary office in February 1982. Sadly, Adeline, his wife of forty-five years, died that May. As a tribute to their artistic collaboration, Terra announced his proposal to build a "$100 million museum" on North Michigan Avenue. Terra effusively remarked, "I happen to think it would be great for Chicago . . . American art has taken a back seat for too long."[12] Three months later, in July, Terra captured the attention of the art world once again by paying a record price for an American painting, $3.5 million for *Gallery of the Louvre*, 1831–1833, by Samuel F. B. Morse.

The acquisition of *Gallery of the Louvre* was decisive in expanding Terra's vision for his museum in Chicago. The painting was committed to travel to France as part of the precedent-setting exhibition *A New World: Masterpieces of American Painting, 1760–1910*, one of the first shows of historic American art to be shown in Europe. Terra organized a tour within the United States for his American masterpiece as well, carrying forward Morse's vision of a national tour to instruct the public about the history of art.[13]

The national American press coverage was extraordinary and provides valuable insights into Terra's personal association with Gallery of the Louvre.[14]

Terra frequently related idealized accounts of capturing the perfect painting for his collection, and the acquisition of *Gallery of the Louvre* was no exception. To provide himself a history with the painting and to establish his identity with Morse the scientist, Terra told a tale of how he came to know about the painting while writing a paper as a chemistry student in college. In his role as ambassador, his comments suggest his political views: "*Gallery of the Louvre* epitomizes that American spirit of vitality, initiative, and drive for self-improvement so evident in the lives and times of two remarkable men responsible for creating this work—Samuel Morse and James Fenimore Cooper."[15] He later linked himself with Morse as the promoter of culture: "Here you have these two great figures of their time [Morse and Cooper] trying to bring European culture to America. I hope it's a bit like my job."[16] To add personal poignancy to the mystique of his acquisition of Gallery of the Louvre, the recently widowed Terra credited Adeline as the driving force behind obtaining the painting and designating it as an American icon. The convergence of Terra's political appointment as Reagan's Ambassador-at-Large for Cultural Affairs, whose responsibilities placed him in the middle of a national discussion on the arts, and the historic purchase of the painting cemented his reputation as a world-class collector of American art and gained national and international recognition for himself and his museum.

Politics and Art
The high profile of Terra Museum of American Art as the embodiment of Daniel J. Terra's political philosophy and the prime example of the Reagan administration's mission to privatize the arts makes its contribution to the historiography of art museums exceptional. As a member of President Reagan's unofficial "kitchen cabinet," the cultural-ambassador-cum-Chicago-businessman became one of the most important figures to represent the association between philanthropy in the arts and public policy. Although his official responsibilities were primarily advisory, Ambassador Terra's many speaking engagements provided a forum for him to promulgate his views on the arts for eight years.

One of President Reagan's first acts after his inauguration was to establish a Task Force for the Arts and Humanities to examine the question of the federal government's role in the arts, with Ambassador Terra as spokesperson for the administration. In his first two years in office, Reagan's budget for the National Endowment for the Arts and the National Endowment for the Humanities (both had been created by federal legislation in 1966) was slashed by one half. Vehement protest from the national arts communities ensured that Congress maintained the endowments' budgets. However, without an increase and taking inflation into account, the real spending power of the endowments was diminished. Terra, as the administration's cultural spokesperson, was immediately on the defensive. He encouraged private philanthropy as a replacement for the federally funded endowments. Terra argued, "Private money funding the arts is truly more democratic. Private contributors can choose for themselves which arts to support."[17] Critics charged that the Reagan arts funding philosophy had elitist implications: the arts would be denied to a wider public.

Ambassador Terra was committed to Reagan's policy of privatizing arts funding, believing it to be the "American way." In 1966 the total private support for the arts was $200 million; in 1984 it was $4 billion. Terra candidly interpreted this increase, "Let's face it, 90% of all philanthropy is tax-related."[18] That is, because tax deductions are the most compelling reason for individual giving, the government is explicitly involved in charitable donations. For Terra, the economic philosophy of enlightened self-interest is the basis for private funding, and tax deductions are the fiscal reality of altruistic philanthropy.

This intermingling of art, money, and politics was drastically altered during the Reagan era by the Tax Reform Act of 1986—the most sweeping tax changes since World War II—which eliminated deductions on the appreciated value of artworks when donated to museums. The combination of lower taxes and the abolition of tax deductions based on charitable giving reduced incentives for potential philanthropists, even though they had more income available to make donations. Despite Terra's confidence in private support for the arts, the reality was that the size of individual donations to the arts decreased under

13. Together in Paris in 1831, Morse and his friend and patron the American novelist James Fenimore Cooper conceived of touring *Gallery of the Louvre* in major American cities in hopes of heightening their countrymen's cultural awareness. For a fee, visitors could study the 6-x-9-foot painting with its accompanying *Descriptive Catalogue of the Pictures*, which identified the thirty-seven European paintings depicted in the painting. The tour was a failure. See David Tatham, "Samuel F. B. Morse's *Gallery of the Louvre*: The Figures in the Foreground," *The American Art Journal* 13, no. 4 (autumn 1981): 33–48.

14. See, for example, the three-page spread in *People Magazine*, January 17, 1983, that identified all the paintings depicted in *Gallery of the Louvre*.

15. Terra Museum of American Art press release, July 29, 1982.

16. Quoted in "Newsmakers," *Newsweek*, August 9, 1982.

17. Quoted in Joe Kullman, "What Has Reagan Meant to the Arizona Arts," *New Times*, January 11–17, 1984, 31.

18. Quoted in Jo Chesworth, "Terra: Cultural Ambassador and Fine Arts Entrepreneur," *The Penn Stater*, September-October 1982, 9.

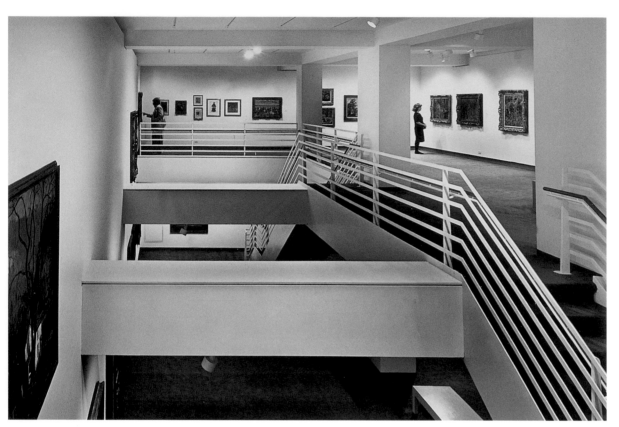

Exhibition gallery,
Terra Museum of American
Art in Chicago, 1999

19. Judd Tully, "End of Chilling Effect," *Artnews* 92, no. 8 (October 1993): 44.

20. Quoted in M. W. Newman and Gilbert Jimenez, "Terra Builds Museum for US Treasures," *Chicago Sun Times*, March 3, 1987.

the Reagan Administration. Throughout the 1980s, there was a significant decline in major art gifts.

The contradiction of the 1980s tax reforms with the Reagan era's espousal of the privatization of the arts posed a problem for Terra and his museum. Extensive lobbying by art museums and donors to overturn the dire results of the 1986 policy produced the Tax Extension Act of 1991, which once again allowed deductions to be taken for the appreciation of property, such as art, when contributed to a charitable organization. A dramatic increase of gifts prompted a second extension to June 30, 1992.[19] Realizing the disastrous consequences to art museums and other charitable organizations, Congress fully restored the tax deductibility on gifts of artwork at current market value in 1993. Possibly in response to the new opportunities for deduction, Terra gave a significant number of paintings to the Terra Foundation for the Arts in 1992. That year saw Terra launch a museum in France to complement his downtown Chicago museum, which he had inaugurated in 1987.

Chicago's Terra Museum of American Art

Announced in April 1982, the Terra Museum's relocation to downtown Chicago in 1987 attracted national news coverage and was much heralded by the local press. Proclaiming "The Americans Are Coming," Terra's publicity recalled a cry from our revolutionary past and spoke to his cultural mission of claiming greatness for America's expressions of art. On the pragmatic front, Terra, not surprisingly, described the relocation as both a business enterprise and a museum innovation, "I think this is a wise investment. This is a milestone for American art. A vertical museum built on the most valuable land in the city, bringing art to where the people are—that's a new concept."[20] Confident that the heavy pedestrian traffic on Chicago's Magnificent Mile—several blocks of high-profile shops—would guarantee the success of his museum, the ambassador yet again emulated the Whitney Museum, whose Madison Avenue address is a prime commercial location.

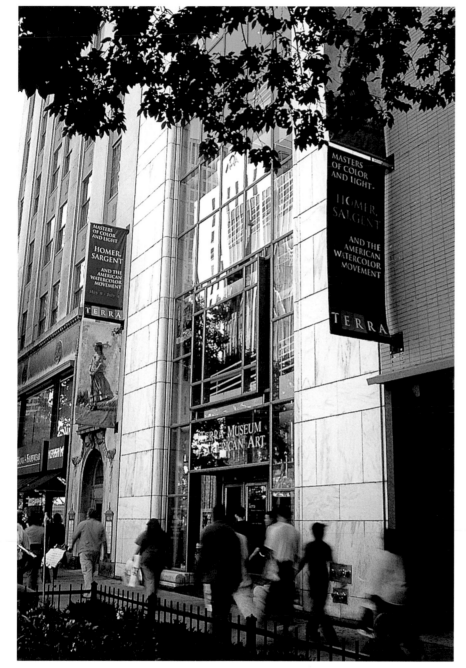

Terra Museum of American
Art on Michigan Avenue
in Chicago, 1999

Terra's challenge to the architectural firm of Booth/Hansen & Associates was to unite two adjoining but dissimilar buildings—one five stories and the other eleven stories high. In this era of multiple-use museums, it was necessary to plan for more than gallery space. Educational programs required an auditorium, visitors desired a restaurant, and, of course, a museum shop was crucial. To create the museum's identity, or face on the street, the facade of the five-story building was clad with a white marble skin and a four-story window was inserted, which metaphorically and realistically invited passersby to view the art galleries. The four-story atrium, dominated by alternating ramps and stairs, was reminiscent of the spiraling gallery space of the Solomon R. Guggenheim Museum in New York City. When entering the Terra Museum of American Art, visitors must pass through the museum shop, which looks like its retail neighbors. The adjacent eleven-story building retained its first-floor retail shop whose rent was a source of revenue for the museum, while the upper stories were converted into gallery space, with the top four levels reserved for the museum's administration offices.

The design of the galleries is distinctive; two bi-level galleries each boast a balconied section reached by interior stairs and enhanced by one double-height wall. Although the museum had won an award for Laurence Booth's "sense of sheer rightness about shapes and forms and materials-good-concern for timelessness," the museum's critics were quick to point out its flaws.[21] Blending the two buildings created a confusing layout and prevented the creation of logically flowing gallery spaces. Furthermore, the restaurant and auditorium were missing. The museum dismissed the negative remarks, reminding the public that it was still in Phase I of its development, and Phases II and III would remedy these shortcomings when a new wing would replace a third adjoining building.

The arduous preparations and numerous difficulties, most of them zoning- and building-related, that preceded the official opening on April 22, 1987, were forgotten as Barbara Bush, the vice-president's wife, cut the traditional ribbon to launch Chicago's Terra Museum of American Art. As much a political event as an arts occasion, the governor of Illinois James Thompson and Chicago's mayor Harold Washington were present as a reminder of the importance of the

21. Paul Gapp, "Terra's Infirmities:
It's a Stylish Place to Visit,
but It's Hard to See the Art,"
Chicago Tribune, April 19, 1987,
sect. 13, 14.

new museum to the cultural life of Chicago and the Midwest. With his new wife, Judith Banks Terra, whom he had married in 1986, at his side, Terra was justifiably proud of his contribution to Chicago's diverse array of museums, one that celebrates American culture.

In a shrewd marketing move, the Chicago museum's inaugural exhibition, *A Proud Heritage*, showcased the Terra collection alongside works of art from the Pennsylvania Academy of the Fine Arts, one of the oldest and most prestigious American art collections in the country. In a bow to Terra's desire to emulate the Whitney Museum's dual focus on historic and modern American art, a major exhibition of contemporary art, *Two Decades of Chicago Painting, 1970s through 1980s*, opened the following September. As Terra's then Curator of Modern Art Judith Russi Kirshner recalls, Terra envisaged contemporary art shows as a complement to his historic collection, but not as an area of growth. For a short while, in 1987, there were three curators of art, a sign of the ambitious exhibition programming considered when opening the Chicago location. But by the end of the year, D. Scott Atkinson carried on alone, and did so for the next decade.

Christened a "star-spangled temple of art," the Terra Museum of American Art symbolized Terra's political beliefs in the efficacy of individual effort and private enterprise.[22] President Reagan lauded his cultural ambassador for "doing more for American art than any other man in the history of the country."[23] To reduce the museum's founding to merely a political philosophy is to overlook Terra's sense of patriotic duty and his deep commitment to heralding American painting before 1940 as a major component of the world's artistic endeavors.

The Terra Collection of American Art

The Terra Foundation for the Arts (TFA) was established with a mission to acquire, preserve, exhibit, and interpret original works of art to foster a greater understanding and appreciation of America's rich artistic and cultural heritage. In 1980 fifty paintings were on loan from Terra's personal collection to the just-established Evanston museum. During the 1987 press extravaganza, surrounding the opening of the Chicago museum, reports claimed that his collection boasted seven to eight hundred paintings,

an unbelievably dramatic increase. Terra was a man with a purpose. As he put it, "I am learning to make purchases for the sake of the museum rather than satisfy my own likes and dislikes."[24] In a reversal of the tradition of founding a museum to showcase a fully formed collection, Terra had rapidly acquired works of art to prepare for his move to the larger galleries in his Chicago museum.

The evolution of Terra's personal collection is unrecorded. However, the works of art Terra gave to the TFA establish that from 1981 to 1990, he acquired 290 works, and after 1990, another 238 objects, of which 150 were prints. After 1987 Terra's acquisitions captured less attention in the art world, with the exception of the record-setting price for Edmund Tarbell's *In the Orchard*, 1891 (p. 123) in 1992. In the weeks before his death, the ambassador was still avidly buying art, finally acquiring the fourth Sargent sketch that had earlier eluded him. The Sargent sketches were reunited and, by June 1996, Terra's collection of American art numbered over 600 objects, which he bequeathed to the TFA.

Among the myriad and complex motivations that Terra had for building a collection of American art, two stand out. To Terra, love of country meant love of the free market, and one of the most exciting aspects of buying American impressionist paintings was that he believed they were both aesthetically and monetarily undervalued.[25] Terra was never shy about his considerable expenditures for art being known. He thrilled to both the increase in individual valuations of a painting as well as winning a desired work of art with the highest bid at an auction, which served to validate his aesthetic choices and his business acumen.

A second impetus for buying American art was Terra's emotional connection to a work of art, which was often expressed as patriotism. David Sokol, the Evanston museum's curator of art, recalled that after the excitement of buying a painting, Terra loved talking about why he was attracted to it. As a first-generation American, Terra saw American art as an expression of patriotism, as did other American art collectors such as Maxim Karolik and Richard Manoogian, who were also from immigrant families: "I have an innate patriotic feeling. It really exists, and it always has been there. My father came to America from Italy as a teenager in 1886. I was born in 1911, and I remember the Armistice Day Parade

22. Michael Kilian, "The Collector: DJT Loves American Art So Much He Spent a Fortune to Build a New Chicago Museum in Its Honor," *Chicago Tribune*, April 19, 1987: sect. 10, 8, 12–16, 26–27.

23. Meg Cox, "The Collector: Daniel J. Terra Builds a Chicago Monument: His Own Art Museum," *The Wall Street Journal*, April 21, 1987, 1, Midwest edition.

24. Quoted in Schulze, "Terra Incognita:" 87.

25. Lauerman, "Terra Museum's Daniel Terra."

President Ronald Reagan
and First Lady Nancy Reagan
with Judith and Daniel J. Terra,
c. 1986

26. Quoted in Alan G. Artner, "Terra's Million-Dollar Painting Puts a High Price on Patriotism," *Chicago Tribune*, August 8, 1982, 4.

27. Ibid.

I must pay a special tribute to my colleagues, Sarah Blackwood and Shelly Roman, for the ongoing dialogue that helped me clarify my arguments.
Comments on an early version of my essay by Katie Bourguignon and Francesca Rose were particularly helpful in understanding a transatlantic perspective. I very much appreciated observations on my essay by Kathy Foster, Liz Glassman and Ted Stebbins. My final words of thanks are for Beth Johns, who inspired me to ask hard questions, and John Schussler for his patient support.

in Philadelphia. I remember the way my father stood. He loved this country, and I was indoctrinated with that feeling."[26] Terra's aggressive buying for twenty-five years contributed to a thriving market for American art. But more important, he assembled a notable collection of American art that he willingly and in a democratic spirit shared with the general public. There is no doubt that Terra saw the collecting and exhibiting of his American art collection as a patriotic mission.

Conclusion

Over the years, Terra's ability to relate personally to his favorite paintings, especially *Gallery of the Louvre* and *The Wedding March*, contributed significantly to his affinity with France. Honored by the French government in 1985 when named Commander of the Order of Arts and Letters, Terra was recognized for his commitment to supporting the arts. Surely these associations influenced Terra's innovative museological venture—to establish a museum of American art in Giverny, the rural home of the French impressionist painter Claude Monet and the celebrated American artists'colony.

The opening of the Musée d'Art Américain Giverny in 1992, as might be expected, affected the Chicago museum. Expansion of the Terra Museum was abandoned, and the curatorial and education departments were called on to develop programming for the new museum. The most significant outcome of Terra's cross-cultural venture was the sharing of the collection between the two institutions. Terra's original vision to celebrate America's artistic heritage in its homeland was transformed by the founding of a museum in France, whose audience would be exposed, often for the first time, to a collection of American art dating to before 1940. This transatlantic undertaking offers a unique perspective on the TFA collection, which claims a national identity while commemorating international artistic influences. Terra was a visionary in his pursuit of educating an unaware American public and, later, a skeptical French audience about the value of American art.

A pragmatic businessman with a passion for politics and art, Daniel J. Terra opened the Terra Museum of American Art in Chicago with the determination to organize a world-class museum that honored American art and history and embodied his political belief in private funding for the arts. Late in life, Terra indulged his personal delight in art by buying American art for his collection, assembled, for the most part, as he prepared to open the Chicago museum. But his true pleasure was in sharing his art with others: "If people can develop an interest in art, they can have a much richer life. I think it builds character and nourishes value—that's what makes art what it is. As corny as it might sound, I think art is food for the spirit."[27]

2

An American in Giverny
Daniel J. Terra and the Musée
d'Art Américain Giverny

Katherine M. Bourguignon

Musée d'Art Américain Giverny gardens

1. The museum changed its name
from Musée Américain Giverny
to Musée d'Art Américain Giverny
at the end of the 1993 season
to clarify itself as an art museum.
References to the museum in this
text reflect the date of the name
change. Many local and interna-
tional newspaper articles recount
the excitement of opening day.
See especially Catherine Montourcy,
"L'impressionnisme américain a sa
vitrine: un second grand musée
à Giverny!" *Le Démocrate*, Vernon,
June 3, 1992.

2. Jack Lang to Daniel J. Terra,
June 1, 1992: "la grande enterprise
culturelle que vous avez souhaité
établir dans notre pays, et que nous
sommes heureux d'accueillir."
Archives, Musée d'Art Américain
Giverny.

On June 1, 1992, over sixty volunteers arrived
at the brand-new Musée Américain in Giverny to assist
in the opening day festivities.[1] The volunteers had
much to do: 250 journalists attended a press
conference in the morning, and over 1,200 guests
had accepted invitations to visit the museum that
afternoon and eat dinner in a temporary structure built
on the museum parking lot. The small, tightly knit staff
of the museum had worked hard for many months to
organize the opening, and Ambassador Daniel J. Terra
and his wife, Judith, had hired a French publicist
to facilitate their communication with the press.
Scholars, curators, and politicians from Europe and
the United States attended the opening ceremony
on that sunny Monday in June. Unable to attend,
the French Minister of Culture Jack Lang wrote
a kind letter thanking Terra for "this great cultural
enterprise that you wished to establish in our country,
and which we are happy to welcome."[2] Just prior
to the ribbon cutting, several people who had played
a role in the museum's birth made short speeches.
D. Scott Atkinson spoke about the inaugural
exhibition he had organized; Claire Joyes Toulgouat,
a local authority on impressionism, spoke about
the history of Giverny. Finally, Mr. and Mrs. Terra,
in the company of Walter Curley and Jacques
Andréani, ambassadors to France and the United
States respectively, and Bernard Berche, then mayor
of Giverny, officially inaugurated the new museum
amid applause and photographs.

The Terras and their guests had good reason
to celebrate. The opening of the Musée Américain
occurred after six years of persistent efforts on the
part of Terra whose desire to open his own museum
in France met with skepticism and opposition.
The story began in 1986, one hundred years after
American artists first began to settle in Giverny,
when the Terras purchased a house and began
to dream of opening a museum. Their collection,
already strong in American impressionism, would
continue to grow, and their mission—to educate
the public about American art—would take shape.
In addition to opening a museum in Giverny,
Terra purchased numerous properties in the town,
with hopes of establishing a new sort of American
art colony. His museum and research center
for American art in the impressionist stronghold
of Giverny may have seemed overly ambitious at first,
but many of his dreams are becoming reality.

A House and a Dream

Located in the part of the village known as Le Pressoir
(cider press) and adjacent to property once owned
by Claude Monet (1840–1926), the house at the heart
of Terra's Giverny adventure is known to local villagers
as Le Hameau (hamlet), but for Terra it would always

Musée d'Art Américain
Giverny, 1992

be the Perry House. Many American artists had lived in this house during the late nineteenth and early twentieth centuries when Monet lived next door. Among the most famous residents was Lilla Cabot Perry who rented the house with her husband and family for the summer seasons from 1894 to 1896. Perry was one of the few American artists in Giverny to develop a lasting friendship with Monet and his family, and she often met him strolling in the gardens after lunch. Over the years, he offered advice on her painting.[3] After Perry, an American art teacher named Mary C. Wheeler (1846–1920) rented the house and its gardens from 1907 to 1916 and invited artists staying in Giverny to teach the young American women enrolled in her classes.[4] The painter Frederick Carl Frieseke, who lived in Giverny from 1906 until about 1920, worked as a teacher at Le Hameau and probably lived there for a short period with his family. He painted several pictures in the gardens of his Giverny homes, including *Lady in a Garden*, about 1912 (p. 145), *Lilies*, about 1911 (p. 32), a painting once described by Terra as "a drop dead picture"[5], and *Tea Time in a Giverny Garden*, about 1911 (TFA 1987.21).

After Monet died in 1926 and the American stock market crashed in 1929, American artists abandoned Giverny as a painting colony. Le Hameau passed through a variety of owners, and its rich artistic past faded. When the Monet house and gardens opened to the public in 1980, tourists began flooding this small Norman village, and the little house next door began to attract attention.[6] In 1986 local impressionist experts Claire Joyes and her husband, Jean-Marie Toulgouat, (the grandson of Theodore Butler and Monet's stepdaughter Suzanne Hoschedé) learned

3. Lilla Cabot Perry, "Reminiscences of Claude Monet from 1889–1909," *American Magazine of Art* 18 (March 1927): 119–125.

4. Pierre Toulgouat, "Peintres américains à Giverny," *Rapports: France–États-Unis*, no. 62 (May 1952): 65–73. See also David Sellin, "Frieseke in Le Pouldu and Giverny: The Black Gang and the Giverny Group," in *Frederick Carl Frieseke: The Evolution of an American Impressionist* (Savannah, Ga.: Telfair Museum of Art, 2001).

5. Quoted in Dodie Kanzanjian, "Daniel J. Terra," *House and Garden* (May 1987).

6. When he died in 1966, Monet's son Michel left his collection, house, and gardens to the Académie des Beaux-Arts (one of the five academies that make up the Institut de France). Under the direction of Gérald Van der Kemp, and with financial support from French and American individuals, the Claude Monet Foundation transformed the neglected house and redesigned the gardens, opening to the public in 1980.

Opposite page:
Le Hameau, 1998

Frederick Carl Frieseke, *Lilies*,
c. 1911, oil on canvas,
65.4 x 81.6 cm
(25 3/4 x 32 1/8 in.).
TFA, Daniel J. Terra Collection
1999.55

Theodore Robinson, *Portrait
of Monet*, c. 1888–1890,
cyanotype, 24 x 16.8 cm
(9 7/16 x 6 5/8 in.). TFA, Gift of
Ira Spanierman C1985.1.6

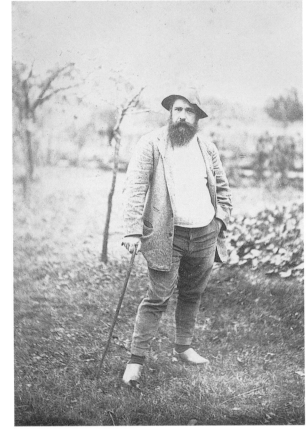

7. Stephen Weil, conversation with
the author, October 5, 2001. Terra
kept his plans for Giverny secret
from the American press for a long
time. In an interview with a journa-
list in May 1987, for example, Terra
spoke in detail about Giverny and
Le Hameau without actually
mentioning that he currently owned
the house or had plans for building
a museum there. See Kanzanjian,
"Daniel J. Terra."

8. *American Impressionism*,
organized by the Smithsonian
Institution Traveling Exhibition
Service, was presented at the Petit
Palais March 31–May 30, 1982.
*A New World: Masterpieces
of American Painting, 1760–1910*,
organized by the Museum of Fine
Arts, Boston, appeared at the Grand
Palais, March 13–June 11, 1984.

9. The Order of Arts and Letters,
established in 1957 by the French
government, recognizes people
who have contributed to furthering
the arts in France and throughout
the world.

that the owners of Le Hameau wanted to sell.
Advocates for preserving the town's cultural history,
the Toulgouats worked hard to find a buyer.
One summer day Joyes discussed the house with
the deputy director of the Hirshhorn Museum,
Stephen Weil, and his wife Elizabeth Carbone Weil,
then chief corporate development officer at the
National Gallery of Art in Washington D.C. and an
acquaintance of the Toulgouats. Over lunch, Joyes
mentioned her concern that the house would be
purchased by a wealthy Parisian as a summer home,
and that its rich artistic history would remain buried.
Weil thought immediately of Terra as a potential
buyer and left a message for him via his museum in
Evanston. Just a few days later, Terra sent a message
back to Weil saying he should forget the "crazy idea."
Meanwhile, Terra and his wife had made plans
to arrive in Giverny.[7] After brief discussions with the
Toulgouats, the owners of Le Hameau, and a notary
public, Terra and his wife struck a deal and began
to dream of opening a museum. At the time, Terra
owned numerous canvases painted by American artists
who had at one time visited or worked in Giverny.

He could imagine nothing better than to exhibit these
pictures in a museum devoted to American art right
in the village Monet had called home. After all,
France had recently expressed an interest in American
art with two significant exhibitions, featuring pictures
owned by Terra.[8] As America's Ambassador-at-Large
for Cultural Affairs, Terra traveled often to France
and was named Commander of the Order of Arts
and Letters in 1985, a highly prestigious honor for
a foreigner.[9] Yet, despite these French connections,
Terra was not a francophone, was not familiar with
the French legal system, and would face countless
difficulties as he worked to establish his museum.
His incredible zeal for American art, however,
and his sheer persistence in the face of opposition,
made him believe that this ambitious project would
really happen.

A Museum of American Art

Terra soon realized the small house of Le Hameau
could not accommodate his vast collection of American
impressionism as well as the thousands of visitors
he expected, so in 1987 he purchased land across

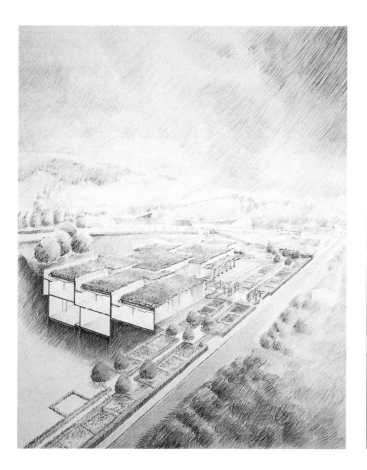

Drawing of Musée d'Art
Américain Giverny,
Reichen et Robert,
architects,
c. 1990

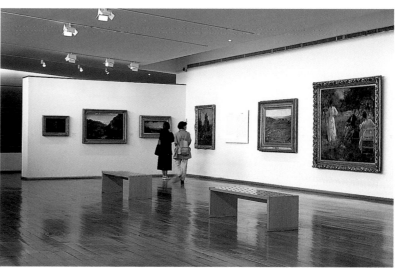

Exhibition gallery, Musée d'Art
Américain Giverny, 1998

10. The Giverny council accepted the idea for the project of a museum as early as October 15, 1987, but would continue to debate the architectural plans and other concerns, such as parking, for several years. See "Le Musée Terra en question." *Le Démocrate*, Vernon, November 15, 1989, as well as numerous articles in local newspapers *Eure Inter Information*, *Le Démocrate*, and *Paris-Normandie* from this period. Giverny-based architect Philippe Robert knew of Terra through his friend Laurence Booth, the architect for the Terra Museum of American Art in Chicago. The architectural firm Reichen et Robert had already garnered attention for buildings integrated into their sites (for example, the Grande Halle de la Villette in Paris, 1985, and the French Embassy in Qatar, 1987) Information on the museum came, in part, from Philippe Robert himself, conversation with the author, October 25, 2001.

11. Robert, in Jean-Louis Perrier, "Giverny cimaises d'Amérique," *Le Monde*, April 13, 1991: "Nous avons beaucoup travaillé pour que notre architecture soit inexistante.... Le plus grand compliment serait que l'on nous demande où est notre travail."

the street. Original ideas of constructing a large, Normandy-inspired thatched cottage building on the site met with opposition at the Giverny municipal council. Villagers objected to the ostentatious nature of the design and how it would alter the view of the hill behind the site. At one of the heated meetings in the office of Mayor Berche, a local architect named Philippe Robert made quick sketches of a building that would literally sink into the hillside and be surrounded by gardens and trees. Inspired by Monet's house and gardens, Robert, of the Paris architectural firm Reichen et Robert, drew plans to include a bridge, an arcade, and a long garden running parallel to the rue Claude Monet. During the meeting, several people noticed Robert's drawings and showed them to Terra, who soon hired him. The final drawings easily obtained the construction permit needed to start building, and ground breaking occurred in 1990.[10]

The museum design combines nature, architecture, and light. Robert's goal was to integrate the impressionist paintings in the collection with the natural site of Giverny and to produce a unique space in close contact with both nature and art. Discreet,

the clean white building extends horizontally across the land, covered and surrounded with plants. As Robert has said, "We have worked hard to make our architecture non-existent. . . . The biggest compliment would be for someone to ask us where our work is."[11] A large, bright entry hall welcomes visitors. To the right, a restaurant and a gift shop provide necessary amenities, and to the left, three main exhibition galleries, constructed on different levels, fit closely into the hillside. On the lower level, a large auditorium offers space for conferences and concerts. Having all the high-tech requirements for a modern museum, including light and climate control, and in complete harmony with its natural environment, the museum building met Terra's requirements and placated most villagers.

The first design for the gardens in front of the museum came from sketches made by Robert and one of his colleagues, Florence Robert, a landscape architect then working for Reichen et Robert. Although the gardens had already been planted in 1990, the Terras changed their mind in late 1991 and hired Mark Rudkin, an American landscape

Musée d'Art Américain
Giverny under
construction, c. 1991

12. The author had the opportunity to speak with Didier Brunner, Florence Robert, and Mark Rudkin for details related to the museum gardens.

13. Numerous articles from this time refer to the opposition Terra faced in the local community. See especially, Rone Tempest, "Another Normandy Invasion: The Battle for Musée Américain," *Los Angeles Times*, June 3, 1992, in which Terra mentioned that he almost gave up the entire project at least four different times. Terra's museum project exacerbated parking problems already present in Giverny since the opening of the Monet house and gardens.

14. "Parking extérieure = vie meilleure" and "Oui à la culture, non aux voitures." Articles published on the occasion of the museum's opening in June 1992 made reference to the parking dispute. See especially Jean-Claude Louvat, "Musée Américain Giverny: un impressionnant panorama historique," *Eure Inter Information*, no. 873, June 4, 1992, 2, and D. Bureau, "La révolte silencieuse des pancartes," *Paris-Normandie*, June 2, 1992.

15. Several articles compared the Musée Américain to Euro Disney. See Frédéric Edelmann, "L'empire américain débarque à Giverny," *Le Monde*, June 3, 1992, in which the author calls the museum compensation for Euro-Disneyland; Annick Colonna-César, "Impressions d'Amérique," *L'Express*, (June 11, 1992): 33; and Josephine Le Foll, "Terra sous Terre," *D'Architectures*, no. 27 (July–August 1992): 29. It is important to remember that most French museums receive funding from local and national government, and that private philanthropy, especially the creation and funding of a cultural institution by a single person, remains a rarity in France.

16. Original staff included Patrick Baeyens, who worked directly for Terra as his all-around assistant and translator; Marie Bosson, in charge of the gift shop; Didier Brunner, gardener; Quentin Donoghue, who assisted in communication with the press; Diana Guillaume, general office assistant and later specialist in group visits; Jacqueline Maimbourg, accountant; and Olivier Touren, security. Several members of the original staff provided valuable information for this essay, including Jean Bergaust, Mayalène Crossley, Marie Bosson, Didier Brunner, and Diana Guillaume.

architect living in Paris, to consult on the project. Rudkin, known for his design of the gardens at the Palais Royal, maintained the long, central walkway and the idea of squared planted segments. He enclosed the squares with hedges and modified the types of plants in each section to make separate, intensely colored garden "rooms." The new design by Rudkin created an elaborate, dynamic garden entrance to the museum and continues to please visitors.[12]

Terra had overcome opposition in the Giverny municipal council with his new architectural plans, but he would soon learn that several villagers resisted not just the building but the very idea of a museum of American art. Inundated with visitors to the Monet Foundation since its opening to the public in 1980 (over 400,000 per year), several Givernois expressed concern that their quality of life would drastically change as cars and buses crowded their streets and tourists invaded their town. They mounted steep opposition to the museum, even filing a lawsuit against Terra, who did little, at first, to diminish their worries, and even boasted to the press that his new museum would attract as many visitors as the Monet Foundation.[13] Concerned about inadequate parking, the villagers protested the solution proposed by Terra of a parking area directly across from his museum, in the center of town. On opening day, with many

of the disputes unresolved, several unhappy residents hung banners that read, "Exterior Parking = Better Life" and "Yes to culture, no to cars."[14] Terra's naïve passion for his project and lack of French language skills distanced him from the people of Giverny. Perhaps he underestimated their skepticism that an American millionaire would truly open a cultural, non-profit institution in their town. Without a tradition of privately funded cultural institutions, the French public may have mistaken the new museum for a business venture. After all, France was preparing for another American commercial "invasion," the opening of Disneyland Paris, in the spring of 1992.[15]

Between 1987 and 1992 Terra traveled to France every two weeks. To help ease local conflict, communicate in French, and supervise construction of the building while absent from France, Terra relied heavily on his small, hard-working initial staff. An American friend of the Terras and former ambassador to UNESCO, Jean Bergaust supervised construction and acted as administrator. Mayalène Crossley arrived in 1991 to work on public relations and help Bergaust with communicating in French (Crossley later became administrator). These two women worked with Terra to hire other employees during this early period.[16] Members of the staff have described the atmosphere at this time as both exciting

Daniel J. Terra in front
of the Musée d'Art
Américain Giverny, 1992

17. Madame Ahrweiler shared
memories of Daniel J. Terra and
the origins of the museum in
a conversation with the author,
October 4, 2001. It should be
noted that to operate under French
law, Terra established a French
association in 1992 (incorporated
under a 1901 law that gives
guidelines for non-profit associa-
tions). The association, which
offered guidance for the museum
but did not provide funding,
dissolved in 1998, leaving financial
and administrative responsibility to
the Terra Foundation for the Arts.

and stressful, the kind of environment that bred camaraderie. At the age of eighty, Terra's energy rarely faltered. He was omnipresent, worked around the clock when in France, and telephoned at all hours when in the United States. He often made appointments for 7:00 A.M. (much to the surprise of French contractors who quickly learned to adjust their schedules if they wanted to do business with him). Terra placed an enormous amount of responsibility on his employees and could be a difficult, demanding boss. At times impatient, even harsh, he could also be incredibly enthusiastic and had a good sense of humor. Always the businessman, Terra maintained control of finances and had curious spending habits, willing to invest millions in art, property, and the image of the museum, yet careful to economize on purchases for the bookstore and hesitant to acquire computers for the museum offices.

Terra's willpower and optimism paired with the dedication of his staff helped him overcome obstacles as the museum took form, but he would still need extra help navigating the maze of French bureaucracy. Getting his museum accepted by the local population was proving difficult, but tackling the French cultural audience and inviting them to accept another art museum, particularly one featuring American art and

funded by an American millionaire, would take time and the right kind of friends. Luckily, Terra's ambassador status allowed him to meet several influential people at the right time. Marceau Long, vice-president of the Conseil d'État, invited Terra and his wife to meet Mr. and Mrs. Ahrweiler at a private lunch at the Palais Royal in Paris. Recteur Hélène Ahrweiler, professor at the Sorbonne and president of the Centre Georges Pompidou in Paris, thought Terra appeared pushy when she first met him, but she quickly became a key supporter of his project. Terra had brought his architectural drawings for the museum to the lunch and displayed them around the room. Of foreign origin herself, Ahrweiler knew Terra would face resistance getting his museum going, and she decided to assist him. She established an advisory council for the museum and served as its president, organized two important seminars for American and European scholars, and later served as chairman and president of the Terra Foundation for the Arts.[17]

When the Musée Américain de Giverny opened in 1992, it lacked a curatorial staff and a clear plan for development. As one journalist said, "Terra is still not sure how it will work, what the budget is, who the curator will be or where all the cars will park. This does not dampen his enthusiasm."[18] In fact, the museum

GIVERNY (Eure). - Maison Rose

faced several limitations, many that would not be resolved for years. It succeeded nevertheless in attracting visitors and attention as soon as it opened. The inaugural exhibition, *Lasting Impressions: American Painters in France, 1865–1915*, included examples from Terra's comprehensive collection of American impressionism, such as works by Perry, Frieseke, Theodore Robinson, Theodore Butler, and John Leslie Breck. Organized by D. Scott Atkinson, then head curator at the Terra Museum of American Art, Chicago, and accompanied by a large catalogue written by the American impressionist expert William H. Gerdts, the show demonstrated why Terra had opened the museum. After all, many of the canvases had been painted right there in Giverny, an aspect of the exhibit that fascinated visitors. Over the next several years this show became a kind of permanent installation complemented by smaller exhibitions focusing on individual artists (Maurice Brazil Prendergast in 1993, James McNeill Whistler in 1994, Winslow Homer in 1995, and Mary Cassatt in 1996). Terra and his supporters spoke often of hiring a professional curator for Giverny and of organizing temporary shows that would extend beyond the sphere of American impressionists, but these kinds

of changes would not happen until many years later. Although the number of visitors to the museum never approached Terra's enthusiastic projections of 400,000, the museum did and continues to attract tens of thousands of visitors from all over the world and numerous students from neighboring cities. The first year it opened, with a shortened season (June 2–October 31, 1992), the museum welcomed 49,000 visitors, a number that would grow to reach 72,000 by the mid-1990s and remain relatively stable. The new museum had certainly created a splash in the French countryside.

Just as he had done in his two museums in Evanston and Chicago, Terra once again placed a priority on education. From the outset, he wanted to welcome school groups and teach students about American art. Most of the original educational programming came from the Terra Museum of American Art's staff in Chicago, but the museum would soon hire an education specialist and later create a full education department to develop programs specific to French schoolchildren. In its first year, the museum welcomed just over 1,800 students; by 2001 the number had grown to over 5,000.[19]

18. Sharon Waxman, "Terra Museum in France Hopes to Make Impression," *Chicago Tribune*, June 2, 1992.

19. Diana Guillaume and Véréna Herrgott provided details related to attendance and the education program at the museum.

Design for the Perry House
(Le Hameau) renovation
project, Catherine Proux,
architect, 1995

1- Lilla Cabot Perry's house
2- the grassed orchard
3- the ateliers
4- the open alcove
5- the ticket office
6- the transition hedge-groves
7- sanitary installations
8- pergolas
9- closed garden
10- wall

20. Terra and his wife spoke
to the press about plans to create
a learning center in 1993.
See Nathalie d'Andrea,
"Les grandes ambitions du musée
Terra," *Le Démocrate*, Vernon,
June 23, 1993, 14. Among the
projects the author mentioned
were an "institut de formation
pour les jeunes peintres,"
"une biblio-thèque pour les
chercheurs," and "un centre
artistique." [An educational
institution for young painters,
a library for researchers, and an
artistic center.]

21. Jocelyne and Serge Legendre,
*Vernon et sa Région 1890–1940,
cinquante ans de vie et d'histoire*
(Luneray, France: Impr. Bertout,
1999): 338.

22. Terra already had ideas for the
house before he actually purchased
it. On September 26, 1993,
he mentioned to his advisory
council that the house could be
a site for a library and asked if he
should continue to collect books.
On October 21, 1995, after he had
purchased the house, he spoke
of it again to his advisory council,
saying that it would be useful for
educational projects. Terra and
Recteur Ahrweiler had already
discussed a proposed research
library in 1993 in Nathalie
d'Andrea, "Les grandes ambitions
du musée Terra," *Le Démocrate*,
Vernon, June 23, 1993, 14.
The Terra Foundation for the Arts
is still hoping to create a research
library in Giverny.

A Learning and Research Center

Even before the museum opened to the public in
1992, Terra began to dream beyond the walls of an
exhibition space.[20] Fascinated by the history
of American artists who had visited Giverny and made
it their home, he purchased houses near the future
site of the museum. Some of the houses had
an art historical past; others were simply close by
and could serve museum-related purposes.
Terra seldom spoke of his plans to those outside
his tight circle of friends, but when looking at the
history of purchases, he seems to have had an idea
in mind. He would create not just a single site of
American art on French soil (the museum itself),
but he would start to put into place a center for
research and learning about American art, to re-create
an art colony in Giverny by opening houses
to visiting artists and scholars and inviting students
to spend the summer in the same area that had
inspired Monet. Terra acquired land and houses
in the village because he wanted to preserve
the rural beauty of Giverny and prevent commercial
development. More important, the purchases allowed
him to imagine a learning center or "campus" beyond
the walls of the museum.

In 1988, while the Giverny municipal council
debated the architectural plans for the museum, Terra
purchased two houses in town. From 1990 to 1994
Terra purchased four additional houses and several
parcels of land in the village, including the hillside
behind his new museum and land on the nearby
Grande Ile. Much of the land in the center of town
would be transformed into an orchard-like parking lot
while the hillside would be left undeveloped. In 1995,
the year before his death, Terra purchased three more
houses in the center of the village and several more
parcels of land. These final houses included the
fabulous Maison Rose, a large, historic house and
hotel featured in numerous old postcards of the area.
The house and its vast gardens had welcomed many
celebrities including Blanche Hoschedé, Monet's step
daughter, who often came to paint in the gardens,
and the dancer Isadora Duncan.[21] Another important
house purchased in 1995 (known as the Cannet
House) once belonged to the American artist Theodore
Butler, Monet's son-in-law. It was this art historical
significance that attracted Terra, who mentioned his
desire to transform the house into a library.[22] Terra had
already begun to collect books on American art with
the hopes of establishing a comprehensive library,

unique in Europe, as a complement to his museum and a necessary component of his research center.

The most important house for Terra would always be the Perry House. Used as a residence by the Terras in the years preceding the museum's opening, the house later served as office space. In late 1994 Terra asked the architect Catherine Proux to draw up plans for a full-scale renovation of the house to open it to the public. Strategically located between the Monet House and the Musée d'Art Américain, Le Hameau property would entice visitors walking between the two museums. The ambitious project would have allowed visitors into the studios (where they would watch videos in a newly designed room), the house (where plans called for a large boutique area), and the front garden and orchard area (with a proposed ticket booth and restrooms). The south gardens would be viewable to the public through windows cut into the wall surrounding the property. Rejecting the construction permit in October 1995, the Giverny mayor wrote that the village already received too many visitors and that the house should remain a residence, not be transformed into a museum.[23] The Musée d'Art Américain abandoned plans to open the house to the public but decided to renovate it to its nineteenth-century appearance. In April 1996 members of the advisory council suggested it could serve as headquarters for The Terra Institute of American Culture or The Giverny Learning Center, two possible names for the learning and research center Terra had envisioned.

Terra purchased houses and land with the goal of creating this proposed learning center, but he needed outside advice to develop a clear plan. Seminars organized by Recteur Ahrweiler in 1993 and 1997 helped formulate the project. Terra and his wife wrote to several American and European art scholars inviting them to attend the first seminar in Giverny: "In order to insure that this museum becomes a center for serious scholarly study, we are planning a small, select seminar of art scholars. . . . The purpose of the seminar would be to look at the museum project as it is now and to help give definition and direction to the way it should proceed in order to have maximum impact on the world of art scholarship."[24]

Professors and curators met over a few days in September 1993 to discuss the current status of the museum and its dreams for the future. Optimism

reigned during this first meeting as scholars emphasized an educational mission for the museum. Participants mentioned their desire to have the Musée d'Art Américain invite students and scholars to visit Giverny for short periods of time. One successful project the museum developed in 1996 and 1997 allowed several artists from the University of the Arts, Philadelphia, to spend six weeks in Giverny. The artists resided in houses owned by the Terra Foundation for the Arts, worked in adjacent studios, and exhibited their paintings and photographs in one of the museum galleries.

By the second seminar in 1997, the five-year-old museum had become a more permanent institution in Giverny, but still sought a permanent identity. After Terra died in 1996, the museum and the Terra Foundation for the Arts underwent a period of transition and reevaluation. This second seminar of European and American art professionals was, in part, a response to this need for change. Seminar participants advocated the hiring of a curatorial staff in Giverny to organize temporary exhibitions. They also supported education initiatives and the potential affiliation of the museum with American and European universities.

A Dynamic Museum for the Future

Over the past ten years, the Musée d'Art Américain Giverny has matured into a serious center of cultural exchange and international dialogue. In 1999 the Terra Foundation for the Arts named a new director to the museum in Giverny and encouraged him to make changes necessary to its future growth. During his two years as the institution's first art historian director, Derrick R. Cartwright refocused the direction of the museum and its learning center. One of his first tasks was to establish a permanent education department that would expand the educational projects in place since 1993. The museum currently introduces thousands of primary and secondary students to American art every year and offers numerous studio and workshop classes. Cartwright also coordinated several temporary exhibits to introduce French audiences to pictures in Terra's collection from the colonial period to the twentieth century. In addition, he hired a full-time French curator to facilitate links with French museums. The decision to hire a curator in Giverny, and in particular one with a French

23. "Annexe à l'Avis du Maire," signed by Mayor G. Colombel on October 12, 1995, Archives, Musée d'Art Américain Giverny.

24. Mr. and Mrs. Terra to prospective seminar participants, undated, Archives, Musée d'Art Américain Giverny.

Entrance to the Musée
d'Art Américain Giverny,
1998

Over the past several months,
numerous people have spoken with
me about the early years of the
Musée d'Art Américain Giverny.
They shared memories, offered
advice, and provided important
documents to enrich my text.
I am also grateful to the people
of Giverny who responded to my
questions about their village's rich
artistic history; to my colleagues
at Musée d'Art Américain Giverny
for their contagious enthusiasm
and steadfast support; and, finally,
to Elizabeth Glassman, Bronwyn
Griffith, Elizabeth Kennedy,
Sophie Lévy, and Francesca Rose
for helpful comments on earlier
versions of this text.

diploma, solved many of the problems the museum had faced since its creation. Sophie Lévy currently heads an active curatorial department that prepares exhibitions covering a wide range of American art and culture. The Musée d'Art Américain develops its own exhibitions, often borrowing works of art from major French and American institutions.

The learning and research center also has matured over the last few years. In 2001 the Terra Foundation for the Arts and the Musée d'Art Américain launched the Terra Summer Residency in Giverny. The residency provided support for artists and academics to engage in independent study within a framework of interdisciplinary dialogue. During its pilot year, the program brought together eleven international students and five senior scholars for a period of six weeks. The fellows, advanced fine arts students and doctoral students in art history with a research focus on American art, resided and worked in the houses Terra had purchased years earlier for just that purpose. During their stay, the students attended lectures and seminars, worked directly with professional artists and scholars, produced artworks, and conducted their own research. Pleased that her husband's dreams were being

realized, Judith Terra welcomed the fellows at her home in Vernon to spend a relaxing summer evening.

In addition to the exhibitions and summer programs, the museum has recently devoted itself to producing a series of publications related to its collections and exhibitions. These catalogues, published in both French and English, parallel the multilingual environment of the museum and contribute to its scholarly reputation. In turn, they reflect Terra's original goals of integrating American art into the French cultural scene.

Today, with a full schedule of conferences, lectures, and concerts, the museum fulfills its mission of educating a diverse audience about American art and culture. It has become all the more attractive for international visitors and also plays a more vital role in the local community.

Perhaps Terra's crazy, naïve idea of building a museum of American art in Giverny, the cradle of impressionism, was not so crazy after all.

3

Catalogue
From John Singleton Copley
to Edward Hopper

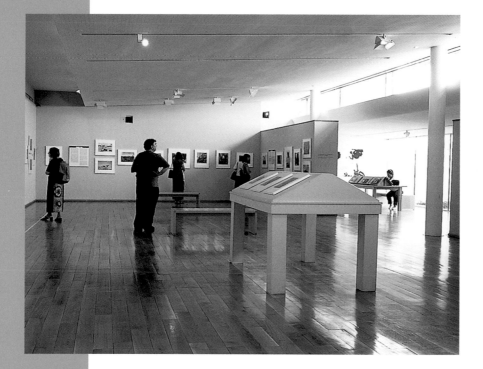

Measurements for paintings are given as height by width and do not include frame dimensions.
Linear diagrams accompanying color plates are one tenth actual size of the paintings. Catalogue entries,
arranged in a rough chronological order by object date, are followed by an annex with selected
bibliography, provenance, and exhibition history. Dates are provided for artists referred to in the entries
but not featured in the catalogue. Inventory numbers are listed for works in the Terra Foundation for
the Arts collection not reproduced in this publication.

Exhibition gallery, Musée d'Art Américain Giverny

John Singleton **Copley**

Boston 1738–1815 London

Portrait of Mrs. John Stevens
(Judith Sargent, Later Mrs. John Murray), 1770–1772

Considered the best portrait painter of the colonial era, John Singleton Copley was America's first great native-born artist. With the rise of the middle class, portraiture dominated American painting in the mid-eighteenth century, and Copley's portraits of merchants, military officers, clergymen, the gentry, as well as such political figures as Paul Revere, Samuel Adams, and John Hancock helped shape pre-Revolutionary colonial identity.

Raised in Boston, Copley's successful career was an astonishing achievement given that colonial America lacked formal art institutions or schools where an aspiring artist might learn. His stepfather, Peter Pelham, was a professional mezzotint engraver from England, and the young Copley learned to draw by copying imported European prints. Copley also studied the portraits of Robert Feke (about 1707–about 1752), John Greenwood (1727–1792), and Joseph Blackburn (about 1700–about 1765) to learn the artistic formulas necessary to communicate the values of his potential patrons.

John Singleton Copley,
Portrait of a Lady
in a Blue Dress,
1763, oil on canvas,
127.6 x 101 cm
(50 1/4 x 39 3/4 in.).
TFA, Daniel J. Terra Collection
1992.28

Copley painted *Portrait of Mrs. John Stevens* at the height of his artistic powers. His mature style, characterized by simplicity of design, fidelity to likeness, strong value contrasts, and a convincing representation of three-dimensional form on a flat surface, made him the most sought after painter in New England. This portrait was commissioned to mark the marriage of eighteen-year-old Judith Sargent to Captain John Stevens, a prominent Gloucester merchant. Sophisticated and elegant, Judith sits within a sylvan setting. Her sumptuous silk and satin garments, as well as her stylish pearl-adorned Turkish turban, were imported from England and reflect the material wealth of New England's mercantile elite. The basket of roses suggests Judith's fertility and the promise of a flourishing marriage, although she did not have children until her second marriage, in 1788, to the Reverend John Murray, the "Father of American Universalism. "After the American Revolution, Judith became an accomplished writer active in the Universalist religious movement. She distinguished herself as America's first public champion of women's equality, female education, and economic independence in her many essays, poems, and plays.

Copley, a Loyalist sympathizer, left the colonies for England in 1774. A prolific artist, Copley painted more than three hundred portraits while living in the colonies. *Portrait of a Lady in a Blue Dress*, 1763, also in the Terra Foundation for the Arts collection, is an interesting complement to *Portrait of Mrs. John Stevens*. The two together provide excellent examples of, respectively, Copley's early developing style and his mature work. In England, Copley continued to paint for the next forty years, establishing himself as a fashionable portrait painter.

127 x 101.6 cm
50 x 40 in.

*Portrait of
Mrs. John Stevens
(Judith Sargent, Later
Mrs. John Murray)*

1770–1772
Oil on canvas

Edward **Hicks**

Attleboro [now Langhorne], Pennsylvania 1780–1849 Newtown, Pennsylvania

A Peaceable Kingdom with Quakers Bearing Banners,
about 1827

Edward Hicks gained a reputation in his community for his work as an ornamental painter and his outspoken participation in the Society of Friends, popularly known as the Quakers. A lifelong resident of rural Bucks County, Pennsylvania, Hicks had a limited formal education. At the age of thirteen, he apprenticed to a coach painter. Later he married and set up shop painting signs, coaches, and other utilitarian objects. This profession was in conflict with the spare life advocated by his faith, and his increasing activity as a traveling minister kept him away from his business. Why or when Hicks turned to easel painting is unknown, but about 1820 he began to explore an allegorical subject that he found infinitely variable and satisfying. *A Peaceable Kingdom with Quakers Bearing Banners* portrays the tolerant coexistence among all the animals and humanity described in Isaiah 11: 6–9. Depicting wildness calmed by gentleness and worldliness tempered by innocence, the message of the Peaceable Kingdom became for Hicks a form of testament, a painted articulation of his deepest beliefs.

A Peaceable Kingdom with Quakers Bearing Banners places Hicks at the center of a religious controversy that split the Quakers into factions. Hicks' elderly cousin Elias promoted an extreme form of Quaker quietism, in which the faithful were urged to discard all but the most basic elements of daily life to open themselves to divine grace and be guided by the Inward Light of Christ. Elias and his followers, known as Hicksites, withdrew from the Quaker Orthodoxy, prompting accusations of heresy. A series of one hundred Banner paintings by Hicks announce his solidarity with his cousin's beliefs, while calling for peaceful coexistence among the factions.

Standing in the front row of the figures at the left and holding a handkerchief he used to mop his brow when preaching, Elias Hicks is accompanied by George Washington and William Penn. The Apostles stand behind them. The banners read "mind the LIGHT within IT IS GLAD TIDEING of Grate Joy PEACE ON EARTH GOOD WILL to ALL MEN everywhere," the words of the Apostle Luke and a basic tenet of the Quaker faith. Like other early American depictions of statesmen in the Terra Foundation for the Arts collection, such as John James Barralet's (1747–1815) *Apotheosis of Washington*, n.d. (TFA 1999.9), Hicks' deification of Washington and Penn illustrates how, by combining vernacular and high art traditions, he created an allegorical language in direct response to the issues and demands of his faith and country.

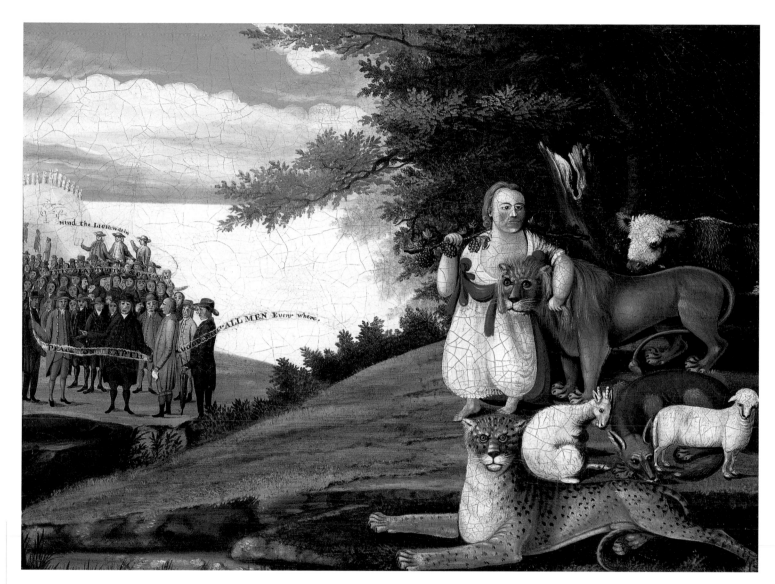

44.8 x 60 cm
17 5/8 x 23 5/8 in.

*A Peaceable Kingdom
with Quakers Bearing
Banners*

c. 1827
Oil on canvas

Inscribed, b.c. of frame:
"Peacable [*sic*] Kingdom"

Ammi **Phillips**

Colebrook, Connecticut 1788–1865 Curtisville [now Interlaken], Massachusetts

Girl in a Red Dress, about 1835

In 1809 Ammi Philips began advertising his services as a portraitist. Although paintings were considered a luxury in early-nineteenth-century America, the "practical" art of portraiture thrived. Demand for portraits steadily increased with the rise of the nation's merchant and middle classes, and self-trained artists like Phillips made a living traveling from town to town painting on commission. His prolific success as a portrait painter spanned more than fifty years. Unlike many itinerant artists, however, he often settled, with his family, in a town or village for several years at a time, only moving on when he had exhausted the possibilities for employment in that community.

Although many of his works are neither signed nor dated, ongoing scholarship has carefully reconstructed Phillips' œuvre by tracing his career through county and town records, land deeds, and a collection of official documentation that places the artist in specific regions during certain years. Stylistically linked to a period between 1830 and 1835, when Phillips was working in Kent, Connecticut, and Amenia, New York, *Girl in a Red Dress* exemplifies the artist's method of using an interchangeable stock of garments and props for his portraits. The painting is one of several similar likenesses in which a young sitter wears a wide-necked red dress, coral necklace, and pulled-back hair surrounded by a dog, carpet, and berries. This stylistic streamlining would not only save time and money for the artist, but would also ensure that each new client would have a reasonable idea of what to expect from the finished product.

The red dress stands out in brilliant relief against the dark background and throws light on the impassive face of the child. In an era when boy as well as girl children wore dresses, the coral necklace identifies the sitter as female. Underneath her bell shaped skirt, a dog peeks out with an expression of quiet observation that echoes his mistress' docile gaze. Following the eighteenth-century portrait tradition of using emblematic attributes, Phillips' incorporation of the puppy and berries represents, respectively, the sitter's fidelity and youthful vitality.

Daniel J. Terra's commitment to building a significant folk art collection was confirmed by his much-publicized acquisition of *Girl in a Red Dress* in 1985 for which he paid a record-breaking sum. Since then, the collection has expanded to include *Mary Elizabeth Smith*, 1827 (TFA 1992.56) also by Phillips, as well as important works by other folk artists active in the early nineteenth century, among them Erastus Salisbury Field, William Matthew Prior (1806–1873), and Joseph Whiting Stock (1815–1855). Together these paintings represent both the range and the commonality of conventions and styles of the itinerant American portrait painter.

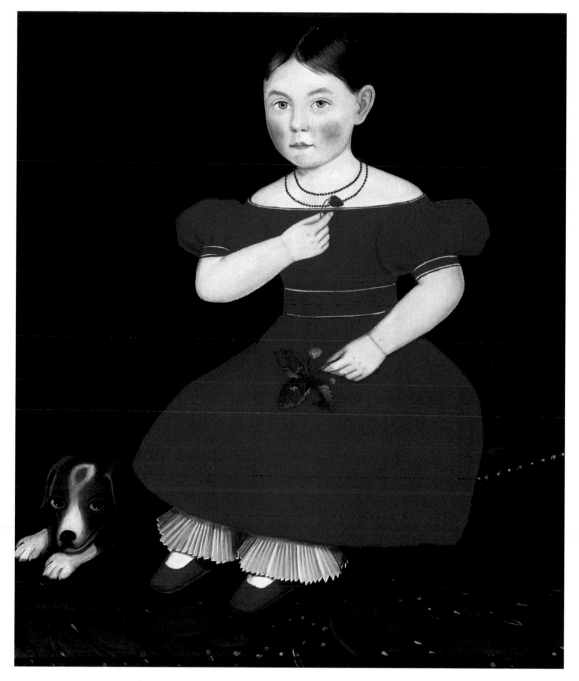

82.2 x 69.5 cm
32 3/8 x 27 3/8 in.

Girl in a Red Dress c. 1835
Oil on canvas

Erastus Salisbury **Field**
Leverett, Massachusetts 1805–1900

*Portrait of a Woman Said to Be Clarissa Gallond Cook,
in Front of a Cityscape*, about 1838–1839

Largely self-taught, Erastus Salisbury Field briefly studied with one of early-nineteenth-century America's most prominent academic artists, Samuel F. B. Morse. Before Field turned to literary and biblical subjects about 1860, he painted portraits throughout his native Connecticut River Valley.

Many of Field's commissions involved painting portraits of several members of a single family. In 1838–1839, at the height of his career as a portrait painter, Field painted the Gallond family of Petersham, Massachusetts. His portrait of Louisa Gallond—wife of Nathaniel Cook, 1838 (Shelburne Museum, Shelburne, Vermont), is virtually identical in pose and background to the present portrait, which has been identified as a likeness of Louisa's sister Clarissa, the wife of Nathaniel Cook's brother William. While the similarities in these portraits may have been intended to reflect these double family ties, Field differentiated his sitters through details of coiffure, dress, and pose of the hands.

Field observed contemporary conventions of fashionable portraiture by including pictorial elements to help "define" the sitter. A red drape is drawn back to reveal a column and parapet framing a landscape background. Although women were typically portrayed alongside natural emblems of fecundity, virtue, and piety, here Field presented a vista of a port city. This prosperous place with red brick commercial structures interspersed with churches fronts a body of water plied by numerous ships. The sitter's bright-eyed expression of firm command is consistent with the possibility that, as the background suggests, she was active in business affairs. In addition, she grasps what appears to be a sheaf of loose paper, perhaps business correspondence.

The straight edge of Clarissa's black dress follows the line of the marble parapet behind her. The slope of the hill framing the distant vista and the intersecting edge of the red drapery echo the unnatural albeit fashionable slope of her shoulders. The diagonals of the diamond shape suggested by her diaphanous white collar, mimicked in the diamond patterns embroidered on the trim of her sleeves, play off against the rectilinear "frame" created by sofa back, parapet, column, and tree. Field's emphasis on such decorative patterning in his composition enhances the emblematic quality of this work, a tribute to the status and character of New England's provincial aristocracy.

The Terra Foundation for the Arts collection is particularly rich in images of women. Field's portrait of Clarissa Gallond Cook makes an interesting comparison to the recently acquired *Portrait of Mrs. John Stevens (Judith Sargent, Later Mrs. John Murray)*, 1770–1772, by John Singleton Copley (p. 43).

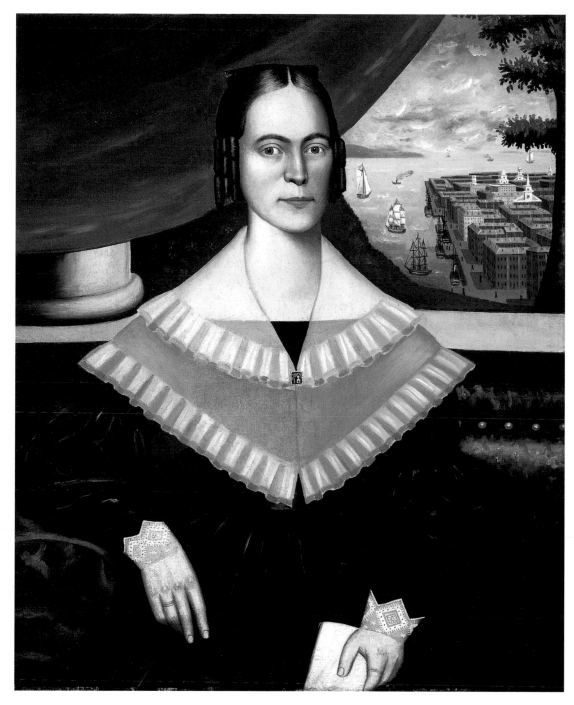

38.1 x 45.7 cm
15 x 18 in.

Portrait of a Woman
Said to Be Clarissa
Gallond Cook,
in Front of a Cityscape

c. 1838–1839
Oil on canvas

Samuel Finley Breese **Morse**
Charlestown, Massachusetts 1791–1872 New York City

Gallery of the Louvre, 1831–1833

1. See David Tatham, "Samuel F. B Morse's *Gallery of the Louvre*: The Figures in the Foreground," *The American Art Journal*, 13: 4 (Autumn 1981): 33–48.

Known above all as the inventor of the electric telegraph and the Morse code, Samuel Finley Breese Morse also left his mark on American art. Though a portraitist by necessity, he aspired to be a history painter. His keen desire to promote the genre of history painting in the United States led Morse in 1826 to help found the National Academy of Design, of which he was president until 1845.

After a trip to Italy where he executed many copies of masterpieces, in 1831 Morse undertook an ambitious painting designed to edify his fellow Americans. This was *Gallery of the Louvre*, begun in Paris and completed fourteen months later, after his return to New York. The painting is impressive for its size and the number of works depicted, in an attempt to measure up to the Musée du Louvre, that temple of European painting. Demonstrating his mastery of perspective, Morse lends monumental scope to the gallery, at the same time displaying his own virtuosity by copying the style of old masters. He even accomplishes a tour de force by showing Paolo Veronese's *Marriage at Cana*, 1562–1563 (Musée du Louvre, Paris) in remarkable foreshortening. Morse also respected certain conventions within the tradition of fanciful versions of art galleries: figures are added to enliven the composition, whether they be anonymous visitors strolling in the background or portraits of celebrities such as American novelist James Fenimore Cooper (seen on the left with his family). Morse himself is depicted in the middle, in the guise of a teacher advising a pupil.[1]

Cooper, a close friend of the artist, had commissioned Morse to do a copy of Rembrandt's *Angel Leaving the Family of Tobias*, 1637 (Musée du Louvre, Paris). Cooper, placed near Rembrandt's painting in the *Gallery of the Louvre*, may have been behind the project.

Although the painting initially appears to be a faithful reproduction of the Louvre, the selection, hanging, and proportions of works have been freely adapted to Morse's tastes and ideas. The goal of *Gallery of the Louvre* was perhaps to make Americans more aware of the history of art. To achieve this goal, Morse did his best to arouse public curiosity and wonder with the choice of a spectacular title (referring to the longest gallery in the world), and a planned costly tour for which admission would be charged. Morse, however, met with incomprehension from the public. First exhibited in New York City in 1833, then in New Haven, Connecticut, and Boston, the work did not encounter the anticipated enthusiasm. A disappointed Morse subsequently devoted himself totally to scientific research—which he had never totally abandoned— thereby securing his fame.

This painting remained in the collection of Syracuse University for nearly a century, until it was bought with great fanfare by Daniel J. Terra in 1982. Joined in 1984 by Morse's study of *Francis I*, 1831–1833 (TFA C1984.5) given by Berry-Hill Galleries, *Gallery of the Louvre* has henceforth occupied a key place in the collection, due to its historical and symbolic significance.

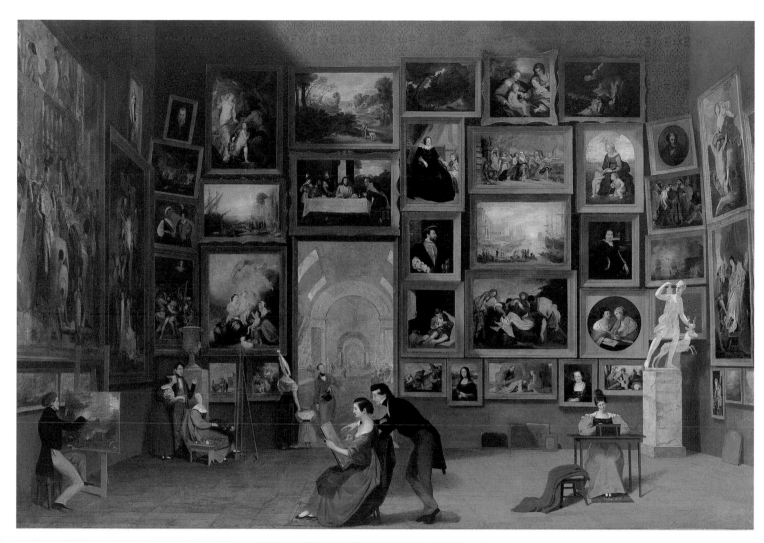

187,3 x 274,3 cm
73 3/4 x 108 in.

*Gallery
of the Louvre*

1831–1833
Oil on canvas

Signed and dated, b.c.:
"S F B M/1833"

Washington **Allston**

Georgetown, South Carolina 1779–1843 Cambridgeport, Massachusetts

Lorenzo and Jessica, 1832

A genteel southerner by birth with a Harvard University degree, Washington Allston's art appealed to a cultivated audience that was well versed in classical learning and familiar with the Bible and literature. A student of Benjamin West (1738–1820), Allston spent much of his early, successful career in Europe before returning to Boston. Though an accomplished painter of portraits, landscapes, and genre scenes, Allston invested his highest ambitions in literary and biblical works, through which he hoped to introduce Grand Manner history painting to America. Also a poet and novelist, Allston was admired by his contemporaries as a "man of genius" and the embodiment of the spirit of romanticism. At the time of his death, however, the American aesthetic was shifting from idealism to realism and Allston's reputation suffered. Consequently, his significant influence on the growth of historical and literary painting in American art in the 1840s and 1850s only began to be understood in the last few decades.

During his first European sojourn, Allston lived in Rome and immersed himself in Italian art. Throughout his career he painted landscapes and history paintings that reveal his admiration for such Renaissance masters as Titian (about 1485–1576) and Giorgione (about 1477–1510). The artist also strove to picture a dreamy ideal of the Italian Renaissance itself in many generic figural works showing contemplative, romanticized women in Renaissance dress. Twilight settings and a softened, generalized treatment of figures characterize these works, which evoke a mood of timeless reverie and repose, often tinged with mystery or longing.

Among Allston's works inspired by Shakespeare, two are from *The Merchant of Venice*. This image of the lovers Lorenzo and Jessica illustrates act 5, scene 1, a romantic interlude in the tragedy in which the solitary newlyweds enjoy the calm of evening. They talk of love, moonlight, and the "divine harmony" of the "music of the spheres." In Shakespeare's drama, Jessica betrays her father, Shylock, and elopes with Lorenzo, actions that reveal the play's main theme of bitter racial strife. But Allston ignored such disturbing implications of the lovers' relationship, instead isolating the specific emotion of the scene to create a straightforward illustration of romantic love. The work's diminutive scale emphasizes the intimate, private nature of its subject. Silhouetted against the glowing twilight sky, the figures recline together on a bank, their paired heads repeated in the twin sections of the palace in the left background. Forms are deliberately obscured in rich shadows, which suggest not only twilight but the passage of ages. An evocation of sixteenth-century Italy as an ideal world of romantic fantasy, Allston's *Lorenzo and Jessica* is the first work by the artist to enter the Terra Foundation for the Arts collection.

38.1 x 45.7 cm
15 x 18 in.

*Lorenzo
and Jessica*

1832
Oil on artist's board

Signed, dated, and
inscribed, on verso:
"Jessica and Lorenzo/
How Sweet the moonlight
sleeps upon this bank!'/
Merchant of Venice Act V,
Scene I./W. Allston A. R. A.
pinxit./1832."

Thomas **Cole**

Bolton-le-Moor, Lancashire, England 1801–1848 Catskill, New York

Landscape with Figures:
A Scene from "The Last of the Mohicans," 1826

The English-born painter Thomas Cole, key figure of the Hudson River School, recognized the epic potential of the American landscape. On his arrival in Philadelphia at the age of seventeen, he had already been apprenticed to an engraver. Cole soon turned his interest to painting and enrolled in the Pennsylvania Academy of the Fine Arts. He later moved to New York City and, inspired by the magnificent vistas along the Hudson River, began to define landscape as a spiritual subject that could transcend its function as a mere topographical record. In this way, Cole contributed to the romantic transformation of landscape painting from documentary and picturesque views into a discourse on the human experience set against the enduring forces of nature. Like his European contemporaries Caspar David Friedrich (1774–1840) and Joseph William Mallord Turner (1775–1851), Cole elevated the once modest genre of landscape painting to an expression of the heroic sublime.

In *Landscape with Figures: A Scene from "The Last of the Mohicans"* the human figures are dwarfed by an awe-inspiring vista of towering mountains and an expansive sky. Cole portrays the denouement of James Fenimore Cooper's newly published,

popular novel *The Last of the Mohicans* (1826). The painting visualizes the novel's climactic scene in which the hero frontiersman Hawkeye aims his shotgun at Magua, the native villain, who tries to flee down a cliff. Cora Munro, the heroine of the novel, after being kidnapped and brutalized by Magua, lies dying at Hawkeye's feet. The depiction of a tree blasted by lightning, gnarled and leafless, echoes the heroine's eminent death. The grandeur of Cole's autumnal wilderness of scarlet leaves and wild rushing mountain streams overwhelms the narrative, reminding the viewer that there are greater forces in the universe than human conflict and desire.

The painting, one of a series of four drawn from Cooper's novel, was commissioned by the Stevens family of Hoboken, New Jersey, for the main cabin of the Hudson River steamboat the *Albany*. While at work on the painting Cole had visited the settings of Cooper's novel, including Lake George and Fort Ticonderoga, but his interpretation transcends naturalistic illustration. *Landscape with Figures: A Scene from "The Last of the Mohicans"* is equal to Cooper's story in its epic vision of the American experience.

66.4 x 109.4 cm
26 1/8 x 43 1/16 in.

*Landscape with Figures:
A Scene from "The Last
of the Mohicans"*

1826
Oil on panel

Signed and dated, b.c.:
"T Cole./1826"

John James **Audubon**

Les Cayes, Haiti 1785–1851 New York City

Pileated Woodpecker, in *The Birds of America*,
vol. 1, 1827–1838

One of the most fascinating figures in nineteenth-century art and science, John James Audubon has come to symbolize the study of nature and, in particular, birds. Born in Haiti, the illegitimate son of a French sea captain whose name he bears, Audubon was mainly raised in France. He came to the United States in 1803 and, after many business failures, devoted himself to his longtime passion, drawing and painting birds. Published in double elephant folio size in London, Audubon's four-volume opus, *The Birds of America*, which took decades to produce, contains 435 prints of 1065 life-size birds. Audubon's monumental achievement was also accompanied by a five-volume text, *Ornithological Biography* (1831–1839), which describes the physical aspect and habits of birds.

Audubon was the key creative figure in the production of *The Birds of America*, but he also delegated roles to others. The hand-colored engravings were made by Robert Havell Jr. (1793–1878) from Audubon's original artworks, principally watercolors. Often, other artists provided botanical details and landscape settings. The extent to which Audubon directed each final print has never been documented, but the harmonious integration of the birds within the natural setting suggests a reliance on his original compositions.

Pileated Woodpecker demonstrates Audubon's ability to skillfully manipulate composition: the combination of birds in their natural elements actively leads the eye to each motif. The angle of the central woodpecker's beak points downward to the mirrored pairing of the birds on the lower right. These two birds are in turn balanced by the strong horizontal of the topmost bird flying to the left. The composition and lush colors give the viewer the sensation that these woodpeckers are alive and engaged in complex behaviors and activities. This lifelike quality, which Audubon strove to record through his lengthy expeditions in the field and his experiments in rendering birds in motion, was his greatest innovation and still draws people to his art today.

Daniel J. Terra purchased all four volumes of *The Birds of America*, one of only 134 complete sets in existence due to the popular practice of framing and selling individual prints, for a record-setting price in 1984. His acquisition perhaps indicated his interest in the nineteenth-century joining of art and science, as evidenced in works by Samuel F. B. Morse and Frederic Edwin Church.

PLATE CXI

Pileated Woodpecker

PICUS PILEATUS, Linn.

Adult Male 1. Adult Female 2. Young Male 3. 4.

Common Grape. Vitis æstivalis.

99.1 x 66.7 cm
39 x 26 1/4 in.

Pileated Woodpecker
in *The Birds*
of *America*, vol. 1

1827–1838
Hand-colored aquatint
engraving

William Sidney **Mount**
Setauket, New York 1807–1868

The Trap Sprung, 1844

1. Quoted in Elizabeth Johns, *American Genre Painting: The Politics of Everyday Life* (New Haven: Yale University Press, 1991), 42.

Hailed by his contemporary critics as an original American artist, William Sidney Mount studied briefly at the National Academy of Design after a short apprenticeship as a sign maker, but he was primarily self-taught. An ambitious painter, inventor, and entrepreneur who worked both in New York City and in a rural area on Long Island Sound near Setauket, Mount carefully developed his image as a homegrown talent. Mount's paintings of everyday life rejected the high-culture demand for grand historical scenes made popular by European trends; his subsequent refusal to travel abroad for further study underscored Mount's commitment to the American scene. By the late 1830s one New York critic could rave, Mount was "a vigorous, untaught, untutored plant, who borrows from no one, imitates no one."[1]

Mount's familiar subjects of agrarian labor, childhood innocence, and Yankee ingenuity spoke directly to the American experience. Yet, despite their innocent veneer, Mount's works often deliver a deeper message. *The Trap Sprung*, for example, seems to celebrate the excitement of youthful anticipation, as two country boys rush to a rabbit trap to collect their prize. Painted in the years following the Panic of 1837, the informed contemporary would not have failed to recognize

Mount's veiled political message. In the aftermath of the economic crisis, the conservative Whig party sought to blame the populist-based Democrats for the nation's troubles, and thereby convert (or trap) the large Democratic electorate base to the Whig cause. Mount's use of a rabbit trap draws on the familiar association of "rabbit," or "hare," with the Whigs in popular joke books and suggests that the victim (the Democrat) was lured unsuspectingly by the trapper's (the Whig) unsophisticated, though effective, trapping technology. Alternatively known as *The Dead Fall* in reference to a type of trap that instantly kills its prey, Mount's painting would have had resonance as an image of rural life with a political message.

Mount's canvas is also recognized for its sentimental appeal. Commissioned by E. L. Carey, a successful Philadelphia book publisher, *The Trap Sprung* is a reworked version of an earlier painting that had appeared in the final edition of Carey's popular series *The Gift*, a holiday gift publication of poetry, prose, and images published between 1836 and 1845. Accompanying Mount's work in reproduction was a short fictional story of a country boy and a city boy united in the quest to find a pet rabbit for an unfortunate crippled girl—a narrative that undercut the image's potential political meaning.

The Trap Sprung
(reverse)

On the reverse of *The Trap Sprung* is an oil sketch of a landscape with the inscription "Landscape by Dow Figures by Jewett." A man bent over from strenuous effort pulls a heavily loaded cart with a woman closely following him. Her red headscarf stands out as a bright accent in the otherwise monochromatic scene. Interestingly, children are prominently depicted—a boy leading the way into a wooded area with a smaller girl last in the procession. Just as the painting's original narrative is enigmatic for today's audience, the relationship of this sketch to the painting remains a mystery.

32.7 x 43.3 cm
12 7/8 x 17 1/16 in.

The Trap Sprung 1844
Oil on panel

Signed and dated, l.l.:
"Wm. S. Mount 1844"

Thomas **Moran**

Bolton, Lancashire, England 1837–1926 Santa Barbara, California

Autumn on the Wissahickon, 1864

1. The "Opus list" is preserved in the archives of the Gilcrease Museum, Tulsa, Oklahoma.

A naturally gifted draftsman and painter, Thomas Moran acquired his professional training outside a school curriculum with the help of his eldest brother, Edward, later a distinguished landscape painter himself, and the Philadelphia-based marine painter James Hamilton (1819–1878). During a trip to England in 1862, the year of a London World Exhibition, Moran became inspired by the works of the great Romantic artist Joseph Mallord William Turner (1775–1851), which he viewed at the National Gallery. Accompanied by his brother, Moran explored the countryside painted by Turner and discovered the freedom with which the artist had transposed the settings onto canvas, a technique that became the guiding principle of Moran's own painting. Later recognized as one of the "artist explorers" of the American West and a famed illustrator of the country's mountain scenery for the journals *Scribner's Monthly* and *Harper's Weekly*, Thomas Moran used the same basic procedure throughout his career: collect visual material for his pictures by sketching and painting on site, and then reshape these elements into highly structured compositions for the final work.

Moran utilized this method in his early work, *Autumn on the Wissahickon*. Following a sketching trip in the forests around Philadelphia, Moran executed a series of rural landscapes that testify to the young artist's aptitude for detailed renditions and subtle manipulation of color. A picturesque winding stream, grazing cattle near a pool, and rocks are skillfully framed by richly colored foliage on either side. In his "Opus list,"[1] Moran noted that he believed *Autumn on the Wissahickon*

to be his best picture to date and that it had been sold to a private collector for the highest price he had obtained thus far. We also learn from these records that Moran employed a photograph of a cartoon he had executed of the composition, and subsequently destroyed. The use of yet another intermediary stage between nature studies and final work further distanced the artist from his motif.

Moran drew on sketches, cartoons, and photographs for ends other than technical accuracy or aesthetic effect. Landscape painting, for Thomas Moran, was essentially political. By using pieces of the existing landscape and recombining them in an altered form, the American frontier becomes incomparably beautiful and magnificent, the incarnation of the national spirit. The political purpose of *Autumn on the Wissahickon* becomes more evident when one notices the train of covered wagons (symbol of America's Manifest Destiny) crossing the idyllic landscape in the middle distance.

Moran participated in the federal government's exploration of the Rocky Mountains and what is today Yellowstone National Park in the summer of 1871. His western watercolors played a definitive role in the formation of this protected wilderness, the first national park in the United States. Frequently signing his name "Thomas 'Yellowstone' Moran," the artist was forever identified with his most famous subject, magnificently captured in his monumental *Grand Canyon of the Yellowstone*, 1872 (Department of the Interior Museum, Washington, D.C.).

76.8 x 114.9 cm
30 1/4 x 45 1/4 in.

*Autumn on
the Wissahickon*

1864
Oil on canvas

Signed, dated, and
inscribed, l.l.:
"Thos. Moran 1864 Op. 9"

Fitz Hugh **Lane**

Gloucester, Massachusetts 1804–1865

Brace's Rock, Brace's Cove, 1864

1. Ralph Waldo Emerson, *Nature. Selections from Ralph Waldo Emerson*, ed. Stephen E. Whicher (Boston: Houghton Mifflin), 24.

2. Earl A. Powell III, "Luminism and the American Sublime," in John Wilmerding, *American Light: The Luminist Movement, 1850–1875, Paintings, Drawings and Photographs*. New York: Harper and Row. Washington, D.C.: National Gallery of Art, 1980, 81.

"Standing on bare ground,—my head bathed by the blithe air, and uplifted into infinite space,—all mean egotism vanishes. I become a transparent eyeball; I am nothing; I see all; the currents of the Universal Being circulate through me; I am part and particle of God."[1]

So wrote the American philosopher and poet Ralph Waldo Emerson in his 1836 treatise *Nature*. Espousing the union of man and the divine through the perpetual observation and experience of the natural world, Emerson's transcendental musings struck a chord in the American consciousness and coincided with the increasingly reverent interpretations of American scenery found in landscape painting of the mid-nineteenth century. A New England landscape and marine painter, Fitz Hugh Lane was among a number of accomplished artists of his generation whose mature style of painting, termed by some contemporary art historians as "luminist," bore a close affinity with the transcendentalist perception of nature. Lane capitalized on his natural ability to draw, first training as a lithographer in Boston in the 1830s, and opening his own lithography shop by 1845. His earliest oil paintings, produced about 1840, contain the crisp edges and close details of his prints, whereas some of his later pictures have softer, more muted forms.

In paintings of inlets, bays, and beaches surrounding the Massachusetts harbor ports of Boston and his native Gloucester, Lane depicted nature as at once intimately familiar and suffused with poetic feeling. His most moving pictures exude silence and calm, the serene light and intuitive balance of elements of sea, sky, and shore meticulously ordered on the horizontal canvas to achieve a nostalgic, almost spiritual effect.

Brace's Rock, Brace's Cove is the culmination of Lane's mature artistic style. One in a series of four small-scale paintings of the dramatic outcropping of rocks off Eastern Point in Gloucester, the work speaks to Lane's deep connection with the remote coastal shores around Cape Anne, Massachusetts. His depiction of the barren rocks and shoreline, the late afternoon sun, and the small boat, abandoned and wrecked in the shallow water, bears no trace of the artist's hand. Lane deliberately removed any human presence from the image to impart a sense of timelessness. The art historian Earl A. Powell described the *Brace's Rock* series as "fragile visions, surreal in their intense, penetrating analysis of the silence of nature, unifying that mood with a state of mind."[2]

26 x 38.7 cm
10 1/4 x 15 1/4 in.

Brace's Rock,
Brace's Cove

1864
Oil on canvas

Signed and dated, l.r.:
"F. H. Lane 1864"

Martin Johnson **Heade**

Lumberville, Pennsylvania 1819–1904 St. Augustine, Florida

Newburyport Marshes: Approaching Storm, 1865–1870

Martin Johnson Heade left Pennsylvania in 1843 and moved around the country supporting himself by painting portraits in the cities where he temporarily resided. After a trip to Rome, Heade added genre scenes to his repertoire, and in 1855 he painted his first known landscape. In 1858 he settled in New York City in the Tenth Street Studio Building. Heade struck up an enduring friendship with Frederic Edwin Church whose canvases recording the exotic landscape of South America received overwhelming critical acclaim. From this point on Heade focused his energy on landscape and floral painting, the two subjects for which he is today most renowned.

In the summer of 1859 Heade discovered the pictorial potential of the marshlands around Newburyport, Massachusetts. He made extensive sketches of the region and painted several lyrical views of the low-lying land studded with grainstacks. Yet Heade soon sought inspiration elsewhere, making his first journeys to the tropics—to Brazil in 1864 and then to Central America in 1866. Once back in the United States, Heade returned to painting marshlands, a subject

he addressed more than one hundred times over the course of his career. *Newburyport Marshes: Approaching Storm*, painted after his travels to the tropics, dates to the period in which the subject was resolved in Heade's imagination.

Using simple pictorial elements—the low horizon, the serpentine stream, the placement of the grainstack, and reflections on the water—Heade evoked mood and atmosphere through the subtle modulation of color and light. The serenity of Heade's interpretation reveals his regard for nature. His reverent approach illustrates an aspect of luminism, a style that attempted faithfully to depict the play of light in nature. The calm, broad vista differs from the panoramic sweep and dramatic spectacle seen in the landscape paintings of the Hudson River School. More meditative than epic, the eerie stillness of Heade's *Newburyport Marshes: Approaching Storm* is characteristic of the poetic rendering of the luminist vision as compared to its prosaic interpretation by John Frederick Kensett in his *Almy Pond, Newport*, 1855–1859.

John Frederick Kensett,
Almy Pond, Newport,
1855–1859,
oil on canvas,
32.1 x 56.2 cm
(12 5/8 x 22 1/8 in.).
TFA, Daniel J. Terra Collection
1992.42

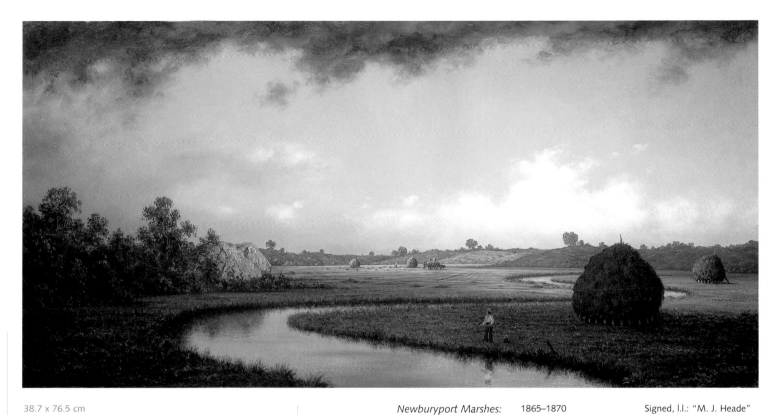

38.7 x 76.5 cm
15 1/4 x 30 1/8 in.

Newburyport Marshes:
Approaching Storm

1865–1870
Oil on canvas

Signed, l.l.: "M. J. Heade"

Martin Johnson **Heade**

Lumberville, Pennsylvania 1819–1904 St. Augustine, Florida

Still Life with Apple Blossoms in a Nautilus Shell, 1870

1. Theodore E. Stebbins Jr., *The Life and Work of Martin Johnson Heade: A Critical Analysis and Catalogue Raisonné* (New Haven: Yale University Press, 2000), 128.

Martin Johnson Heade had only a rudimentary training in the arts, studying with the Quaker painter Edward Hicks from 1837 to 1839. He left Pennsylvania in 1843 and moved from city to city, residing briefly in New York, Trenton, St. Louis, Chicago, and Providence. From 1848 to 1850 he traveled through Europe, spending most of his time in Rome. It was a love of travel that led to his fascination with floral still life. His first of three trips to South and Central America in 1863 ignited his interest in exotic blooms and hummingbirds, and twenty years later, when he moved to St. Augustine, Florida, his attention turned to painting orchids. Hailed by critics for his sensitivity to nature in his flower studies, Heade displayed a distinctive approach that was both sensuous and suggestive of meaning.

The objects in *Still Life with Apple Blossoms in a Nautilus Shell* are strewn across the tabletop in seemingly random profusion. Like the fallen petals on the table, the pearl-buttoned glove and the ivory fan appear carelessly dropped, in strong contrast to the calculated placement of the string of pearls; tossed into a gilded salver, its cross pendant is clearly displayed. The muted tones of the fabrics—a rich blue, gold, and silver damask table cover and the blue-gray drape with its golden fringe—provide a nuanced backdrop for the central feature of the composition: the bright sprig of apple blossom in a vase made from a luminescent nautilus shell. The feminine association of the objects is underscored by the depicted flower. Apple blossom was long associated with Venus and springtime, and, in the Victorian language of flowers, it symbolized femininity.

Heade painted at least twenty-five still lifes featuring the delicate bloom. In a letter to Heade, Church boasted to his friend, "I had more apple blossoms on my farm this season than you ever painted."[1] The clarity of the floral painting in *Still Life with Apple Blossoms* suggests Heade's deep appreciation of and careful attention to nature, even when incorporating it into a symbolic essay on femininity in an imagined corner of a well-appointed, middle-class parlor.

The veiled symbolic suggestions of the components of Heade's still life imply a delicate sensuality that is also achieved by Charles Demuth in *Seven Plums in a Chinese Bowl*, 1923 (p. 172), through the blending of the watercolor's delicate washes of color into the appearance of lush ripened fruit.

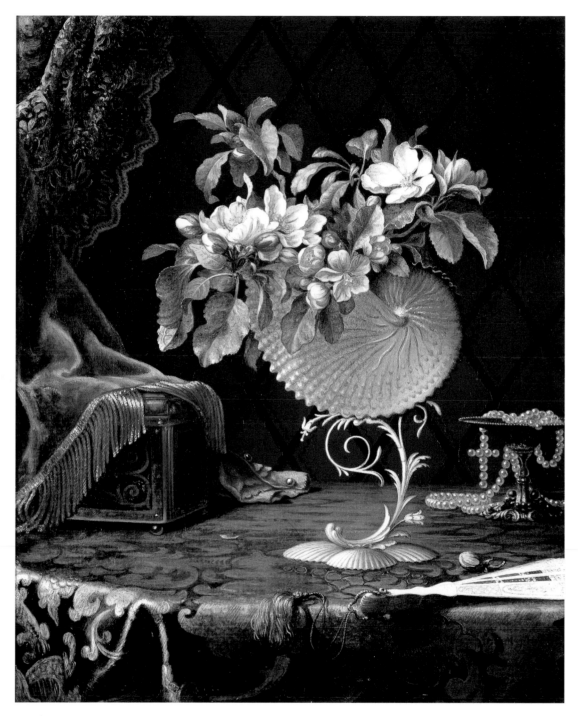

53.3 x 43.1 cm
21 x 17 in.

Still Life with Apple Blossoms in a Nautilus Shell

1870
Oil on canvas

Signed and dated, l.r.:
"M. J. Heade 1870"

John **La Farge**

New York City 1835–1910 Providence, Rhode Island

Paradise Valley, about 1865

1. La Farge, 1905, quoted in James L. Yarnell, *John La Farge in Paradise: The Painter and His Muse* (Newport, R.I.: William Varieka Fine Arts, 1995), 103 n. 145.

Not only one of America's early artist-intellectuals but also an innovator in wood engraving, still life, and landscape painting, John La Farge pioneered America's first mural movement and invented opalescent glass, which he used to spectacular effect in window designs. His comprehensive decorative scheme for the interior of Boston's Trinity Church, a colorful and intriguing mix of painted prophets and purely abstract decorations, initiated the movement now known as the American Renaissance.

Paradise Valley is considered the magnus opus of La Farge's theoretical painting studies. An X-ray of the painting indicates that the artist first painted a kneeling Madonna praying in an open meadow with a child at her feet, figures for whom he used his wife and son as models. He painted over the figures the image of a lamb lying in a rocky sheep pasture. The realistic coastal landscape's everydayness recalls the Barbizon School, whose practice of *en plein air* painting achieved a spontaneity of effect. Ironically, the artist labored on *Paradise Valley* for two years, applying the ideas of the French theorist M. E. Chevreul, found in *The Principles of Harmony and Contrasts of Colors* (1854), of randomly selecting pure colors to enliven the composition and construct the shadows.

Surprisingly, La Farge did not exhibit *New England Pasture*, the painting's original title, until the spring of 1876 at the National Academy of Design. Two years later at the Paris Salon, the artist renamed the landscape to refer to its accurate topological location, *Paradise Valley, Newport, Rhode Island*. Much to La Farge's chagrin, contemporary critics focused on the perceived spirituality of the pastoral scene. In response to the biblical symbolism touted in reviews, La Farge insisted on the scientific basis of the painting's conception, "My programme was to paint from nature a portrait . . . which was both novel and absolutely 'everydayish.' I therefore had to choose a special moment of the day and a special kind of weather at a special time of year when I could count upon the same effect being repeated."[1]

American critics hailed *Paradise Valley* as both precocious and prototypical, referring to it as "one of the first impressionist landscapes in this country," no doubt influencing Daniel J. Terra's decision to purchase it, his last acquisition before his death in 1996. The landmark status of La Farge's large, theoretically inspired landscape offers an invaluable contrast to the heroic visions of the Hudson River School and the atmospheric explorations of American luminism already in his collection.

82.9 x 106.7 cm
32 5/8 x 42 in.

Paradise Valley c. 1865
Oil on canvas

Sanford Robinson **Gifford**

Greenfield, New York 1823–1880 New York City

Hunter Mountain, Twilight, 1866

1. *New York Post*, May, 11 1866, 1, quoted in Kevin Avery, *American Paradise: The World of the Hudson River School*. (New York: The Metropolitan Museum of Art, 1987).

The landscape painter Sanford Robinson Gifford worked briefly in Europe, Asia, and on America's western frontier but found his greatest success depicting the rural landscape of his native Hudson River Valley. Early studies with Thomas Cole grounded Gifford's observational and interpretative methods. His luminous paintings of the Hudson River Valley and Catskill and Berkshire mountain ranges define nature's contours with crisp lines.

When Gifford first showed *Hunter Mountain, Twilight* at the National Academy of Design in 1866, American critics hailed the work as the artist's greatest success. A critic from the *New York Post* raved that the painting "best expresses the intensity and disciplined strength of Gifford's genius. . . . What an idea of silence and endurance is expressed by that Mountain! What depth and clearness of tone!"[1] In spite of its representational clarity, the message is elusive. Set in the Catskills, *Hunter Mountain, Twilight* portrays the region's second largest mountain as a backdrop for a rustic cabin nestled among trees. Cows graze at the edge of a small stream, and the sun casts a warm and pleasant glow across the twilight sky. An element of discord seems to pervade this idyllic scene. Not only has the water source dwindled nearly to a trickle, but a vast and eerie field, recently cleared of trees and studded with stumps and gnarled boulders, dominates the painting's composition. The iconographic conventions celebrating settlement and progress—a comfortable homestead within a picturesque view—are complicated by a field ravaged of trees. In its depiction of the wilderness cultivated for human use, Gifford calls into question the relationship between man and nature.

Like Cole before him, Gifford found in nature the means for aesthetic, nationalistic, and often moral expression. Gifford worked in the last decades of the nineteenth century through a period of intense industrial growth, westward expansion, and post-Civil War tension, and his landscapes often provide a point of escape, contemplation, or guidance for a public faced with rapid economic and social change. *Hunter Mountain, Twilight* stands out as the most powerful example of Hudson River School painting in the Terra Foundation for the Arts collection and is complemented by the range of landscapes by his contemporaries John Frederick Kensett, Fitz Hugh Lane, and Frederic Edwin Church.

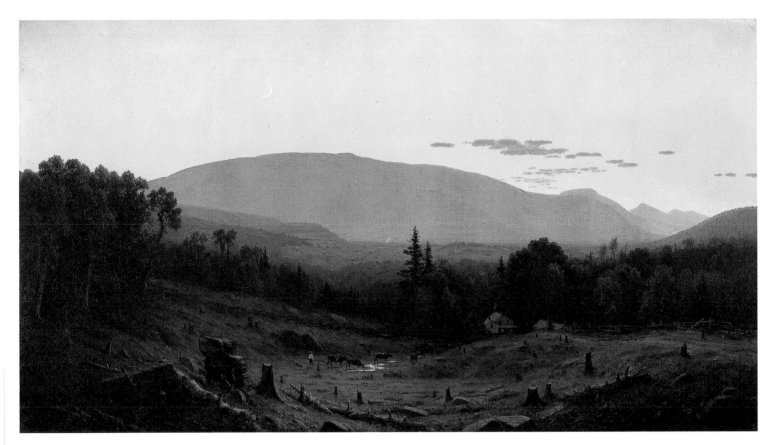

77.8 x 137.5 cm
30 5/8 x 54 1/8 in.

Hunter Mountain,
Twilight

1866
Oil on canvas

Signed and dated, l.r.:
"S. R. Gifford 1866"

Francis Augustus **Silva**
New York City 1835–1886

Ten Pound Island, Gloucester, 1871–1872

Francis Augustus Silva began his active professional career as an artist in the late 1860s, after the American Civil War, in which he served. He was largely self-taught, having learned the rudiments of painting while an apprentice to a sign painter. Based in New York City and, toward the end of his life, in New Jersey, Silva repeatedly traveled along the New England coast in search of maritime subjects. With few exceptions, this theme inspired him throughout his career.

Ten Pound Island, Gloucester exemplifies certain key aspects of nineteenth-century American painting that came to be known as luminism, for its expression of the effects of light through paint. The even light depicted in this painting contains no strong dark contrasts and gently casts ships, shore, and lighthouse in a nostalgic haze; by the early 1870s steamers, not sailboats, dominated the waters. Complementing the light is the dominant purple tone of the sky at sunset, reflected in the water. The sense of serenity is reinforced by the calm waves and clouds and by Silva's horizon line, which extends, uninterrupted, from one edge of the canvas to the other, allowing the viewer to imagine the scene continuing indefinitely.

Perhaps the most striking note in this peaceful image is the reflection in the water of the sun and the lighthouse beacon, which offered Silva yet another opportunity to display his mastery of light effects. In keeping with the limitless expanse of sky and water, the reflections may also suggest the transitory condition of man in relation to the eternal monumentality of nature.

While Daniel J. Terra's acquisitions in the field of American impressionism are justifiably well known, his major efforts to collect American luminist paintings have not received attention. The Terra Foundation for the Arts collection contains important examples by the main figures of luminism, including Fitz Hugh Lane, John Frederick Kensett, and Martin Johnson Heade.

35.9 x 61.6 cm
14 1/8 x 24 1/4 in.

Ten Pound Island,
Gloucester

1871–1872
Oil on canvas

Signed, l.l.:
"F. A. Silva"

John Frederick **Kensett**

Cheshire, Connecticut 1816–1872 New York City

Near Newport, Rhode Island, 1872

One of the most prominent and successful members of the second generation of the Hudson River School, John Frederick Kensett is best known for serene images of the New England coastline. The reductive compositions, subtle color, and crystalline light effects of his late landscape paintings constitute a benchmark in the artistic movement known as luminism.

While many of his contemporaries traveled widely to paint the most spectacular scenery of the Americas, Kensett focused on settings within easy reach of his New York studio. His depictions of northeastern tourist haunts drew an enthusiastic response from the increasing numbers of visitors to those sites. In the mid-1850s Kensett began to specialize in scenes of coast and shore. After his first visit to Newport, Rhode Island in 1854, he returned almost annually and painted at least one landscape of the site each year for the rest of his career.

Kensett's arrival in Newport coincided with a simplification of his compositions. Possibly influenced by the broad vistas of coastal settings, Kensett emphasized atmosphere and light over tangible features of the landscape. *Near Newport, Rhode Island* recapitulates the artist's favorite formula: a stretch of beach terminating in a rocky promontory fronting a broad vista of ocean and sky. Many of his interpretations of this theme are remarkable for their evocation of perfect stillness. However, the present painting shows a leaden, threatening sky above a dramatic sea whose crashing waves seem all the more formidable in relation to the diminutive figures of a man and dog on the beach; the former, dressed in an artist's broad-brimmed hat and smock and carrying what may be a sketchbook under his arm, seems a stand-in for the artist, whose initials appear just below. The forbidding cliff, delineated with Kensett's characteristic geologic specificity, bars the man's way as it terminates the vista. The wreckage of a boat tossed in the surf at the right sounds a warning to the ships on the distant horizon; its counterpart, a dinghy drawn well up on the beach at the far left, is draped by a slip of brilliant red fabric like an impotent flag of danger. Painted in the year of the artist's untimely death from pneumonia contracted after a failed attempt to rescue a drowning friend, *Near Newport, Rhode Island* seems a prophetic vision of the compelling yet perilous appeal of the sea.

A second painting by Kensett in the Terra Foundation for the Arts collection, *Almy Pond, Newport*, 1855–1859 (p. 64), is a surprising contrast to *Near Newport, Rhode Island* in its depiction of tranquil, low-lying coastal land. A painting by William Stanley Haseltine (1835–1900), *Rocks at Nahant*, 1864, is more closely aligned with Kensett's vision of the awesome fierceness of a coastal landscape that dwarfs mankind's claim to mastery of nature.

William Stanley Haseltine,
Rocks at Nahant,
1864, oil on canvas,
56.8 x 102.9 cm
(22 3/8 x 40 1/2 in.).
TFA, Daniel J. Terra Collection
1999.65

36.8 x 61 cm
14 1/2 x 24 in.

*Near Newport,
Rhode Island*

1872
Oil on canvas

Signed and dated, l.l.:
"J F K '72"

Frederic Edwin **Church**

Hartford, Connecticut 1826–1900 New York City

The Iceberg, about 1875

Born in Hartford, Connecticut, Frederic Edwin Church left home at eighteen to study for two years with the Hudson River School painter Thomas Cole. The young man came to share Cole's conviction that a landscape painter needed to transcend the literal documentation of the natural world in his art. While on sketching tours of the Berkshires, Church found further inspiration in the early volumes of *Cosmos: A Sketch of a Physical Description of the Universe* (1845–1862), in which Alexander von Humboldt asserted that an inherent harmony unified all aspects of creation, a theory that gave weight to Church's belief that landscape had epic potential. After early successes in painting New England scenery, the artist began to seek his subjects in more distant lands. Inspired by Humboldt's journeys, Church made two trips to South America. The popular success of his grand landscape themes, such as *Niagara Falls*, 1857 (Corcoran Gallery of Art, Washington, D.C.), and *The Heart of the Andes*, 1859 (The Metropolitan Museum of Art, New York), earned him a reputation as the American master of the "Great Picture."

The Iceberg recalls the journey Church made to the Arctic Circle in the summer of 1859. In the company of his friend the natural scientist Louis Legrand Noble,

Church set out to view the massive detached cliffs of frozen water that floated in the northern seas. Public expectations for Church's expedition were high, for he had announced that his intended subject, *The Crown of the Arctic Regions*, would stand as a pendant to his well-regarded *The Heart of the Andes*. However, the outbreak of the Civil War in 1861 overshadowed the debut of the work now titled *The Icebergs*, 1861 (Dallas Museum of Art). Church instead chose to echo national sentiment by painting a patriotic allegory *Our Banner in the Sky*, 1861. About 1875, Church finally returned to the subject of icebergs, painting the astonishing sight from memory.

In *The Iceberg*, the sun glances off the highest jagged peak just as a schooner glides past. This unorthodox use of light gives the modest, dark-toned canvas a dramatic focus. Like his fellow artists Albert Bierstadt (1830–1902) and Worthington Whittredge (1820–1910), Church testified to his first-hand observations in detailed renderings. It is interesting to note, however, that this forbidding vista ultimately conveys a sort of intimacy as the majesty of nature is burnished by time and recollection.

Frederic Edwin Church,
Our Banner in the Sky,
1861, oil on paper mounted
on cardboard,
55.9 x 68.6 cm
(22 x 27 in.).
TFA, Daniel J. Terra Collection
1992.27

55.9 x 68.6 cm
22 x 27 in.

The Iceberg c. 1875
Oil on canvas

George **Inness**

Newburgh, New York 1825–1894 Bridge of Allan, Scotland

Summer, Montclair, 1877

George Inness was considered by his contemporaries a philosopher as well as a painter. Much admired for the poetic and spiritual quality of his paintings, his work was understood as a counterpoint to the Hudson River School, whose panoramic visions of the American landscape stunned the public with the detailed manner in which they were executed. Largely self-taught, Inness had a brief but influential encounter when he studied for just one month with the French Romantic painter Régis-François Gignoux (1816–1882) in New York City. A first visit to Italy in 1851–1852, followed by two other visits to France and Italy in the mid-1850s and mid-1870s, exposed Inness to traditional and modern European art and further contributed to his artistic education. But painting, for Inness, remained a personal quest, a form of knowledge that could be attained only through ongoing careful and thoughtful exploration.

In 1863 Inness became a member of a community that espoused the tenets of the eighteenth-century Swedish philosopher Emanuel Swedenborg, who believed the spiritual world to be as much a reality as the material world. Four years later Inness published an artistic statement, "Colors and Their Correspondences," in the *New Jerusalem Messenger*, the newspaper of the Swedenborgian Church, which explained his integration of Swedenborgian theological themes into art through the spare use of symbolic color. This mystical tendency is especially apparent in the artist's later œuvre, as in

Sunset, Étretat, 1892. In these works, the clear outlines of objects are obfuscated by thick layers of paint. Color and form become the vehicle for suggesting a world hidden from sight.

Summer, Montclair, an earlier work, was painted one year before Inness made Montclair, New Jersey, his permanent home, and the painting evokes a peaceful landscape that the artist seems to know intimately. The atmosphere is serene and quiet. Two figures enjoy the bliss of a sunny day, one boy holding a line to catch fish, the other resting in the grass. The season is suggested by the lush landscape depicted, with bright patches of green composing the grass and dense foliage of the trees. Although more naturalistic than his late works, Inness' *Summer, Montclair* does not aim at a mimetic realism. The elements of the scene are rendered somewhat blurry and indistinct, inviting the viewer to look at this representation of nature with an eye tuned more to the correspondences between things than to their fixed identity. Inness' meditative landscape emphasizes humanity's relationship to nature. Rather than a dazzling evocation of nature's spectacle, it turns the gaze inward. In its search for a more private vision, *Summer, Montclair* recalls the work of the Barbizon painters Jean-Baptiste-Camille Corot (1796–1875) and Jean-François Millet (1814–1875), where nature inspires introspection and, in the case of Inness, a deeply religious man, prayer.

George Inness,
Sunset, Étretat,
1892, oil on canvas,
76.7 x 114.6 cm
(30 3/16 x 45 1/8 in.).
TFA, Daniel J. Terra
Collection 1993.4

106.2 x 85.7 cm
41 13/16 x 33 3/4 in.

Summer,
Montclair

1877
Oil on canvas

Signed, l.l.:
"G. Inness"

Robert Spear **Dunning**

Brunswick, Maine 1829–1905 Westport Harbor, Massachusetts

Still Life with Fruit, 1868

Robert Spear Dunning moved with his family to Fall River, Massachusetts—a center for maritime activity and mercantile exchange in the nineteenth century—at the age of five from his birthplace, Brunswick, Maine. Leaving only briefly to pursue artistic training, first with James Robertson (about 1810–about 1881) in Tiverton, Maine, and then with Daniel Huntington (1816–1906) in New York City, Dunning remained in Fall River, launching his career as a portraitist in 1852. By 1865 he turned his attention to still-life painting, five years later helping to found the Fall River Evening Drawing School. For nearly sixty years, the Massachusetts town hosted a distinctive circle of painters. Defined by their interest in still life and a conservative approach to illusionist depiction, many of the notable artists of the Fall River School, including Albert F. Monroe (1844–1925) and Mary L. Macomber (1861–1916), studied with Dunning, a master of still life.

As a celebration of abundance, *Still Life with Fruit* characterizes Dunning's early style. Dark and rich in tone, it features a sumptuous display of ripe fruit filling a silver dish and spilling out of a cut-glass bowl.

The assortment of fruit displays his skill at visual illusion, from the shining skin of the polished apples to the rugged rind of the muskmelon to the gleaming grapes bursting with juice. Here the bananas, a luxury item that had to be shipped over a great distance to the Fall River port, suggest an exotic treat. Typical of Dunning are the decorative objects; the patterned cloths, transparent glass, glinting silver, and highly polished wooden tabletop gave Dunning an opportunity to showcase his bravura command of light playing upon a variety of surfaces.

Other still-life paintings in the Terra Foundation for the Arts collection reveal the range of the genre's potential, which often extends beyond the celebration of the good life, its most traditional characteristic. *Fruit Pieces: Apples on Tin Cups*, 1864 (TFA 1999.100), by William Sidney Mount, for example, presents a healing message of unity to Civil War America, while Dunning's own *Harvest of Cherries*, 1866 (TFA 1999.48) features two straw hats abandoned near a basket of luscious fruit and hints at a romantic anecdote.

63.5 x 76.8 cm
25 x 30 1/4 in.

Still Life with Fruit 1868 Signed and dated, l.l.:
 Oil on canvas "R. S. Dunning 1868"

Robert **Wylie**

Douglas, Isle of Man, England 1839–1877 Pont-Aven, France

The Breton Audience, about 1870

1. "Notes: Some New Pictures," *Art Journal* 12 (December 1878): 380.

Founder of the American art colony in Pont-Aven, Brittany, in 1864, Robert Wylie was one of the first of many post-Civil War American artists and patrons to become fascinated by peasantry. Having seemingly maintained their picturesque local customs and devotion to family, religion, and community, the peasantry came to symbolize for many artists the values that were apparently threatened in the rapidly industrializing United States. Unusually, however, Wylie's innovative paintings acknowledge these contemporary concerns without romanticizing the subject, instead remaining attentive to the realities of peasant life. His unique approach proved successful. Wylie frequently exhibited at the Paris Salon, winning a second-class medal in 1872. He was among the very few American artists to be represented by the famous art gallery of Goupil and Company, and by the turn-of-the-century, his work hung in several major museums in the eastern United States.

Recent scholarship indicates that *The Breton Audience* may, in fact, be *Les Modèles de Pont-Aven* shown at Wylie's posthumous 1878 exhibition and exhibited later that year as *Brittany Peasants* in New York City, where it was described as a "curiously conceived picture of fifteen or twenty 'models' living in Pont-Aven in France. Each face is a distinct type, and the composition is happily done."[1] The identification of this work as *Les Modèles* is confirmed by the fact that figures in it were used as models in Wylie's *Ragpicker and Pottery*

Seller in Finistère (unlocated) and *Peddlar* (unlocated), both exhibited at the 1875 Paris Salon. His *Five Brittany Children*, about 1875 (unlocated), also depicts, in a very similar composition, the central children in *The Breton Audience*. Thus, perhaps *The Breton Audience/Les Modèles de Pont-Aven* was inspired when models of the art colony crowded around Wylie to watch him paint the smaller *Five Brittany Children*. Regardless of the title, the painting is "curious," to use the nineteenth-century critic's words. To many French and American painters, peasants existed only as types to be depicted in genre scenes. Wylie, however, recognized the individuality of his models by painting what amounts to a group portrait. Unlike many Americans who visited rural France only in the summers, by 1870 Wylie had lived in Pont-Aven for approximately five years, and these people were very likely his friends and neighbors.

The Breton Audience is one of the few Wylie works accessible in a public collection and stands out in the Terra Foundation for the Arts collection as a rare and exceptionally fine example of work by the first generation of American artists, the pre-impressionist generation, who painted in Europe in the latter part of the nineteenth century. It is complemented by the collection's diverse grouping of works by artists who lived and worked in the art colonies of Brittany and Normandy, such as Henry Bacon (1839–1912), George Inness, and James McNeill Whistler.

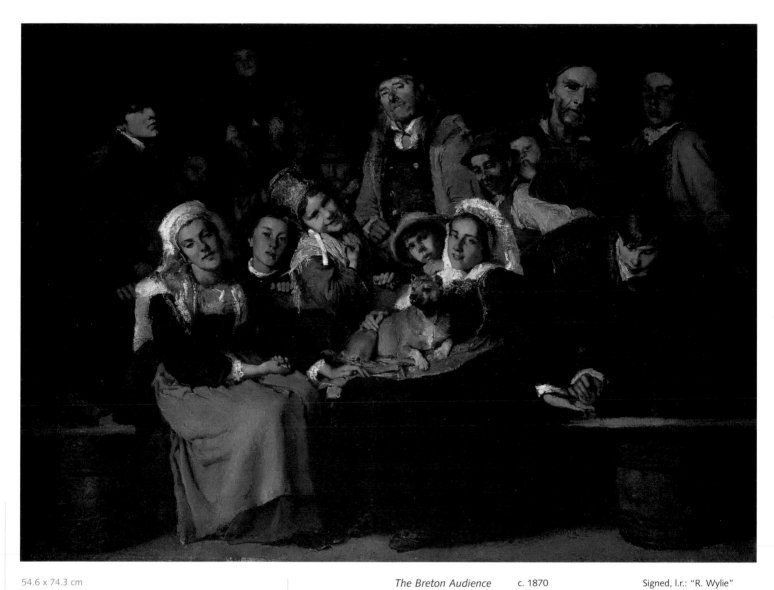

54.6 x 74.3 cm
21 1/2 x 29 1/4 in.

The Breton Audience c. 1870 Signed, l.r.: "R. Wylie"

Oil on canvas

John George **Brown**

Durham, England 1831–1913 New York City

The Cider Mill, 1880

Born into a poor family in Durham, England, Brown served as an apprentice to a glass cutter in nearby Newcastle-upon-Tyne during his youth. He supplemented his training with evening drawing classes, and in 1852 moved to Edinburgh to study art at the Trustees' Academy. After a brief stay in London, Brown immigrated to the United States, where he found work in Brooklyn, New York, sketching stained-glass window designs at the Flint Glass Works. In 1855 Brown married his employer's daughter and redirected his career. He enrolled at the National Academy of Design in New York City and, along with Winslow Homer and Eastman Johnson (1824–1906), rented a studio in the Tenth Street Studio Building. In 1861 Brown became a founding member of the Brooklyn Art Association, and the following year he was naturalized as a citizen of the United States. By this time, Brown had developed his signature subject—anecdotal images of children— for which he enjoyed consistent success throughout his career.

While Brown gained his fame painting mischievous urban boys, including bootblacks, newsboys, street toughs, and secret smokers, his summer vacations in the Catskills and the Adirondack Mountains inspired a more sentimental view of childhood in a rural setting. In *The Cider Mill* five girls indulge in the late summer pleasure of the apple harvest. Seated in front of wooden barrels of cider, each bites into a crisp, ripe apple. Every element in the scene alludes to abundance: the overflowing basket in the foreground, the ripening corn in the distance, and the bright fall foliage that hangs like fringe from the trees. With their full, round faces and glowing complexions, the girls seem to embody wholesome health and innocence.

The subject of childhood held a strong appeal for American artists after the Civil War. Youth came to symbolize a promise of better times in a peaceful future. While Winslow Homer chose an iconic approach, as seen in the vigilant boy in *On Guard*, about 1864 (p. 89), or the demure girls in *Apple Picking*, 1878 (p. 91), Brown preferred to portray childhood energy and curiosity through his narratives.

76.2 x 61 cm
30 x 24 in.

The Cider Mill

1880
Oil on canvas

Signed and dated, l.r.:
"J. G. Brown, N. A./1880"

Dennis Miller **Bunker**
New York City 1861–1890 Boston

Brittany Town Morning, Larmor, 1884

In 1882 Dennis Miller Bunker traveled to Paris, where he sought to refine the artistic skills he had developed at the National Academy of Design under the guidance of William Merritt Chase. Following the advice of fellow artists, Bunker enrolled at the prestigious École des Beaux-Arts, where he studied rigorously for two years in the atelier of Jean-Léon Gérôme (1824–1904). In France, he further developed his already skillful draftsmanship and brushwork and, inspired by the work of Barbizon painter Jean-Baptiste-Camille Corot (1796–1875), acquired a mastery of color and form.

Fleeing the cramped ateliers in Paris, Bunker spent the summers with other American painters seeking inspiration in the French countryside. In 1884, rather than staying at one of the established Breton art colonies, Bunker joined his artist friends in the isolated coastal village of Larmor. It was there that the twenty-three-year-old Bunker reached a turning point in his artistic development.

John Singer Sargent,
*Dennis Miller Bunker
Painting at Calcot*,
1888, oil on canvas mounted
on masonite,
68.6 x 64.1 cm
(27 x 25 1/4 in.).
TFA, Daniel J. Terra Collection
1999.130

In *Brittany Town Morning, Larmor*, Bunker goes beyondsimply painting a landscape; he recreates the physical sensation of a Breton morning. The light in the painting vibrates, thick with early morning mist. The formidable steeple of the medieval church of Notre Dame, encircled by a flock of birds, rises from the compact architecture of the village, its dark form contrasting with the silver light sharply reflecting off the slate rooftops. The crisply painted edges of the architecture cut into the sky and accentuate the soft texture of the lush field. Two women standing against the stone wall give a sense of scale to the work, yet they are rendered visible only by the light falling on their white bonnets. Closer to the viewer, a laundress lays clothes out to dry on low-lying bushes. Two dabs of paint on the clothes, one red, the other blue, are the sole use of primary color in the painting, accenting the otherwise monochromatic field of the foreground.

Bunker exhibited this painting at the National Academy of Design on his return to the United States in the winter of 1884. He also painted a smaller, less-finished version of it inscribed "To Joe," most likely his long time friend Joseph Evans. In 1885 Bunker settled in Boston, where he would teach at the Cowles Art School for five years. His art came to the attention of the flamboyant Boston socialite Isabella Stewart Gardiner who championed the handsome young artist, commissioning both portraits and "pictures." Soon after John Singer Sargent arrived in Boston in November 1887, he and Bunker struck up a close friendship that influenced Bunker's style during the last two years of his life, tragically cut short at age twenty-nine. In 1888 Sargent invited Bunker to summer with him and his family near London. Their days of painting *en plein air* are captured in Sargent's painting *Dennis Miller Bunker Painting at Calcot*, 1888.

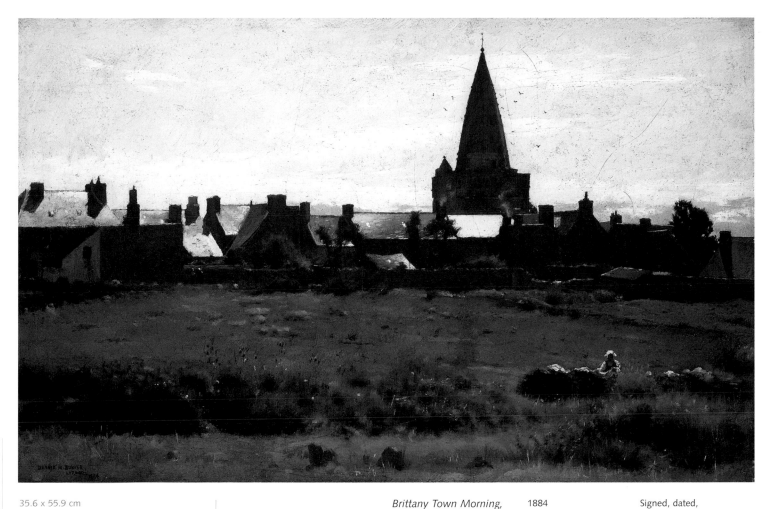

35.6 x 55.9 cm
14 x 22 in.

Brittany Town Morning, Larmor

1884
Oil on canvas

Signed, dated, and inscribed, l.l.: "Dennis M. Bunker/ Larmor/1884"

Winslow **Homer**

Boston 1836–1910 Prout's Neck, Maine

On Guard, 1864

One of the most revered American artists of the nineteenth century, Winslow Homer was lauded by his contemporaries for successfully capturing the relationship between man and nature, something that has always remained at the heart of the national identity. He first honed his skills as a draftsman while an apprentice for two years to a commercial lithographer in Boston. In 1859 he moved to New York City, where he established himself as a freelance illustrator for *Harper's Weekly*, the leading contemporary periodical in the United States, and occasionally found time to attend classes at the National Academy of Design. When the Civil War broke out, *Harper's Weekly* dispatched Homer to cover the front lines of the Union armies as an artist-correspondent. The wartime images he created did not capture heroic moments but concentrated on the daily lives of the soldiers and managed to be expressive and sympathetic without being sentimental.

On Guard is Homer's earliest known image of childhood, a theme to which he would return repeatedly throughout his career. Silhouetted against a bright blue sky, a young boy in country dress and a straw hat sits alone on a fence of felled white birch trees. The broad brim of his hat obscures his face as he looks across a newly planted field at a flock of circling birds. The stick he holds rises vertically at the center of the canvas with a red rag tied to the end. Whether this flag was used to scare away the circling crows or to signal a strategic warning remains ambiguous. *On Guard* is a transitional painting for Homer, from his descriptive Civil War works to those that suggest symbolic readings. It is a work that invites a political interpretation, especially when one considers that it was painted in the last days of the Civil War. In this reading, the fence represents the division of the nation between North and South, and the young boy stands vigil, not simply over the field, but over the future of the nation, still uncertain at the time the painting was completed.

In 1868 Homer revisited this composition to illustrate a poem by J. T. Towbridge in the periodical *Our Young Folks*, changing the title from the weighty *On Guard* to *Watching the Crows*. The only change he made was to remove the rag at the end of the stick, perhaps signifying that the danger of Secession had passed. In both renderings the noble pose of the young boy shows a seriousness and responsibility to his task that stand in contrast to the optimistic images of childhood Homer created after the Civil War, such as the relaxed posture of the sitter in *The Whittling Boy*, 1873. A prominent theme in art and literature toward the end of the nineteenth century, carefree images of youth indicated a longing for an innocence lost and a simpler time in the nation's history.

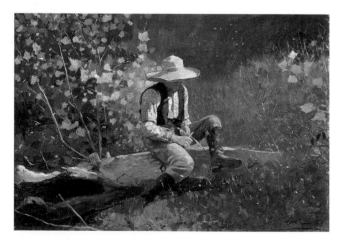

Winslow Homer,
The Whittling Boy,
1873, oil on canvas,
40 x 57.6 cm
(15 3/4 x 22 11/16 in.).
TFA, Daniel J. Terra
Collection 1994.12

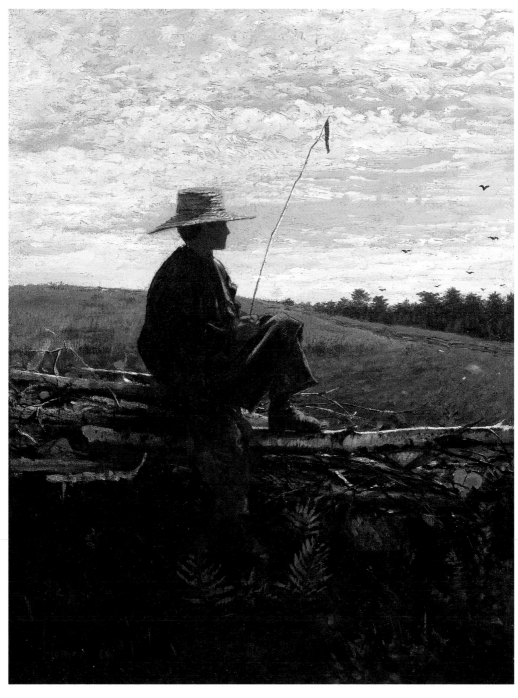

31.1 x 23.5 cm
12 1/4 x 9 1/4 in.

On Guard

1864
Oil on canvas

Signed and dated, l.l.:
"Homer 64"

Winslow **Homer**

Boston 1836–1910 Prout's Neck, Maine

Apple Picking, 1878

1. Susan Nichols Carter, *Art Journal* (March 1879).

"Never before has a collection of his works been so beautiful in sentiment and evinced such a feeling of truth."[1]

In 1878 Winslow Homer spent the summer and autumn months in Mountainville, New York at Houghton Farm, the country home of his most devoted patron, Lawson Valentine. The setting proved to be inspirational for the artist, who completed over fifty watercolors and numerous drawings and oil studies during his stay. The rural subjects Homer explored that summer reflected a wider national trend to depict idealized images of America, a nation still recovering from the divisive forces of the Civil War. The need to redefine a national identity took form in the Colonial Revival movement and the Centennial Exposition of 1876 in Philadelphia, and artists adopted pictorial motifs that celebrated life in the country, providing a sense of continuity and stability in a society that was rapidly becoming industrialized.

On his return to New York City, Homer contributed twenty-three of his Houghton Farm watercolors to the Water-Color Society exhibition in February 1879.

Whereas his earlier watercolors had met with mixed reviews, these works garnered universal praise. Several critics went so far as to proclaim that they marked a turning point, not only for the artist but also for the medium of watercolor in American art. Of particular interest to the critics in *Apple Picking* was Homer's radical experimentation with vivid colors, opaque pigment, and sharply contrasting lights and darks.

In *Apple Picking* a bright band of illuminated grass cuts horizontally across the page between two areas shaded by trees. Gouache highlights are used liberally to create depth and to depict the bright sunlight that falls across the two girls that stand arm-in-arm dressed in long skirts, pinafores, and simple sunbonnets. Though Homer did not begin working seriously in watercolor until 1873, he was familiar with this challenging medium through his mother's accomplishments and rapidly commanded the technique. Painted outdoors to record the fleeting effects of sunlight, the portable watercolors allowed him to work on a scale that was popular in the marketplace. In 1876 he was elected to the American Society of Painters in Water Colors and to this day is considered the preeminent American watercolorist.

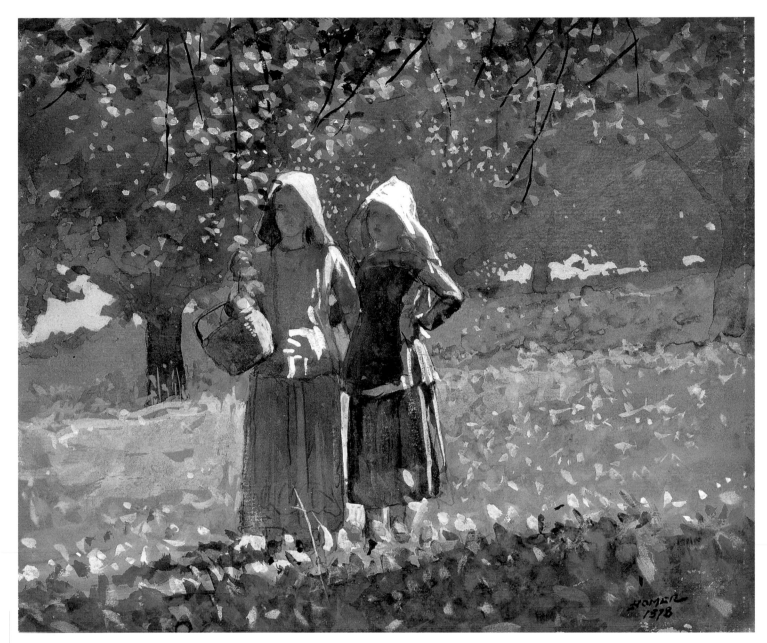

17.8 x 21.3 cm
7 x 8 3/8 in.

Apple Picking

1878
Watercolor and gouache
on paper

Signed and dated, l.r.:
"Homer/1878"

Winslow **Homer**

Boston 1836–1910 Prout's Neck, Maine

A Garden in Nassau, 1885

On December 4, 1884, Winslow Homer boarded the Ward Line steamship *Cienfuegos* destined for the Bahamas, an increasingly popular travel destination for Americans. A commission by *Century Magazine* to illustrate an article by William T. Church on the Bahamas titled "A Midwinter Resort" occasioned his first visit to the tropics. Wintering in Nassau at the Royal Victoria Hotel, the largest building in the Bahamas, Homer had a view overlooking the city and out to sea that proved inspirational. During the next two months, he worked on the assignment, completing more than thirty watercolors on a variety of subjects, before setting sail for Cuba.

Though Homer was obliged to choose subjects that best illustrated the article, he seemed to show particular interest in the everyday activities of the Africans brought to the island as slaves by English planters. In *A Garden in Nassau* and other watercolors painted there, Homer alludes to the economic and racial divisions that existed on the island. Although slavery had been abolished for fifty years, the former slaves and their descendants remained impoverished. In *A Garden*

in Nassau, a high wall and picketed gate bar access to a verdant garden. The coconut palm rising above the wall dwarfs a small boy who stands with hands and feet together staring curiously through the narrow gate. In this sympathetic composition, the viewer, like the boy, is unable to see or enter the garden.

When exhibited in New York City and Boston in 1885 and 1886, reviewers applauded the spontaneity and free handling of Homer's watercolors but were quick to call them sketches rather than pictures. Indeed, the fluidly worked surface shows fewer scrapings and underdrawings than earlier watercolors, indicating that it was most likely painted quickly *en plein air*. Flowing transparent washes give form while the vivid color of the spiky palm fronds, bright red poinsettia leaves, and other details add elements of contrast. The poinsettia is a recurring motif used throughout the tropical watercolors as a highlight against the cool blues and greens. Large areas of paper left unpainted create the stark white light of the clouds, wall, and road under the tropical sun.

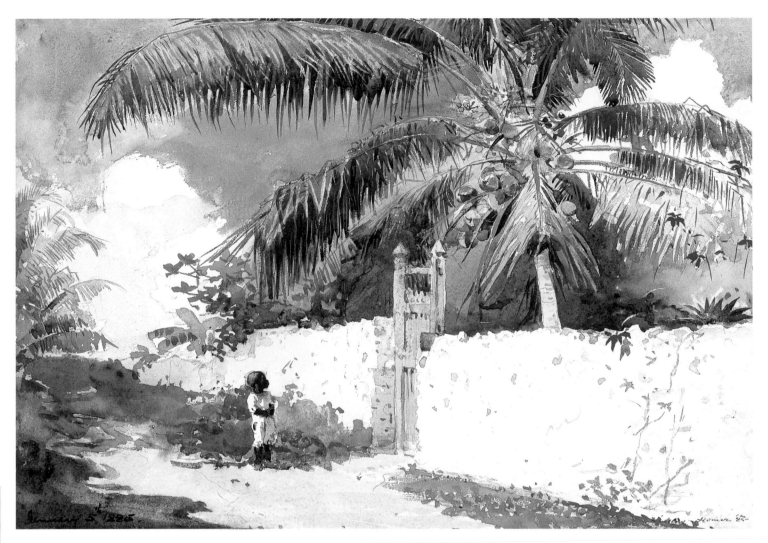

36.8 x 53.3 cm
14 1/2 x 21 in.

A Garden in Nassau

1885
Watercolor, gouache,
and graphite on paper

Signed and dated, l.r.:
"Winslow Homer '85";
dated, l.l.: "January 5th
1885."

John Singer **Sargent**

Florence, Italy 1856–1925 London

Breton Girl with a Basket, Sketch for *The Oyster Gatherers of Cancale*, 1877

1. Letter from Emily Sargent to Violet Paget, July 29, 1877, Special Collection, Colby College, Waterville, Maine.

a. John Singer Sargent, *Girl on the Beach* (sketch for *The Oyster Gatherers of Cancale*), 1877, oil on canvas, 48.3 x 29.2 cm (19 x 11 1/2 in.). TFA, Daniel J. Terra Collection 1999.131

b. John Singer Sargent, *Breton Woman with a Basket* (sketch for *The Oyster Gatherers of Cancale*), 1877, oil on canvas, 47 x 29.8 cm (18 1/2 x 11 3/4 in.). TFA, Daniel J. Terra Collection 1996.53

c. John Singer Sargent, *Young Boy on the Beach* (sketch for *The Oyster Gatherers of Cancale*), 1877, oil on canvas, 43.8 x 26 cm (9 3/4 x 7 3/4 in.). TFA, Daniel J. Terra Collection 1999.132

d. John Singer Sargent, *The Oyster Gatherers of Cancale,* 1878, oil on canvas, 79.1 x 123.2 cm (31 1/8 x 48 1/2 in.). The Corcoran Gallery of Art, Washington, D.C., Museum Purchase, Gallery Fund

John Singer Sargent was born in Florence of expatriate American parents. Thanks to his inquiring mind, he acquired a solid literary, musical, and artistic background shaped by the many travels that marked his youth. Sargent was a perfect incarnation of the cosmopolitan dandy, and rarely left Europe; after spending a dozen years in Paris, he moved permanently to London in 1886, traveling to the America only occasionally. Drawn to art at a very early age, he received his parents' blessing at age eighteen to enter the Paris studio of painter Émile Carolus-Duran (1837–1917). As a teacher, Carolus-Duran stressed a form of realism based more on the rendering of values than on draftsmanship, pointing to Diego Velázquez (1599–1660) and Frans Hals (about 1580/1585–1666) as the great models to be followed. The young Sargent, whose technical agility and sharp sense of observation swiftly became apparent, was determined to win official recognition and exhibited regularly at the Salon from 1877 onward.

a b c

d

Sargent made many trips, during which his powers of detached observation proved valuable. His career thus split into two tendencies right from the start: on the one hand he produced society portraits done in the studio, and on the other, he painted genre scenes that mistakenly appear to be life sketches, mostly done during his travels. Sargent went to Brittany in the summer of 1877, where he did preparatory work on *The Oyster Gatherers of Cancale*. A letter from his sister Emily to a friend describes the difficulties Sargent encountered in finding models and painting them on the beach surrounded by a crowd of onlookers.[1] The Terra Foundation for the Arts collection holds four sketches of these figures, all animated by a lively, fluid style based on light, precise brushwork. Sargent's stylistic interest in monochromatic effects is also noticeable in the sober settings where every feature is characterized by a dominant color, which is then sculpted by the light, thus conveying the perception of space as well as the damp and slightly misty atmosphere of the Breton seaside.

Drawn from life, these figures were later assembled in the studio, first in a kind of final study (now in the Museum of Fine Arts, Boston) and ultimately in a larger composition titled *The Oyster Gatherers of Cancale*, 1878 (Corcoran Gallery of Art, Washington, D.C.), exhibited at the Salon of 1878. Comparison of the sketches with the final canvas reveals Sargent's labor and accomplishment. The resulting composition, although more controlled, manages to retain the liveliness of handling and subject matter. Whereas the *Breton Girl with a Basket* survived intact in the final composition, the *Young Boy* subsequently acquired a basket. The woman and the other girl, meanwhile, were modified, Sargent retaining only certain features such as a garment, a pose, or a color. The large version won an Honorable Mention at the 1878 Salon, whereas the smaller version had been sent a few months earlier to the inaugural show of the Society of American Artists in New York, where it was immediately purchased by the landscape artist Samuel Colman (1832–1920).

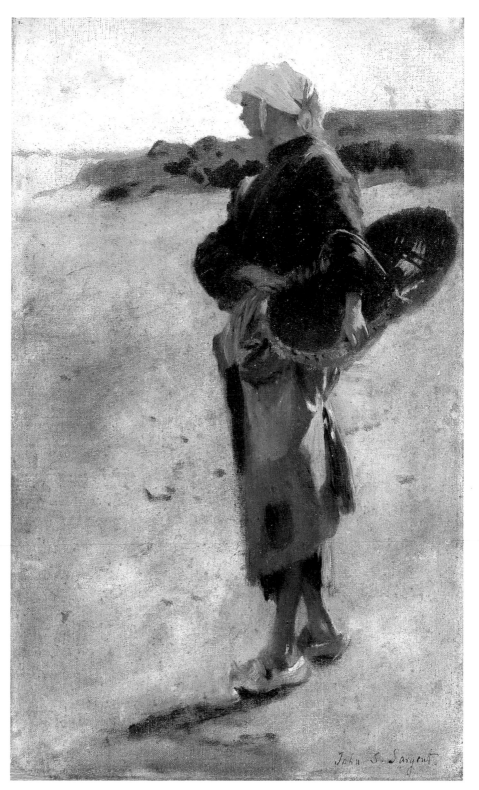

48.3 x 29.2 cm
19 x 11 1/2 in.

*Breton Girl with
a Basket,* Sketch for
*The Oyster Gatherers
of Cancale*

1877
Oil on canvas

Signed, l.r.:
"John S. Sargent"

John Singer **Sargent**

Florence, Italy 1856–1925 London

A Parisian Beggar Girl, about 1880

John Singer Sargent, who had traveled a great deal as a child, would leave on a voyage almost every year in search of exotic subjects and new visual impressions. In late 1878 he went to Naples and Capri, while in September 1879 he left for Madrid in order to copy works by Diego Velázquez (1599–1660) in the Museo del Prado, then headed south to visit Grenada and Seville. By early 1880 he was in Tangiers and Tunis, only returning to Paris at the end of February. These trips and the luminous visions they provided served as inspiration for large genre paintings that he recreated in his studio and that constituted—along with commissioned portraits—the bulk of his output during his Paris years.

A Parisian Beggar Girl was probably a model painted by Sargent in his Paris studio, following his trip to Spain and Morocco in the winter of 1879–1880. It was also exhibited under the title *A Spanish Beggar Girl*, which would confirm the dating. This canvas can be compared to a large painting inspired by Tangiers, *Fumée d'Ambre Gris* (Sterling and Francine Clark Art Institute, Williamstown, Massachusetts), also dated 1880, in which a young woman draped in white stands inside an oriental-style building. Both works involve a similar exploration of shades of white, economy of means and the swift brushwork that manages to render fully not only the girl's graceful, swaying pose but also the literally immaterial delicacy of the fabrics. The picture becomes a blend of various shades of gray— the girl, whose feet barely rest on the ground, seems to melt into the wall behind her, the wall itself being sketchily depicted by a thin wash that leaves the canvas visible. The two triangles formed by the head veil and the waist scarf lend structure to the figure, while touches of pure white, red, pink, and peach endow the model with life and presence.

This sketch was dedicated to Finnish artist Albert Gustav Edelfeldt (1854–1905), who at the time shared a studio with one of Sargent's painter friends, Julian Alden Weir (1852–1919). The five works by Sargent in the Terra Foundation for the Arts collection were all done during the artist's youth, and none of them were designed to be shown in public. These sketches display the young painter's technical skill in its most modern— if not most celebrated—light.

64.5 x 43.7 cm
25 3/8 x 17 3/16 in.

A Parisian
Beggar Girl

c. 1880
Oil on canvas

Signed, l.l.:
"À mon ami Edelfeldt/
John S. Sargent"

Charles Courtney **Curran**
Hartford, Kentucky 1861–1942 New York City

Lotus Lilies, 1888

1. "M. Curran m'a donné une furieuse envie d'aller me promener au milieu des *Lotus du lac Erie, Etats-Unis d'Amérique,* en compagnie des charmantes femmes qui y naviguent si doucement. Voilà un tableau fin et délicieux qu'on aimerait avoir chez soi. C'est de la bonne modernité." Ernest Hoschedé, *Brelan de salons.* Paris: B. Tignol, 1890.

Following a few years of study at the Cincinnati School of Design, Charles Courtney Curran moved to New York City, enrolled at the National Academy of Design and the Art Students League and soon began to exhibit successfully. In the summer of 1888, before making the requisite journey to Paris to continue his studies, Curran completed this luminous canvas, which depicts his new bride, Grace Winthrop Wickham, seated on the left, and her cousin, Charlotte "Lottie" Ada Taylor.

The two women drift in a boat on Old Woman Creek, an estuary of Lake Erie in Ohio, where the Wickham family owned several summer cottages. At a time of unprecedented economic and industrial growth in the United States, the leisure activities enjoyed by the upper and middle classes became a preferred subject for many artists. Like many of his contemporaries, Curran eschewed the history paintings that had for so long been the most valued genre; however, his bolder use of color and freer brushstroke are even here anchored and complemented by tight academic drawing and a balanced composition. It is noteworthy that Curran's espousal of the new aesthetic of impressionism, which had been developing principally in France, predates his enrollment at the Académie Julian in 1889 where he would study with Jules Lefèbvre (1836–1911), Benjamin Constant (1845–1902) and Lucien Doucet (1856–1895).

The idealized image of women in nature is a subject to which Curran frequently returned. However, the present work is particularly evocative because of the balance struck between the intimacy of the scene, which places the viewer in the bow of the boat, and the respectful distance maintained from the contemplative sitters, neither of whom meets the viewer's gaze. Nestled among the lotuses, the two women are in complete harmony with the landscape. The translucent green parasol at their backs corresponds in color and form to the lily pads. Their pale garments are warmly and evenly lit, and the incline of their heads, each adorned with a bonnet covered in flowers and ribbons, is echoed by the tilt of certain blossoms. Little effort is required by the women to approach the oversize blossoms that rise within easy reach on all sides. Indeed, no sign of labor or exertion enters into the tranquil scene, something that is further accentuated by the absence of oars.

Though Charlotte had previously posed as a model for Curran, *Lotus Lilies* is the first painting of his wife. The subject and setting likely held personal significance considering that Grace carried a bouquet of water lilies during their wedding ceremony that summer. The Currans also took the painting with them on their sojourn in Paris, where it was presented at the Salon of 1890. The eminent critic Ernest Hoschedé praised the painting, writing: "M. Curran has given me a fierce desire to go for a ride in the middle of *Lotus Lilies* on Lake Erie, United States of America in the company of the charming women who are boating there so quietly. Here is a fine and delightful scene which one would love to have at home. It is of the best modernity."[1]

45.7 x 81.3 cm
18 x 32 in.

Lotus Lilies

1888
Oil on canvas

Signed, dated,
and inscribed, l.r.: "Lotus
Lilies/Chas. C. Curran
1888"; and inscribed, on
canvas: "Chas. C. Curran/
4 Quai du Marché Neuf/
Paris"

Frederick Childe **Hassam**

Dorchester, Massachusetts 1859–1935 East Hampton, New York

Une Averse, Rue Bonaparte, 1887

Frederick Childe Hassam began his artistic career as an apprentice to a wood-engraver and illustrator of books. Evening classes at the Boston Art Club soon led him to paint in watercolor and oil, and in 1882 he was honored by a one-man show at the Williams & Everett Gallery in Boston. Much of Hassam's early artistic development was shaped by tonalism, a fascination with light and atmospheric effects. By 1885 he had perfected a style of painting that fully reflected these influences and which he successfully used to portray contemporary city life in Boston. In 1886 Hassam and his wife moved to Paris, where he attended classes at the Académie Julian. He soon decided that the most valuable lessons, including the principles of French impressionism, were to be learned outside the academic setting.

On his arrival in Paris, Hassam continued to explore urban subjects, avoided socializing with fellow Americans, and immersed himself in French culture. *Une Averse, Rue Bonaparte*, which depicts a rainy day on the old Parisian street looking south toward the Luxembourg Gardens, is the first major painting that Hassam completed in Paris. The dramatic perspective is reminiscent of some of his Boston paintings, particularly *Rainy Day in Boston*, 1885 (Toledo Museum of Art, Ohio). Hassam embraced the modernity of urban life, and in his early works he deliberately avoided the picturesque. *Une Averse,*

Rue Bonaparte remains true to this aesthetic while representing, both in style and conception, the artist's move toward impressionism. The dramatic cropping of the figures in the foreground, the blurred rendering of the trees receding into the mist, and the variegated colors of the bills posted on the wall demonstrate a departure from academic painting. A subtle, evocative comment on the social order of Parisian street life is revealed in the contrast between the toiling laborer and his daughter, both bareheaded in the rain, and the more well-to-do Parisians in proper hats, beneath umbrellas, strolling down the street just opposite the horse-drawn cabs and liveried drivers waiting to serve them.

Accepted for the juried Salon of 1887, *Une Averse, Rue Bonaparte* received favorable reviews in American and French journals. Pleased with the reception, Hassam proudly declared: "This is my luckiest stroke since I have been here." After his success at the Salon, Hassam exhibited this painting in New York City, Philadelphia, St. Louis, and at the World's Columbian Exposition in Chicago. On his return to the United States in 1889, Hassam settled in New York City, where he would remain for the rest of his life. Displeased with the conventional outlook of the Society of American Artists, Hassam helped found the Ten American Painters, or the Ten.

Frederick Childe Hassam,
Rainy Day, Boston,
1885, oil on canvas,
66.3 x 122 cm
(26 1/8 x 48 in.).
Toledo Museum of Art.
Purchased with funds
from the Florence Scott
Libbey Bequest in Memory
of her Father,
Maurice A. Scott

102.6 x 196.7 cm
40 3/8 x 77 7/16 in.

Une Averse,
Rue Bonaparte

1887
Oil on canvas

Signed, dated, and
inscribed, l.l.:
"Childe Hassam Paris.
1887."

Frederick Childe **Hassam**

Dorchester, Massachusetts 1859–1935 East Hampton, New York

Columbian Exposition, Chicago, 1892

On May 1, 1893, the World's Columbian Exposition opened to great fanfare in Chicago. A commemoration of the four-hundredth anniversary of the arrival of Christopher Columbus in the New World, the exposition celebrated achievements in science, technology, commerce, art, and culture. Impressive structures with Beaux-Arts facades were erected across acres of the city's South Side lakeshore. To combat its reputation as a rough town, the city built fairgrounds that embodied cultural refinement, physical cleanliness, and social order—quickly dubbed the "White City."

A year prior to its official unveiling, exposition organizers commissioned Frederick Childe Hassam and several other artists to enhance existing architectural drawings with figures and skies to create inviting views of the fairgrounds for use in official guidebooks and souvenirs. Though the work on these pastiches did not greatly interest Hassam, it paid well and coincided with

a commission to make original paintings of the exposition buildings for Francis David Millet (1846–1912), the artist in charge of the decorations for the exposition. Among the known works completed for the Millet commission are six detailed watercolors and several smaller studies including *Columbian Exposition, Chicago*. In this gouache, Hassam applies his early training in watercolor and graphic illustration, as well as his mastery of perspective and architectural nuance, to depict part of the north facade of the United States Government Building with detailed accuracy. Yet, his characteristic impressionist style is also evident in the shimmering reflections on the lagoon and in the attention to the transient activity of would-be fairgoers making their way across the footbridge, taking a boat ride, and congregating before the grand entrance. The Government Building was a vast hall crowned by a 120-foot dome. It housed exhibitions for the departments of War, Agriculture, and the Interior, in addition to the National Museum. Rather than simply documenting the building, Hassam focused on certain elements, particularly how the building was situated and how it would be approached and viewed by visitors.

In addition to the commissioned works, Hassam also independently completed several views of the exposition in oil and watercolor. One of these paintings, *World's Fair (Crystal Palace), Chicago Columbian Exposition*, 1893, a view of the Horticultural Building, makes a good comparison. The differences between this watercolor commissioned for publication and the oil painting highlight the balance an artist must strike between the demands of the commercial and fine art markets.

Frederick Childe Hassam, *World's Fair (Crystal Palace), Chicago Columbian Exposition*, 1893, oil on canvas, 47 x 66.7 cm (18 1/2 x 26 1/4 in.). TFA, Daniel J. Terra Collection 1999.67

27 x 35.6 cm
10 5/8 x 14 in.

Columbian Exposition,
Chicago

1892
Gouache "en grisaille"
on paper

Signed, l.r.:
"Childe Hassam"

James Abbott McNeill **Whistler**

Lowell, Massachusetts 1834–1903 London

The Zattere: Harmony in Blue and Brown, 1879–1880

Considered one of the greatest artists of the second half of the nineteenth century, James Abbott McNeill Whistler left his native country at the age of twenty-one, never to return. He pursued an eventful European career that took him to glamorous capitals such as Paris, London, Venice, and Amsterdam. Simultaneously provocative toward traditionalists and anxious for recognition by his contemporaries, Whistler launched a libel suit against the famous British writer and theorist John Ruskin in 1878. Although Whistler won his case, he was not awarded any damages to cover his expenses. Bankrupt by 1879, he abandoned any hope of a successful career within the British art establishment.

That same year, dealers for the Fine Art Society in London commissioned Whistler to produce twelve etchings of Venice. Although he initially gave himself three months to complete the task—in order to deliver the plates before Christmas 1879—Whistler found himself inspired by Venice and ultimately remained there for over a year. Rivalry with official artists in the Royal Academy intensified Whistler's creativity as he produced works that completely opposed the realism advocated by Ruskin. Whistler did not seek to provide a detailed transcription of his visual observations, but rather took the motif as a point of departure for a formalized image that nevertheless conveyed the specificity of the site. As distinct from the poetic, eternal Venice depicted by William Joseph Mallord Turner (1775–1851), Whistler shunned the views endlessly favored by tradition, and he ventured into poorer neighborhoods and secondary canals, as seen here at the Canale della Giudecca to the south of the city: Whistler stresses

the intense activity that enlivens the Zattere quay, where boats loaded and unloaded merchandise every day, watched by a bustling crowd. Placing the horizon line very high, Whistler allocates a substantial surface to the foreground occupied by the quay, whose vanishing point traces a large brown triangle left almost unworked. He concentrates on drawing a few figures with dynamic strokes, which the medium of pastel—extremely friable by nature—makes very difficult. Playing on the properties of complementary colors—here, blue and orange—Whistler manages to create a chromatic palette of delicate shades, thanks to his choice of a warm-toned brown paper. The overall effect is one of meticulousness, both in the precision of the draftsmanship and the stylized limitation of color. These results required more than ten sessions of Whistler's virtuoso skills.

The pastel was exhibited along with some fifty others at the Fine Art Society in London in 1881. Although certain critics were unprepared for Whistler's bold composition and depiction of an unfamiliar Venice, others—such as E. W. Godwin—were generally charmed. These pastels heavily influenced the young generation of American artists, notably John Twachtman and the Society of American Painters in Pastels, founded in 1882.

Purchased by Daniel J. Terra in 1985, the artistic importance of this work goes beyond American art alone. The musical allusions of Whistler's subtitles, referring to notions of harmony, minimize the importance of the subject matter and already bear the seeds of abstraction.

27.9 x 19.4 cm
11 x 7 5/8 in.

The Zattere: Harmony 1879–1880
in Blue and Brown Pastel on paper

James Abbott McNeill **Whistler**

Lowell, Massachusetts 1834–1903 London

Note in Red: The Siesta, 1882–1883

The career of James Abbott McNeill Whistler took a new turn in the 1880s. Abandoning all hope of winning recognition from official circles within the Royal Academy in London, he decided to concentrate on selling his work and promoting his ideas. He partly gave up the graphic arts he had developed over nearly thirty years and made a greater investment in oil painting, producing portraits and small, intimate scenes such as this *Note in Red: The Siesta*.

Maud Franklin, Whistler's mistress, is shown here lying on a couch. The young woman's languid, sensual pose and the delicate play of fabrics recall the virtuoso style of certain rococo artists such as Jean-Honoré Fragonard (1732–1806). Whistler handled oil paint like watercolor, that is to say he diluted the paint to obtain a fluid, translucent substance. Instead of loading the canvas with paint, he applied just a thin layer, even allowing the undercoat to show. The surface of the painting is brushed in broad strokes, left finished at a stage that still seems crude. This method allowed Whistler to progress swiftly during a single session, maintaining the spontaneity of the work and a homogeneous surface. More than a demonstration of technical bravura, this painterly approach should be viewed as a clear decision to favor the arrangement of shapes and colors. Female figure and couch merge in a sinuous shape whose upper curve (along the top of the couch) echoes the embrace of the blackish shadow (along the underside). The title of the work confirms this proclivity—based on the poet and art critic Charles Baudelaire's theory of the correspondence between music and painting, Whistler identifies this canvas with a harmonic composition, alluding to the shared, wave-like nature of both color and sound vibrations. Each visual element takes its place within the score, including the artist's signature. By the late 1860s, Whistler had stopped signing his works with his name, and instead inscribed a monogram that, over time, took the form of a butterfly. In *Note in Red: The Siesta*, this signature is extremely simplified and, like an autonomous graphic element, is integrated into the composition itself.

The painting was exhibited in New York City in 1889, at a time when Whistler's influence was growing in the United States, a country where few of his works had actually been seen by the public. Although some American critics remained hostile to Whistler's experimentation, denouncing titles deemed inappropriate, an increasing number of American art patrons were drawn to him, fully recognizing their compatriot's merits.

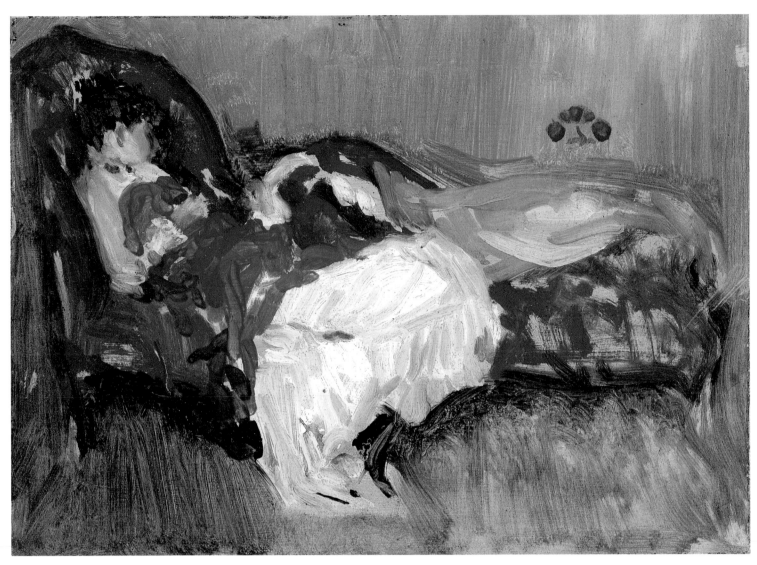

21.1 x 30.5 cm
8 5/16 x 12 in.

Note in Red:
The Siesta

1882–1883
Oil on panel

U.r.: butterfly
monogram

James Abbott McNeill **Whistler**

Lowell, Massachusetts 1834–1903 London

Nocturne: Palaces, 1886

1. See Linda Merrill, *A Pot of Paint: Aesthetics on Trial in Whistler* v. Ruskin, (Washington/London, 1992).

James Abbott McNeill Whistler's activity as an engraver was accompanied by a revival of etching techniques, long abandoned in favor of burin engravings. He learned the basics of the method in 1854 as a Naval cartographer in Washington, D.C., after having been dismissed from West Point Military Academy. Although profoundly influenced by the work of Rembrandt (1606–1669), Whistler asserted his own style at an early date, with his 1858 *French Set*, going further still in 1859 with a series of Thames river landscapes that won praise from Charles Baudelaire.

In 1879, discouraged and bankrupted by his lawsuit against John Ruskin, Whistler undertook a series of twelve etchings of Venice, commissioned by the Fine Art Society in London. Whistler felt inspired by Venice, and his output was prolific. He spent fourteen months in the city, instead of three, and returned with fifty prints instead of twelve, featuring an unfamiliar, mysterious Venice. Whistler executed certain etchings from memory, notably the nocturnes. Etching was at the heart of Whistler's art; he experimented with it from the early 1870s, initially with his views of the Thames, and subsequently in other engravings. This experimentation focused not so much on the work of engraving the plate, which simply supplied a basic schema, but on the moment of inking. Whistler found he could obtain impressionist effects by adding or removing ink from the plate by means of a cloth or even the palm of his hand—he thereby conveyed fleeting sensations and atmospheric effects of great poetic impact.

During his suit against Ruskin, Whistler asserted that his use of titles such as *Nocturne* reflected his aesthetic approach, namely his purely pictorial interest. He wanted to free his imagery from any anecdotal comment that might have been attributed to it.[1] The print held by the Terra Foundation for the Arts alternates firmly hatched lines that underscore certain features (balcony, cornice, door) with fuzzier zones that are fairly pale in the middle of the image but darker on the edges, providing an idea of how Whistler wiped the plate. This effect stresses the sobriety of the composition—far from anecdotal, Whistler focused on the formal aspects of the final image, an aspect underlined by the musical title.

The Venetian engravings were not well received; Whistler was confronted by the incomprehension of the Victorian public, who perceived only sloppy drawing, unfinished works, and empty compositions. Whereas a selection of etchings was exhibited in London in 1880 under the heading *First Venice Set*, other works, including *Nocturne: Palaces*, were published in 1886 with the title of *A Set of Twenty-Six Etchings*. The plates were nevertheless all executed—or at least begun—in Venice in 1879 and 1880, that is to say during the same period when Whistler did *The Zattere: Harmony in Blue and Brown* (p. 105). Despite divergences due to differing techniques, both works display the same concern to create an image where arrangements of colors and lines—rather than subject matter—predominate.

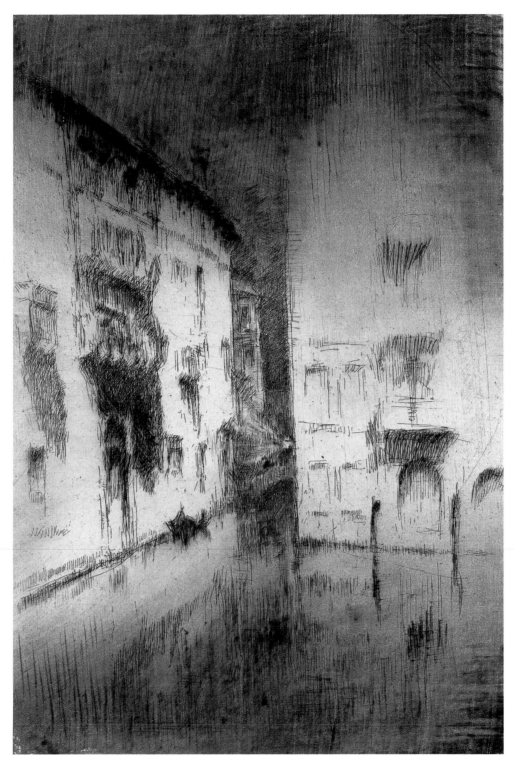

30.8 x 20 cm
12 1/8 x
7 7/8 in.

Nocturne: Palaces

1886
Etching printed
in brown ink

In pencil:
butterfly monogram

William Merritt **Chase**

Williamsburg [now Nineveh], Indiana 1849–1916 New York

Spring Flowers (Peonies), about 1889

A man who enjoyed recognition as a celebrated painter and displayed his success with flamboyant pomp, William Merritt Chase initially intended to follow in his father's footsteps as a shoe salesman in Indiana. Instead, his artistic interests and the support of his mother set him on a path that would eventually lead to study in Europe, where he visited London and Paris before settling in Munich for several years. Early on, Chase developed an ability to draw from a wide variety of influences—German realism, Spanish old masters, French impressionism, Japanese art, the works of James McNeill Whistler—while retaining his individuality as an artist.

Often considered the greatest American pastel artist of the late-nineteenth century, Chase was certainly one of the medium's most enthused advocates. In the 1880s Chase, along with other artists, founded the Society of Painters in Pastel, which sponsored exhibitions that promoted the medium as a serious art form. Pastel, even when formed into easily-wielded sticks or crayons, is challenging and fragile. Since most American artists in Chase's day who used pastel usually worked on a small scale, the grand size of *Spring Flowers (Peonies)* makes a bold statement of its potential and is rare in American art.

Within the work's shallow space, magnificently huge, blushing white peonies compete for attention with a model's kimino and strategically placed Japanese fan. In this pastel tour-de-force, Chase alludes to Whistler's aesthetic philosophy of "art for art's sake" and pays homage to the cult of Japonisme. Chase dramatizes the refined objects by contrasting the brilliant red-orange kimono and vibrant yellow-green tablecloth. A burnished gold background with delicately incised white markings unifies the composition by repeating the red robe's white designs. Throughout, Chase produces deep color effects through layering, emphasizing the lush, velvety texture of pastel.

Daniel J. Terra purchased *Spring Flowers (Peonies)* in 1993 for a then-record sum for the artist and thus augmented an already-significant grouping of works by the artist in the collection. Many of Chase's students are also represented in the collection, including Patrick Henry Bruce, Charles Demuth, Marsden Hartley, Edward Hopper, Rockwell Kent, and Charles Sheeler.

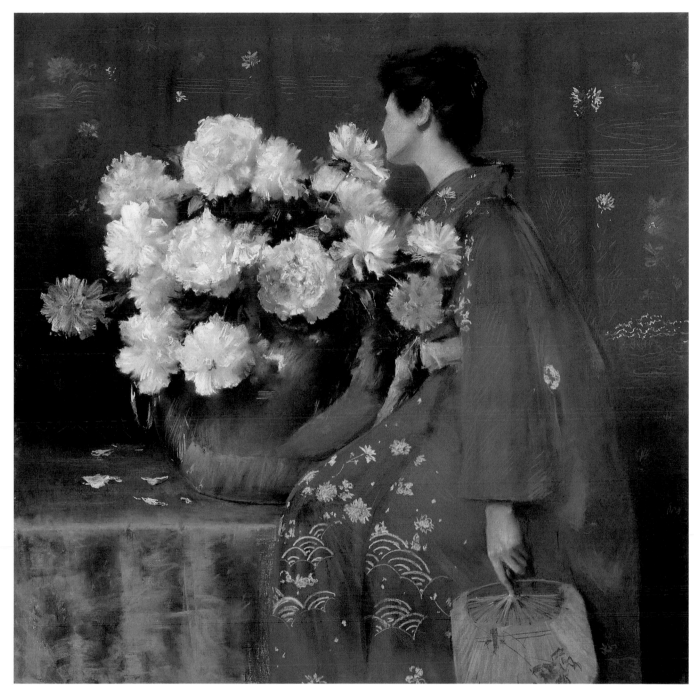

121.9 x 121.9 cm
48 x 48 in.

Spring Flowers
(Peonies)

c. 1889
Pastel on paper

Signed, l.c.:
"Wm M. Chase."

William Merritt **Chase**

Williamsburg [now Nineveh], Indiana 1849–1916 New York

Hall at Shinnecock, 1892

In addition to notable achievements in his artistic career, William Merritt Chase left a legacy as an influential teacher. He taught at the most respected art schools in New York City and Philadelphia, and he also organized teaching ateliers, which included his popular summer classes at Shinnecock, Long Island. Noteworthy in Chase's œuvre are his depictions of his sumptuously decorated studio in the Tenth Street Studio Building in New York City, the most celebrated nineteenth-century artist's space in North America, and his more intimate creative space in his home on Long Island— designed by architect Stanford White (1853–1906)— where Chase summered from 1891 to 1902.

Relinquishing his extravagant bachelor lifestyle for the domestic joys of marriage in 1886, Chase began a series of pictorial tributes to his beautiful young wife, Alice Gerson, and their eight children. *Hall at Shinnecock* is a complex essay on the artist's shifting roles as artist, husband, and father as well as his homage to an artistic master. There seems to be little doubt Chase was here thinking of Diego Velázquez (1599–1660), the artist he most revered, and the Spanish artist's meditation on art, perception, and status in *Las Meninas* of 1656 (Museo del Prado, Madrid). Emulating Velázquez, Chase

ingeniously incorporates himself into a family portrait of his wife and two daughters by way of the reflection in a mirrored armoire. The artist rendered with bravura technical skill the complicated spatial depths of his summer home's center hall. Chase varied the composition of the work with a selective placement of geometric and organic forms and a virtuoso application of pastel. Surrounded by brilliant color— the blue and white vases topped by dark green foliage and curvilinear red chair against the dynamic yellow walls—the black and white garments of the Chase family situate the figures as the focal point of the picture.

Chase's Shinnecock years were important for the degree to which impressionism affected his work and, indeed, the psychologically charged interior may show the influence of such French artists as Edgar Degas (1834–1917). *Hall at Shinnecock* ranks as one of the most important examples of an American artist's meditation on the role of art and the artist. The Terra Foundation for the Arts collection is rich in works of art by Chase, including several related to his Shinnecock era; for example *Morning at Breakwater, Shinnecock*, about 1897 (p. 20).

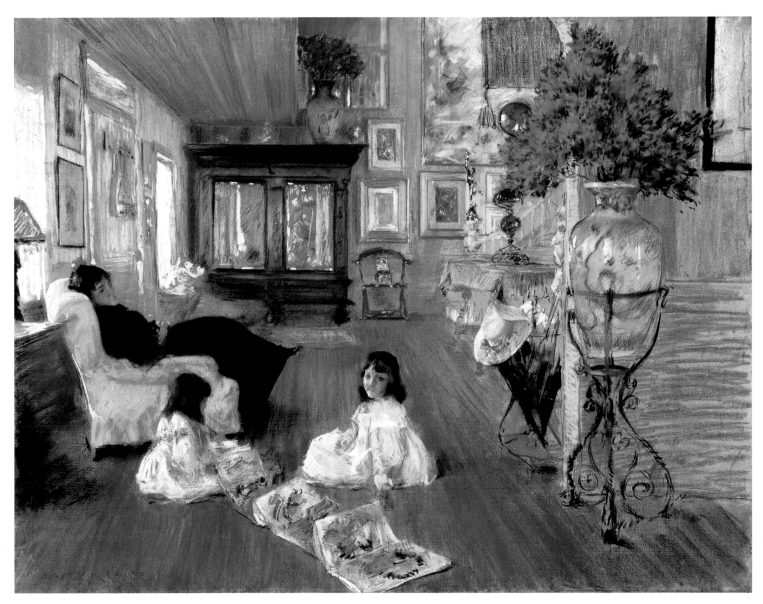

81.6 x 104.1 cm
32 1/8 x 41 in.

Hall at Shinnecock

1892
Pastel on canvas

Signed, l.l.:
"W. M. Chase"

Thomas Buford **Meteyard**
Rock Island, Illinois 1865–1928 Territet, Switzerland

Giverny, Moonlight, about 1890

Thomas Buford Meteyard grew up in Chicago, where his widowed mother, Marion Greenwood Meteyard, taught school and introduced her son to a cultured life rich in notable acquaintances from American and Continental society. Relocating to his mother's former home in Massachusetts, Meteyard briefly attended Harvard University. In 1888 mother and son spent several months in England, where they renewed an acquaintance with Oscar Wilde and where Meteyard embraced the Aesthetic movement, an "art for art's sake" trend that emphasized beauty and visuality. By December of that year Meteyard enrolled in classes at the École des Beaux-Arts in Paris and began working hard on his academic drawing. His own sensibility drew him to the new post-impressionist aesthetic, especially the Nabis, while his social ties with Edvard Munch (1863–1944) brought him into the literary circle of the poet Stéphane Mallarmé. After 1906 the artist lived in England, continuing his career as a painter and book illustrator and exhibiting in both London and Paris.

Meteyard visited Giverny from as early as 1890 until about 1897, residing at the Hôtel Baudy or with friends and becoming active in the American artist community. He formed friendships with Theodore Robinson and John Leslie Breck, among others. Meteyard painted the quiet nocturne scene *Giverny, Moonlight* during one of his first summers in the small town. Deep violet shadows and dark green grass frame a dramatic moonlit street that leads the viewer's gaze into the depths of this intimate painting. Although the moon itself is not visible, a tiny dab of solid white paint hovers in the sky just beyond the empty road, perhaps a bright, distant star. Two small houses occupy the left half of the picture, their roofs glowing pink and purple. The lack of windows or openings in either the houses or the garden wall adds to an overall mood of isolation and quiet.

Meteyard's friendship with Munch and his appreciation of Mallarmé help explain his interest in painting nighttime scenes, a common subject among symbolist painters, but rare among impressionists. Although Breck had painted several twilight landscapes in Giverny a few years earlier, and Meteyard encouraged other Americans like Dawson Dawson-Watson (1832–1892) to paint at night, this picture remains a rare example of a nocturne painted at Giverny. It differs from the sun-dappled canvases of his fellow Americans and emphasizes a spiritual, mysterious aspect of nature. Meteyard's painting, probably completed in a single sitting, inspires solitary meditation.

Always interested in pictures painted in Giverny, Daniel J. Terra purchased this unusual nighttime scene when he saw it exhibited in New York City in 1989. It remains the only work by Meteyard in the collection.

32.4 x 41 cm
12 3/4 x 16 1/8 in.

Giverny,
Moonlight

c. 1890
Oil on canvas

Signed, l.r.:
"T. B. Meteyard"

Lilla **Cabot Perry**

Boston, Massachusetts 1848–1933 Hancock, New Hampshire

Autumn Afternoon, Giverny, n.d.

Born into Boston's high society, Lilla Cabot Perry played an important role in promoting Impressionism in the United States. Raised at Newport in a cultured environment, her friends included the young Henry James. In 1874 she married Thomas Sargeant Perry— a brilliant literary critic who was a direct descendant of Benjamin Franklin as well as being the brother-in-law of painter John La Farge—and the couple played an active role in the cultural life of Boston. In 1887, after Lilla had been studying painting for three years under artists Robert Vonnoh (1858–1933) and Dennis Bunker, the Perrys went to Paris. Aged nearly forty, Lilla Cabot Perry underwent a traditional apprenticeship at the Académie Colarossi with Gustave Courtois (1853–1923), and at the Académie Julian with Tony Robert-Fleury (1837–1911) and William Bouguereau (1825–1905). The couple's European stay included many trips to art centers such as London, Madrid—where Perry made the usual copies of Diego Velázquez (1599–1660)—and Munich where she studied with realist painter Fritz von Uhde (1848–1911). During this period, Perry primarily painted portraits of friends, which she began presenting to the Salon in 1889. That same year, the Perrys discovered the work of Claude Monet (1840–1926) at the Georges Petit Gallery, and decided to spend the summer at Giverny. This discovery constituted a turning point in Perry's career, for she subsequently employed impressionist techniques in her landscapes. She also became one of the leading promoters of the movement among Bostonian collectors. Between 1890 and 1909, the Perry family spent eight summers at Giverny, becoming friends with Monet. Their stays were interspersed with returns to Boston, where Perry actively promoted the works of Monet and the colony of American artists in Giverny.

In *Autumn Afternoon, Giverny*, the dying rays of the sun ignite the Normandy countryside. Like the impressionists, Perry here juxtaposes touches of color that require the viewer's eye to reconstitute pure hues. Following Monet's advice, she took into consideration colored reflections created by variations in light, so that dusk is conveyed by violet-blue. This otherwise ordinary landscape is nevertheless solidly constructed—the open space created by the meadow in the foreground adds to the depth, while the trees and hill in the distance halt the gaze. The houses, although partially in shadow, are delineated by the dark green hedges in front and the golden trees overhead. A horizontal organization predominates, broken by the verticality of the trees, thereby orchestrating the composition. The alternation of warm and cool tones further accentuates the horizontality. Although undated, this painting has been assigned to the second period of stays at Giverny, between 1905 and 1909, following the Perrys' three-year sojourn in Japan, from 1898 to 1901, which is where Perry seems to have acquired her taste for frontal compositions and for a freer use of color.

The Terra Foundation for the Arts today owns seven paintings by Lilla Cabot Perry. Her story was of particular interest to Daniel J. Terra, since the first house he bought in Giverny was occupied by the Perry family in the summers from 1894 to 1897. Next door to Monet's property, the house symbolizes the friendship linking the two families and, in a broader sense, the cultural ties between France and the United States, since other Americans also occupied it at various times.

65.4 x 81 cm
25 3/4 x 31 7/8 in.

Autumn Afternoon, n.d.
Giverny Oil on canvas

John Henry **Twachtman**
Cincinnati, Ohio 1853–1902 Gloucester, Massachusetts

Winter Landscape, 1890–1900

In 1889, John Henry Twachtman moved with his family to a farm in Greenwich, Connecticut. The property provided varied landscapes that became an inexhaustible source of inspiration to the painter, who transformed familiar vistas into private, highly subtle works that were given no title or date. *Winter Landscape* is a good reflection of the vision and aesthetics of those paintings in which Twachtman recorded his experience of nature in delicate brushstrokes and soft tones, revealing his sensitivity to the artistic possibilities of snowy scenes imbued with poetry.

By this time, Twachtman was an accomplished artist who had spent over a dozen years in Europe, from the Royal Academy in Munich to the Académie Julian in Paris and on to Venice (where he met James Abbott McNeill Whistler). Europe altered Twachtman's style, dislodging dynamic realism in favor of thick, dark brushwork (adopted in Munich), of landscapes in clear, transparent tones, and of the light and spontaneous touch typical of Whistler and the impressionists in general. As a modern artist of the late nineteenth century, Twachtman developed a new mode of expression influenced by outdoor techniques, which he applied to American subjects. In 1897, he formed the Ten American Painters group with Thomas Dewing, Frederick Childe Hassam, Edmund Tarbell, and Julian Alden Weir (1852–1919), and he continued to exhibit regularly with this group of American impressionists. So Twachtman did not lead a solitary life on his rural property, but participated actively in the art scenes in New York City—where he taught—and in Boston.

In *Winter Landscape*, the eye moves along the meandering stream and up the branches of the trees that stand against the snowy ground like geometric shapes, providing depth and orchestration to the painting. The snow discloses the contours of the landscape through subtle variations in whiteness, highlighted by opaque touches not only of lavender but also of blues and pale greens. These same hues are found in the soft, clear light that draws the canvas together even as it blurs the boundary between land and sky. The very high horizon line recalls Japanese prints—which Twachtman could have admired in the Museum of Fine Arts in Boston in 1893—and compresses space by underscoring the verticality of the canvas. This approach, in accordance with post-impressionist ideas of the day, stresses the decorative nature of the work and the preeminence of style over the authentic depiction of the subject, as do the square format, the nearly monochrome hues, and the even handling of the entire surface of the painting.

76.5 x 76.5 cm
30 1/8 x 30 1/8 in.

Winter
Landscape

1890–1900
Oil on canvas

Signed, l.r.:
"J H Twachtman"

Theodore **Robinson**

Irasburg, Vermont 1852–1896 New York City

The Wedding March, 1892

Committed to exploring the effects of light in nature, in 1887 Theodore Robinson settled in the small French village of Giverny, home to the celebrated French impressionist painter Claude Monet (1840–1926), to develop his approach to landscape painting. By the following summer, the quiet hamlet was transformed into the site of an active expatriate artist colony—artists set out with their easels into the village landscape. Within this community of Americans, Robinson was known for his quiet withdrawal and his close friendship with Monet, with whom he often painted.

In *The Wedding March*, his most celebrated work, Robinson uncharacteristically used a social event as subject matter. Set in the streets of Giverny, Robinson captures a moment from the wedding of the American painter Theodore Butler (1861–1936), to Monet's stepdaughter, Suzanne Hoschedé. The light-filled canvas and dynamic composition underscore the celebratory nature of the occasion, in spite of Monet's strong opposition to the union. Robinson, who was friendly with both the groom and the unhappy stepfather, possibly painted the scene from memory weeks after the event, and thus the work serves more appropriately as a memento than a document. Accordingly, the identities of the figures remain ambiguous. While the bride and groom are suggested by their costume, it is unlikely that Monet is among those depicted, as neither of the male figures wears the French artist's long, distinctive beard.

Among the final canvases Robinson painted in Giverny before his return to America in 1892, *The Wedding March* confidently announces his fully developed impressionist style. While the linear quality of his earlier work here gives way to a lightened palette and freer technique, Robinson never fully relinquished his allegiance to his academic training. As the result of both personal preference and health problems (he suffered from chronic asthma from which he died at forty-four), Robinson often painted the landscape on site and then returned to his studio to work on figural passages. To do so, Robinson frequently relied on photographs, a significant number of which are in the Terra Foundation for the Arts collection.

Daniel J. Terra's purchase of *The Wedding March* in 1978 marks the founding of one of the finest collections of American impressionist painting in the United States. As a cornerstone of the collection, *The Wedding March* is complemented not only by works of other Giverny colony artists but also by several important paintings by Robinson. Also of note are the thirty-three photographs and three sketchbooks by the artist, enigmatic and fascinating sources that begin to unfold the story of Robinson's little-documented early career and lend insight into his later aesthetic concerns.

56.7 x 67.3 cm
22 3/8 x 26 1/2 in.

The Wedding March 1892 Signed, l.r.:
Oil on canvas "Th Robinson"

Edmund Charles **Tarbell**

West Groton, Massachusetts 1862–1938 New Castle, New Hampshire

In the Orchard, 1891

Originally from the Boston area, Edmund Charles Tarbell displayed a propensity for art at an early age. He began by studying lithography, then turned to painting. At age twenty-one, a scholarship enabled him to leave for Paris with his friend Frank W. Benson (1862–1951). Both attended classes at the Académie Julian and discovered impressionism in Parisian galleries. On returning to Boston in the fall of 1886, Tarbell opened a studio with Benson and taught painting at the Museum School of Art. In 1890, he was named head of the drawing and painting departments at the school, a post he would hold until 1913. Tarbell was also one of the founders of the first impressionist group in the United States, Ten American Painters (known as The Ten). Founded in 1897, the group withdrew from the Society of American Artists to promote an independent style.

In the Orchard depicts a gathering of men and women who chat in the shade of flowering trees on a fine summer afternoon. The painting features members of Tarbell's family, as was often the case: from left to right, his sisters-in-law Lydia Souther Hatch and Myra Eastman, his brother-in-law Richmond Phipps Souther, his wife Emeline Souther Tarbell (seated, with hat), and Lydia once again (from the back). This outdoor scene is striking for the rich palette of colors that convey a summer atmosphere. Tarbell's interest in variations in light can be seen in the skein of fine colored brushstrokes in the grass, and in the multiple reflections playing on the white dress. Along with stylistic features, the subject—a peaceful depiction of a privileged social class—relates unmistakably to impressionism.

Yet Tarbell has not forgotten the drawing skills he acquired as a student. His well-drawn figures do not blend into the landscape in the background. Rather, he challenges compositional conventions by leaving the arm of the woman seen from the back off the edge of the canvas. A solid construction also underpins this work. Trees frame the scene and each figure develops a relationship, through his or her pose, with the other figures. Gazes and gestures construct a kind of circle that links all the characters, to the extent that a silent tale seems to be unfolding within this scene of leisure. This canvas might therefore be seen as an attempt at a synthesis between academic tradition and impressionism.

In the Orchard was exhibited in Boston in 1891 at the St. Botolph Club with works by his friend Benson. Quickly recognized as one of Tarbell's most important works, it was displayed again at the World's Columbian Exposition in Chicago in 1893 and at the Universal Exposition in Paris in 1900. Yet by the late 1890s Tarbell was turning to more conventional depictions of interiors, where his work on light could be compared to the œuvre of Johannes Vermeer (1632–1675).

Having long remained in the artist's family, the painting was acquired for the Daniel J. Terra collection in 1992, at a record sale price for a work by Tarbell. This major purchase was probably linked to the plan to found a museum in Giverny, where so many American artists first found impressionism.

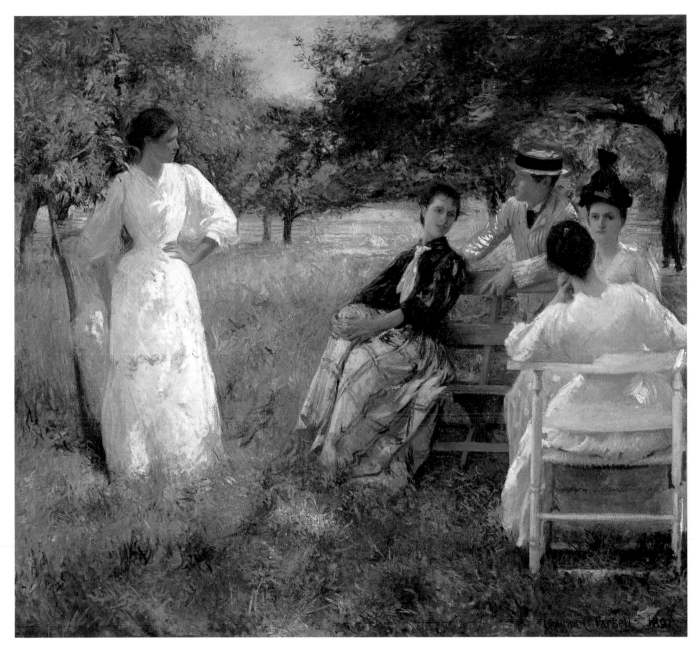

154.3 x 166.4 cm
60 3/4 x 65 1/2 in.

In the Orchard

1891
Oil on canvas

Signed, l.r.:
"Edmund C. Tarbell. 1891"

John Leslie **Breck**

Near Hong Kong 1860–1899 Boston

Morning Fog and Sun, 1892

John Leslie Breck, born into a wealthy Boston family, studied art first at the Royal Academy of Munich (1878–1881) and then in Antwerp (1882), before returning to Boston. He then spent 1886 to 1888 in Paris, taking courses at the Académie Julian. Despite the academicism of those courses, Breck's stay in Paris was crucial, for in 1887 he and a few friends were the first Americans to "discover" Giverny, which profoundly affected their style and choice of subject matter. Breck returned to the village many times, progressively entering Claude Monet's privileged circle of friends, as witnessed by his pictures of the French master's garden and boat. Although intermittent, these contacts established an artistic affiliation that definitively steered Breck toward impressionism. According to John Henry Twachtman—and confirmed by a press clipping from January 1893—Breck was considered to be the leader of the American impressionists during his lifetime. The American colony at Giverny owed its existence to Breck's enthusiasm and intuition. Although he adopted the impressionist aesthetic fairly swiftly, Breck sometimes returned to more traditional techniques, a compromise that earned him an Honorable Mention at the Universal Exposition of 1889 in Paris for his *Autumn, Giverny*, 1889 (TFA 1989.16). He then had several shows in Boston, at venues such as the prestigious St. Botolph Club, certainly thanks to his connections with Boston brahmins such as Lilla Cabot Perry. A commemorative exhibition was also held there in 1899, the year of Breck's tragic death at age thirty-nine.

Given its subject, *Morning Fog and Sun* extends the experiments begun with a series of grainstacks painted in 1891 (*Studies of an Autumn Day*, TFA 1898.4.1–12), certainly as a tribute to Claude Monet. This painting is larger, however, and focuses on atmospheric effects and shimmering light. Breck uses pastel shades, applied in divisionist dots in the foreground and on the lighter parts of the stacks. The same technique is employed to depict the shadows, in an arrangement of colors dominated by touches of blue. The few rays of sun striking the grainstacks are represented by impasto touches so prominent they resemble fringing. In places, it can be seen that Breck primed the canvas with a gray ground, perhaps to enhance the atmospheric effect he sought to create, as well as to make the chromaticism cohere. Never varnished, the painting retains a mat appearance that underscores impressionist techniques and colors, confirming Breck's crucial role in the assimilation of this new aesthetic in America.

The innovative brushwork is balanced by the strong structure of the composition. This factor apparently contributed to the work's critical success in Breck's solo exhibition at the J. Eastman Chase Gallery in 1893. The *Boston Evening Transcript*, for example, described the canvas as the most beautiful morning landscape ever painted by an American.

The purchase of *Morning Fog and Sun* in 1991 by Daniel J. Terra (who already owned twelve of the fifteen grainstacks in the series titled *Studies of an Autumn Day*) constituted a further step in assembling a coherent collection by this little-known artist who was crucial in encouraging impressionist experimentation in the United States.

81.3 x 117.3 cm
32 x 46 3/16 in.

Morning
Fog and Sun

1892
Oil on canvas

Signed, l.l.:
"John Leslie Breck–1892"

Mary Stevenson **Cassatt**

Allegheny City [now Pittsburgh], Pennsylvania 1844–1926 Le Mesnil-Théribus, France

Woman Bathing, 1890–1891

Mary Stevenson Cassatt was one of the few American artists to achieve recognition on both sides of the Atlantic during her lifetime. Her itinerary from the United States to France followed the same path as her male contemporaries, yet her subsequent career reflected a unique talent and determination. Born into an affluent family in the suburbs of Pittsburgh, Cassatt chose an artistic career at an early age. She studied first at the Pennsylvania Academy of the Fine Arts in Philadelphia, at the age of seventeen, and later in Paris under, among others Jean-Léon Gérôme (1824–1904). The young woman traveled not only through France and Italy, but also to Spain and Holland. Starting in 1870, Cassatt regularly submitted canvases to the Salon. She nevertheless developed affinities with the more modern subject matter and approach of independent artists such as Pierre-Auguste Renoir (1841–1919), Claude Monet (1840–1926), and Edgar Degas (1834–1917). She was the only American artist invited to show with the French impressionists, which she did in 1879, during their fourth exhibition, where her paintings were rather well-received by critics. The collaboration was renewed in 1881 and 1886, during the group's sixth and eighth shows. At the same time, Cassatt was sending works to the United States, representing some of the earliest examples of impressionist art exhibited in America. Cassatt also advised her family and friends on the purchase of impressionist works, thus contributing actively to the spread of the movement in the United States. In the spring of 1890, Cassatt went several times to the major exhibition of Japanese art held in the École des Beaux-Arts in Paris. Some seven hundred Japanese works, including a great many prints and illustrated books, were the talk of the Paris art scene. Cassatt was highly enthusiastic about so-called *ukiyo-e* prints that

matched her own concerns in terms of everyday themes, absence of conventional perspective, asymmetrical composition, play between decorative motifs and flat zones of color, and stress on outlines. A few months later, inspired by the exhibition, she produced her first series of Japanese-style color engravings, including *Woman Bathing*.

Cassatt's prints and experiments with new graphic techniques yielded the most original works of her career. Although based on a traditional Japanese approach to engraving, Cassatt's prints diverge from it through her choice of imagery and innovative use of various methods. The bourgeois world and the activities of modern women were at the core of her œuvre. And yet, bucking the cultural taboos of the bourgeoisie of the day, *Woman Bathing* evokes the female body even as it eschews the erotic dimension associated with, for example, Degas' bathers. Unlike the standard brothel or bathing scenes of the day, Cassatt simply depicts a servant's bedroom without displaying the woman's body. And unlike *ukiyo-e* prints, her works were not engraved on wood but rather on copper, using a combination of dry-point and aquatint techniques to imitate the effects of Japanese coloring. In addition, Cassatt employed decorative patterns to enliven her linear compositions and solid backgrounds. Thus the floor here seems strewn with flowers, providing a contrast to the blue background and the woman's striped garment. Far from the empirical concerns of the impressionists, Cassatt's explorations displayed greater affinities with the symbolist movement and artists such as Paul Gauguin (1848–1903) and Odilon Redon (1840–1916), with whom she exhibited at the eighth impressionist show in 1886.

36.2 x 26.7 cm
14 1/4 x 10 1/2 in.

Woman Bathing 1890–1891
Drypoint and aquatint

Mary Stevenson **Cassatt**

Allegheny City [now Pittsburgh], Pennsylvania 1844–1926 Le Mesnil-Théribus, France

Summertime, about 1894

In 1894, Mary Stevenson Cassatt bought the Château de Beaufresne in Mesnil-Théribus, in the countryside north of Paris. At this time she once again took up painting, which she had temporarily abandoned in favor of engraving. This fresh start was accompanied by a change in approach toward her main subject matter— the depiction of women. Her paintings of the 1880s had been set in bourgeois interiors or enclosed exteriors (a kind of outdoor extension of domestic spaces), whereas the woman and little girl in *Summertime* are plunged into nature, having embarked on a pond apparently located on Cassatt's property.

As though in reaction to her prints, here Cassatt has painted a large canvas characterized by monumental forms and a generous use of paint. She stresses the surface of the canvas, animated through bright colors, rich textures, and the lack of a horizon. The pond occupies a predominant place in this work, reinvigorating the modern notion—inspired by Japanese art—of granting the same importance to figure and ground. The staccato movements of the water are represented by long, strikingly vivacious brushstrokes of complementary colors: green-and-red or orange-and-blue convey the effects of light on water. The impression of movement is counterbalanced by the solidity of the figures, while ducks break the monotony of the water and provide stability to the composition.

Mary Cassatt,
Feeding the Ducks,
c. 1894, drypoint
and aquatint in color,
29.8 x 40 cm
(11 3/4 x 15 3/4 in.).
TFA, Daniel J. Terra
Collection 1999.26

In the 1890s, Cassatt produced several variations on this theme, employing diverse media. The peaceful, introspective atmosphere of this period can notably be seen in four works, including the identically titled *Summertime*, about 1894 (Armand Hammer Museum of Art and Culture Center, Los Angeles), *The Boating Party*, 1893–1894 (National Gallery, Washington, D.C.), and an engraving *Feeding the Ducks*, about 1894. Cassatt is particularly well-represented in the Terra Foundation for the Arts collection, which includes sixteen of her works.

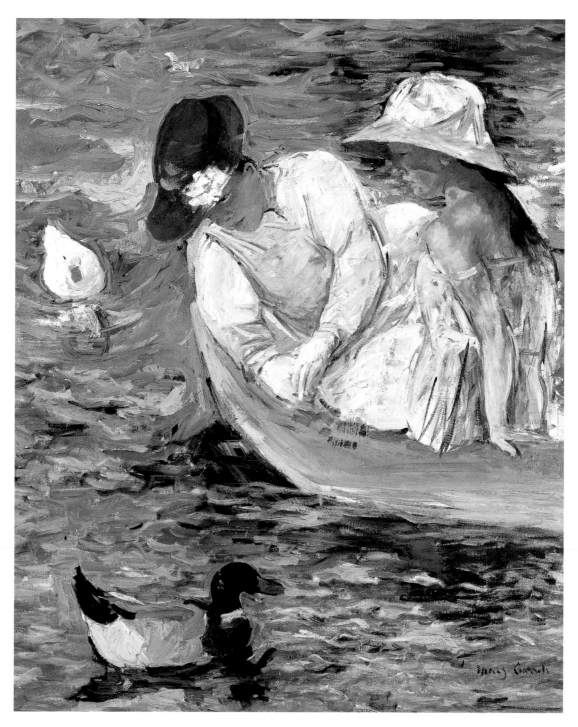

100.6 x 81.3 cm *Summertime* c. 1894 Signed, l.r.:
39 5/8 x 32 in. Oil on canvas "Mary Cassatt"

Mary Stevenson **Cassatt**

Allegheny City [now Pittsburgh], Pennsylvania 1844–1926 Le Mesnil-Théribus, France

La Tasse de thé (The Cup of Tea), 1897

Mary Stevenson Cassatt was probably taught pastel technique at the Pennsylvania Academy of the Fine Arts in Philadelphia in the early 1860s, but only developed a real interest in it after meeting Edgar Degas (1834–1917) in 1877. Their artistic affinities are evident in works from that period: both artists handle the same subjects—women at the theater, for example—and both conducted similar experiments, notably laying pastel pigments over metallic paints. Two decades later, though, pastels by Cassatt, such as *La Tasse de thé*, were displaying different concerns. The theater scenes so beloved by Degas had given way to portraits of women in which the figure assumed a prominent place, to the detriment of her surroundings; the female silhouette henceforth stood against a plain ground, rather than being placed in a setting. Cassatt's compositions now stressed the pensive appearance and intense gaze of the sitter. She forsook a detailed rendering of garments, the better to concentrate on the face with its contemplative expression. This simple, straightforward execution of portraits recalls Jean-Baptiste Siméon Chardin (1699–1779) and Maurice Quentin de La Tour (1704–1788), whose work Cassatt admired in the Louvre and on a visit to Saint-Quentin. Like those eighteenth-century artists, Cassatt used paper glued to canvas as a support for her pastels. At the time, these backed papers, suited to wooden frames, were sold in standard formats by art suppliers. Because they could be set upright on an easel, they offered the advantage of being worked like a painting.

In *La Tasse de thé*, Cassatt drew the outlines of her sitter in black, then applied colored layers of pastel. She delicately modeled the woman's oval face and serene features by superimposing layers of green, flesh tints, and white, plus pink and peach hatching, to produce smooth, velvety surfaces similar to the texture of real skin. To create the shadows on the face, she confidently used green not only in the under layers but also in final touches, drawing inspiration from Italian early-Renaissance Madonnas. Once the work was finished, Cassatt steamed the paper until the darker pastels melded with the other layers, thereby creating a natural effect. The sketchiness of the hands provides an effective contrast with the refined handling of the face. Finally, the vibrant blues, yellows, pinks, and lavenders—applied in long, generous strokes for both the fabric of the dress and the plain ground—illuminate and animate the entire surface of the work.

In a striking anecdote, this work lay behind a dispute between Cassatt and her dealer, Paul Durand-Ruel. The Woman's Art Club of New York asked Cassat to participate in an exhibition. Although she had always supported women's organizations and independent artists, she believed that such shows were meant for unknown artists seeking recognition. Cassat was already well-known, so she categorically refused. Durand-Ruel ignored her instructions and sent the painting, a move which cast a lasting chill on their relationship.

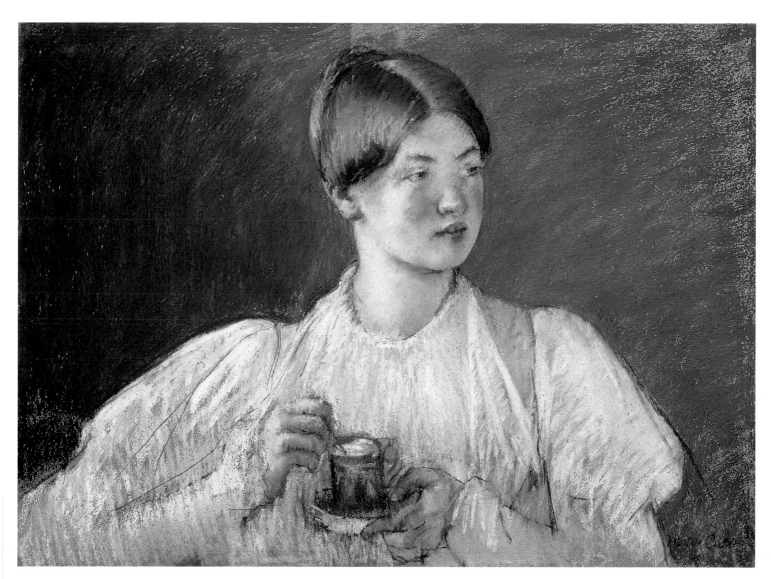

54 x 73 cm
21 1/4 x 28 3/4 in

La Tasse de thé
(The Cup of Tea)

1897
Pastel on paper
mounted on canvas

Signed, l.r.:
"Mary Cassatt"

Thomas Wilmer **Dewing**
Boston 1851–1938 New York City

Portrait of a Lady Holding a Rose, 1910–1915

Inspired by the images of solitary women in domestic interiors by the Dutch master Johannes Vermeer (1632–1675) and the English Pre-Raphaelites, Thomas Wilmer Dewing found expression for his refined sensibility in his depictions of ethereally graceful women. The painter's most pervasive stylistic influence was James McNeill Whistler, with whom Dewing briefly shared a London studio in 1895. Employing Whistler's tonalist palette of neutral, dark hues such as brown and gray, Dewing created shimmering, ambiguous spatial surroundings that focus attention on the isolated figure.

Dewing spent 1876 in Paris studying at the Académie Julian, afterward returning to Boston, his native city, to teach at the new art school of the Museum of Fine Arts. Dewing was a founding member of the Ten American Painters, a group of artists who seceded from the Society of American Artists in December 1897 and exhibited together until 1914. After 1880 his professional life was based in New York City. The most critical support in Dewing's career came from the patronage and friendship of Charles Lang Freer, whose own aesthetic bent assembled works of art by Whistler and Dewing with his collection of Chinese and Japanese fine arts, today on display in the Smithsonian's Freer Gallery in Washington, D.C.

Portrait of a Lady Holding a Rose is Dewing's Japonisme filtered through Whistler and Freer; the wide sleeves of the green fur-trimmed robe suggest a kimono and the presence of the Asian scroll and opaline vase complete the setting. The woman in the foreground is Dewing's homage to Whistler's famous portrait of his mother, *Arrangement in Grey and Black: Portrait of the Painter's Mother*, 1871 (Musée d'Orsay, Paris). The model, Gertrude McNeill, an actress who sat for Dewing several times, exemplifies the artist's preferred physical type—long-necked, high-cheek-boned, and tall with an aristocratic bearing. However, the dramatic note struck by the theatrical gestures of the model's hands belies the languid melancholy often perceived in the artist's paintings of isolated women. Dewing's friend and patron, the New York architect Stanford White (1853–1906) designed the painting's latticework frame. Exquisitely crafted and distinguished from later grille frames cast from molds of White's designs, the cage-like frame in effect transforms the "lady" into a bird of bright green plumage.

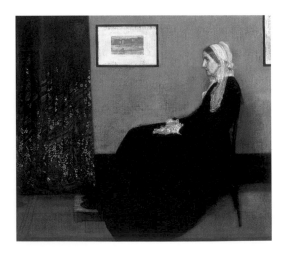

James Abbott McNeill Whistler, *Arrangement in Grey and Black: Portrait of the Painter's Mother,* 1871, oil on canvas, 144.3 x 162.5 cm (56 13/16 x 64 in.). Musée d'Orsay, Paris

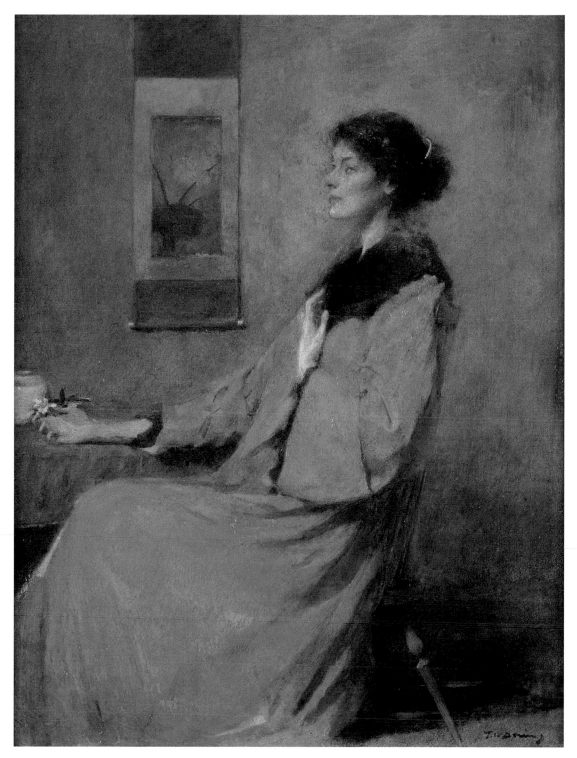

54 x 41.3 cm
21 1/4 x 16 1/4 in.

Portrait of a Lady
Holding a Rose

1910–1915
Oil on canvas

Signed, l.r.:
"T. W. Dewing"

Frederick William **MacMonnies**
Brooklyn, New York 1863–1937, New York City

Self-Portrait, 1896

Apprentice to the famous American sculptor Augustus Saint-Gaudens (1848–1907), Frederick William MacMonnies was well-prepared to enter the École des Beaux-Arts in Paris in 1884 to study with Alexandre Falguière (1831–1900). After twice winning the Prix d'Atelier, the highest honor awarded to foreign students at the École, the promising young American student garnered professional accolades at Chicago's 1893 World's Columbian Exposition for his monumental sculpture *The Barge of State*. Another international triumph was the oversize *Bacchante with Infant Faun*, 1893 (The Metropolitan Museum of Art, New York), exhibited at the Paris Salon of 1894. Although the original became a *succès de scandale* in the United States because it was an image of drunken motherhood, a life-size copy was purchased in 1897 for the Musée du Luxembourg, thereby becoming the first American sculpture bought by the French government. Exhausted by the demands of his public monument commissions,

MacMonnies moved to Giverny and, in 1898, turned to portrait painting as a less stressful vocation. Inspired by his wife, the painter Mary Fairchild (1858–1946), he occasionally submitted paintings to the annual Salon in Paris and exhibited once in the United States in 1903.

In each of the ten known self-portraits, MacMonnies appears only as a fashionably dressed painter, never as a sculptor. Was this vanity or artistic exploration? As the self-portraits were never exhibited, it suggests they were studies of his new identity and practice for his new career inspired by Diego Velázquez (1599–1660) whose art he studied in Madrid in 1898 and 1904. In *Self-Portrait*, the sculptor-turned-painter holds his brush in a manner that imitates Velázquez' famous gesture in *Las Meninas*, 1656 (Museo del Prado, Madrid). The brushstrokes replicate the Spanish master's bravura application of paint in his luminous white shirt and pink tie, as well as in the muted blue-green pattern of the tapestry that hung in his Giverny studio, probably the *Enlèvement d'Iphigénie*. In contrast, his meticulously painted facial features reveal the artist's thorough academic training.

Financial demands and tepid response of critics encouraged MacMonnies to return to sculpture after 1903. "Parlor bronzes," statuette reproductions of major works, designed for the domestic interiors of upwardly mobile American collectors, provided a steady income. The Terra Foundation for the Arts holds a selection of these bronzes, for example, *Bacchante with Infant Faun*, 1894, *Cupid on a Ball*, 1895 (TFA 1988.7), and *Diana*, 1894 (TFA 1988.21), as well as a number of other important MacMonnies paintings.

Frederick William MacMonnies, *Bacchante with Infant Faun*, 1894, bronze with dark green patina, 88.3 x 29.2 x 29.2 cm (34 3/4 x 11 1/2 x 11 1/2 in.). TFA, Daniel J. Terra Collection 1988.20

81.3 x 54.3 cm
32 x 21 3/8 in.

Self-Portrait 1896
 Oil on canvas

Henry Ossawa **Tanner**
Pittsburgh, Pennsylvania 1859–1937 Paris

Les Invalides, Paris, 1896

Son of a pastor from Philadelphia, Henry Ossawa Tanner was the first African-American student admitted to the Pennsylvania Academy of the Fine Arts, where he studied under realist painter Thomas Eakins. Intending to travel to Rome, Tanner stopped in Paris in 1891 and settled there permanently. Like many of his compatriots, he enrolled at the Académie Julian, studying under Jean-Paul Laurens (1838–1921) and Jean-Joseph Benjamin-Constant (1845–1902). There Tanner was above all "an American in Paris," just one foreigner among others. He spent time in Brittany, notably at Pont-Aven at the very moment that Paul Gauguin (1848–1903) and his symbolist friends were working there. Tanner developed the genre of apprenticeship scenes—an adult guiding the first efforts of a young lad—as seen in *The Bagpipe Lesson*, 1892–1893 (Hampton University Museum, Virginia) and *The Young Sabot Maker*, 1895 (Estate of Sadie T. M. Alexander), thus winning his first acceptance at the Salon.

Returning for a year to the United States, Tanner was confronted by racial issues once again. He began to portray African-Americans in his compositions and spoke of the equal artistic potential of the races at the Congress on Africa of the 1893 World's Columbian Exposition in Chicago. On returning to Paris, Tanner specialized in religious scenes such as *Daniel in the*

Lions' Den, 1895 (unlocated) and *The Raising of Lazarus*, 1896 (Musée d'Orsay, Paris), which as final proof of Tanner's integration into the official French system, was bought by the French government in 1897. At this point, his more concise brushwork and unity of tone suggested the influence of religious symbolism in the manner of Georges Desvallières (1861–1950), a tendency that would intensify in Tanner's twentieth-century works.

Yet it was in a markedly different style that he painted this street scene, *Les Invalides, Paris*, in 1896. Never exhibited during Tanner's lifetime, this little painting probably remained in the artist's possession until his death in Paris in 1937, and it reveals a more private side to Tanner's œuvre. Although somewhat sketchy, the work is solidly structured through the opposition of two spaces divided by a diagonal line, lending depth and dynamism to the whole. Into the upper half surges the imposing dome of the chapel of Les Invalides, silhouetted against a vast gray sky rendered in broad strokes. The lower half includes figures of strollers, soldiers, and a woman with poodle on the sandy Place Vauban. Tanner reveals himself here in another light, celebrating the urban landscape of his adopted city even as he applies new impressionist principles in terms of subject matter, powerful construction, handling of light, and choice of palette.

33.3 x 41 cm
13 1/8 x 16 1/8 in.

Les Invalides,
Paris

1896
Oil on canvas

Signed and dated, l.l.:
"H. O. Tanner/96"

Maurice Brazil **Prendergast**
St. John's, Newfoundland 1858–1924 New York City

Red Cape, 1891–1894

Born in Newfoundland, Maurice Brazil Prendergast moved as a young boy to Boston, where he later worked as a commercial artist. In 1891 at the age of thirty-two, Prendergast traveled to Paris and enrolled at the Académies Julian and Colarossi, his first formal artistic training. Although serious about learning the techniques taught in the classes, he also enjoyed making spontaneous sketches and watercolors directly from nature while wandering the city. Prendergast became close friends with the Canadian artist James Wilson Morrice (1865–1924), who introduced him to the work of the French avant-garde, and together the two artists made trips to the Normandy coast and produced numerous sketches of the streets of Paris.

While in France, Prendergast began making monotype prints by applying oil paint to a sheet of glass or metal and then transferring the image to a piece of paper by rolling the paper flat against its surface. Inspired by Japanese prints and the work of James McNeill Whistler,

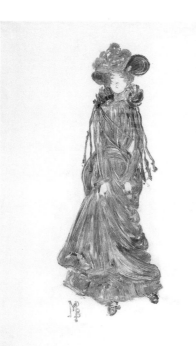

Maurice Brazil Prendergast,
Red Haired Lady with Hat,
1891–1894, monotype,
39.1 x 27.9 cm
(15 3/8 x 11 in.).
TFA, Daniel J. Terra Collection
1992.103

Prendergast excelled at the technique and produced almost two hundred monotypes between 1891 and 1902. Because monotypes require an artist to work quickly, they do not encourage the incorporation of details or shading. Indeed, in *Red Cape*, Prendergast's quick, curving brushstrokes suffice to give form to the woman's clothing.

Red Cape depicts a solitary woman, dressed in an elegant cape, gown, and hat. It resembles sketches made by Prendergast in Paris and published in the magazine *Studio* in 1893, which were erroneously attributed to Michael Dignam. These sketches and the monotypes that followed demonstrate Prendergast's interest in capturing the movement of fashionable Parisian women. In *Red Cape*, the hem of the woman's dress swings forward, flipped outward as if she has been caught mid-stride. Her feet peek out from beneath her gown, one in front, the other behind. The curving flow of her dress and hat add to the mood of spontaneous motion and recall Art Nouveau poster designs, popular at the time. *Red Cape* is similar to other monotypes by Prendergast in the Terra Foundation for the Arts collection. In all these prints, Prendergast unified the depiction of a stylish woman wearing a large hat and carrying a muff or umbrella against a plain background with one or two dominant colors. Prendergast considered monotypes an important part of his œuvre and exhibited them often in the 1890s, although he stopped making them in 1902.

Particularly fond of Prendergast, Daniel J. Terra acquired sixty monotypes, establishing one of the largest collections of the artist's work in this media, as well as twenty-one other watercolors and oil paintings.

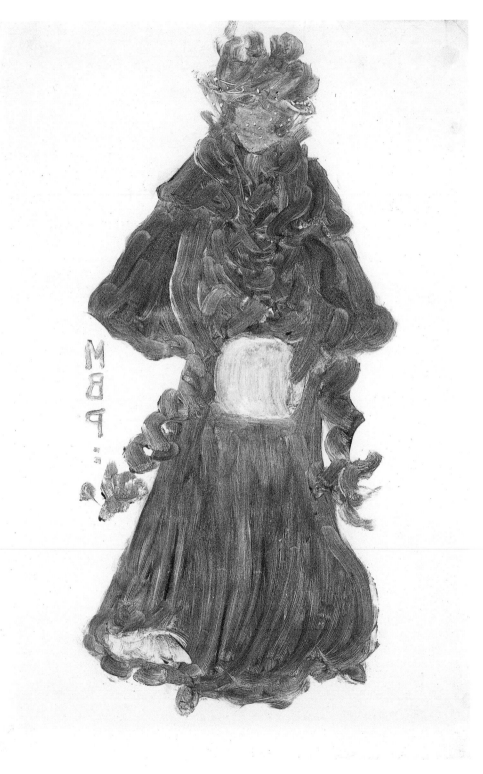

40.3 x 28.3 cm
15 7/8 x 11 1/8 in.

Red Cape 1891–1894 Signed, c.l.: "M B P"
 Monotype

Maurice Brazil **Prendergast**

St. John's, Newfoundland 1858–1924 New York City

Opal Sea, 1907–1910

When Maurice Brazil Prendergast suffered from a hearing loss in 1906, a doctor prescribed year-round nude bathing in Boston Harbor. The unusual therapy did not dramatically improve Prendergast's hearing, but it did provide him with an interest in the seashore as a subject for his art. Indeed, people relaxing along the shore would become a common theme in his later works. Prendergast, known primarily for his watercolors, devoted increasing attention to oil painting after his return from France in late 1907, incorporating elements of European modernism into his art. While still living in Boston, he exhibited with members of the Eight in their infamous 1908 exhibition and participated in the 1913 Armory Show in New York. In 1914 the artist moved to New York City, where he painted and exhibited until his death.

An artist friend of Prendergast, Charles Hovey Pepper (1864–1950), named *Opal Sea* when he purchased the work in 1910 and photographed it in Prendergast's studio. Pepper dated the picture to 1903–1906, but other experts believe a 1907–1910 date to be more accurate. The evocative title and inexact date of the work reflect Prendergast's painting methods around this time. He often made oil paintings that combined sketches of several beaches he had visited over the years. This picture may be a composite of different locations, although one author has suggested City Point Boston as its locale. Prendergast also reworked his canvases over several years, building up layers of paint, making it difficult to assign a definitive date to a work. In this picture, traces of yellow paint on top of areas of pale blue and green may have been an afterthought applied months, even years, later.

Opal Sea continues the experimentation Prendergast made in St. Malo in 1907 (p. 143) and demonstrates tendencies that would recur for the rest of his career—the desire to combine scenes of real life with an expressive style. *Opal Sea* represents a transitional moment in Prendergast's œuvre. The deep space and broad, regular brushwork in the sea and sky, typical of his earlier works, contrasts with the flattened space and rough, overlaid brushwork in the foreground. Despite such juxtapositions, Prendergast achieved an overall harmony in the picture. The rhythmic pattern of thick brushstrokes, the carefully balanced color scheme, and the repeating forms (three donkeys moving left to right, several groups of women moving right to left) all contribute to a balanced, stable composition.

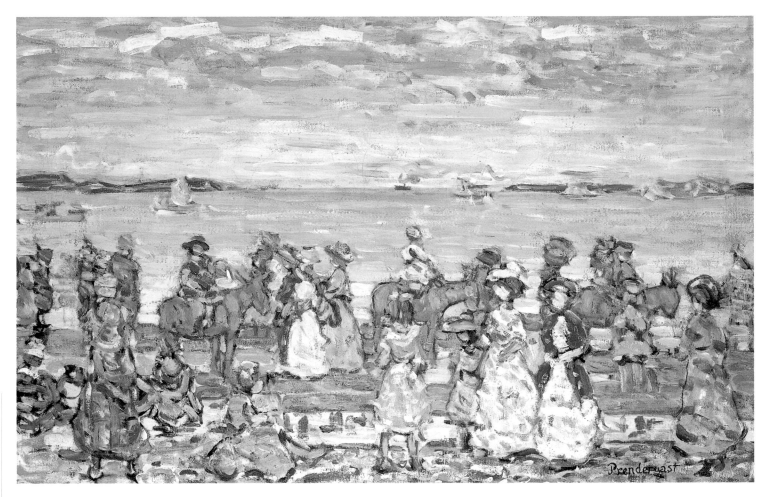

55.9 x 86.7 cm
22 x 34 1/8 in.

Opal Sea

1907–1910
Oil on canvas

Signed, l.r.:
"Prendergast"

Maurice Brazil **Prendergast**
St. John's, Newfoundland 1858–1924 New York City

St. Malo, about 1907

In May 1907, already gaining attention in the United States for his colorful watercolor scenes of modern life, Maurice Brazil Prendergast set sail for France. He had visited several coastal resorts in Normandy and Brittany fifteen years earlier and wanted to paint there again. He also traveled to Paris, however, where he visited important modernist exhibitions including the Champ de Mars, the Salon d'Automne, and two exhibitions devoted to the work of Paul Cézanne (1839–1906). In letters home to his brother, Prendergast wrote enthusiastically about the exciting artworks he saw and described the new forms and bright colors of avant-garde painting. These few months in France represent an active time of experimentation in Prendergast's œuvre (in five months he painted fifty oil paintings and sixty watercolors, over half of which were executed in St. Malo). The trip resulted in a mid-career shift in style as Prendergast moved toward expressive colors and flattened space.

When Prendergast arrived in St. Malo on the northern coast of France for the month of August, he integrated the new styles he had seen in Paris in a series of watercolors and oil paintings. *St. Malo*, one of the most

abstract watercolors from this trip, demonstrates a link to the colorful divisionist works of Paul Signac (1863–1935) and Henri-Edmond Cross (1856–1910). In turn, the flattened space, solid clouds, and areas of unpainted white paper recall Cézanne's watercolors.

In *St. Malo* the town is seen from an elevated distance and divided into three horizontal areas: the sky filled with billowing clouds (typical of Brittany), the houses on the shore, and the sea. Other than the hint of a horse carriage in the lower right, the image is unpopulated. In this way, the work differs from the other watercolors Prendergast made in St. Malo that depict close-up views of crowded beaches. The free-flowing brushstrokes and distant viewpoint found in *St. Malo*, by contrast, mark it as an important experiment and a transition from Prendergast's earlier, more anecdotal scenes to his later, more stylized and expressive works. In *St. Malo*, Prendergast concentrated on an overall pattern of houses and trees and transformed the sky into an almost abstract swirl of paint. Loose, energetic brushwork and bright colors lend a dynamic feeling to the image.

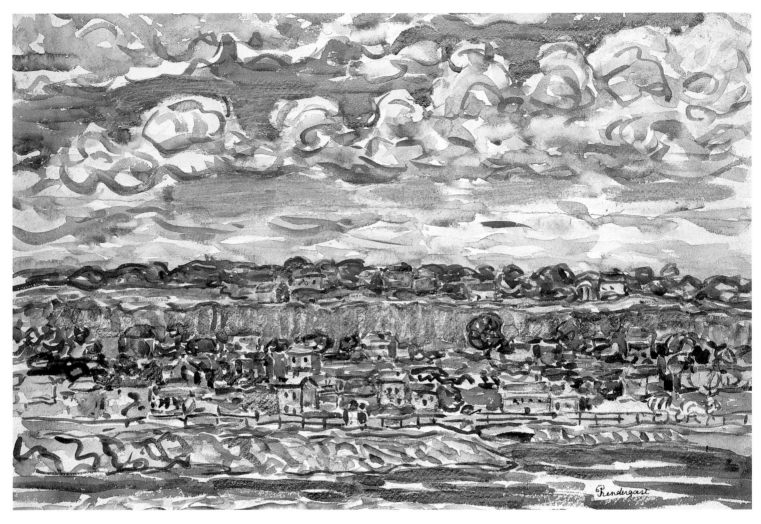

38.4 x 55.9 cm
15 1/8 x 22 in.

Sl. Malo

c. 1907
Watercolor and graphite
on paper

Signed, l.r.:
"Prendergast"

Frederick Carl **Frieseke**

Owosso, Michigan 1874–1939 Le Mesnil-sur-Blangy, France

Lady in a Garden, about 1912

Frederick Carl Frieseke was a leading member of the third wave of American artists who settled in Giverny in the early twentieth century. Along with painters Richard Miller (1875–1943), Guy Rose (1867–1925), and Karl Anderson (1874–1956; known for his painting of the *Tennis Court at Hôtel Baudy*, 1910, TFA 1992.175), Frieseke exhibited his impressionist works in the United States with "The Giverny Group." After studying at the School of Fine Arts in Chicago and the Art Students League in New York City, Frieseke attended courses at the Académie Julian in Paris from 1898 onward. Attracted by the artistic freedom and stimulation he found in Paris, he settled permanently in France. Frieseke showed in exhibitions and acquired a certain notoriety that earned him various honors, including being named to the Légion d'Honneur in 1920.

From 1906 to 1919, Frieseke spent every summer at Giverny with his wife, Sarah. It was probably in their house's garden, tended by Sarah, that in 1912 he painted one of his finest works, *Lady in a Garden*, which is typical of Frieseke's mature style. The impressionist heritage is visible in his handling of the effects of light as colored brushstrokes—violet is used to convey shadows (such as the one on the woman's face), whereas colors in sunny zones are paler (such as the green of the bushes, which tends toward yellow).

However, though fond of variations in light, Frieseke accorded a greater role to female figures than to landscape in his paintings. Here the model is probably Sarah, whom he painted many times. Usually, women are depicted carrying out everyday activities, although they are sometimes portrayed nude outdoors highlighted by the rays of the sun, in the style of Pierre-Auguste Renoir (1841–1919).

Here Frieseke takes impressionist rules to their limits. The shimmering intensity of brushstrokes almost totally eliminates a sense of depth. The floral frills on the model's dress are barely distinguishable from the setting, a phenomenon intensified by flowers that lose their materiality by becoming simple spots of color—woman and flowers become one. This work, in a vertical format inspired by Japanese screens, thus resembles a decorative panel, not unlike certain contemporary works by Nabi painters such as Pierre Bonnard (1867–1947) and Édouard Vuillard (1868–1940).

Frieseke's important role in the colony of American artists at Giverny, along with the decorative aspect of his work, spurred Daniel J. Terra to acquire seven of his paintings.

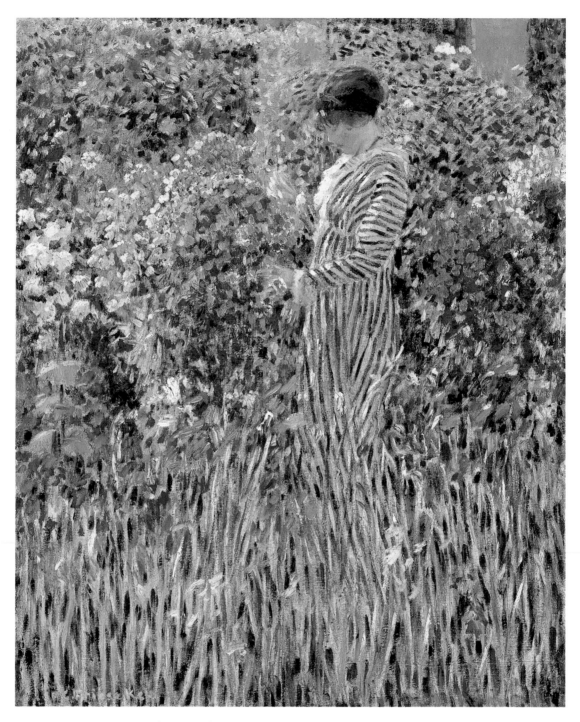

81 x 65.4 cm
31 7/8 x 25 3/4 in.

Lady in a Garden

c. 1912
Oil on canvas

Signed, l.l.:
"F. C. Frieseke"

Thomas **Eakins**
Philadelphia 1844–1916

Portrait of Thomas J. Eagan, 1907

Having completed studies at the Pennsylvania Academy of the Fine Arts in his native city of Philadelphia, Thomas Eakins left for Paris in 1866 to further his academic training at the École des Beaux-Arts in the studio of Jean-Léon Gérôme (1824–1904). During his three years of study there, Eakins became especially attuned to Gérôme's teaching method of drawing and painting after the nude model and learned to consider the depiction of the human figure as the basis of art. On his return to Philadelphia, he began an ambitious painting career, creating some of the most iconic works of American art, the importance of which were not always understood during his lifetime. Simultaneously, he devoted himself to teaching, first at the Pensylvania Academy of the Fine Arts from 1879 to 1886, and later at the Art Students League of Philadelphia and New York. Eakins was forced to resign his position as the Pensylvania Academy of the Fine Arts' School Director and Professor of Painting for multiple reasons, including the use of a nude male model in a mixed-gender classroom. Lauded by critics near the end of his career as the exemplar of American realism, Eakins remained committed to truthful representation.

Portrait of Thomas J. Eagan highlights the exceptional bond that Eakins' investment in teaching inspired. One of Eakins' most loyal students, Eagan left the Academy when Eakins was dismissed. Eagan helped found the Art Students League of Philadelphia, participated in the photographic sessions of nude modeling that Eakins organized there, and later acted as pallbearer at his mentor's funeral. Painted twenty-five years after their friendship began, *Portrait of Thomas J.*

Eagan testifies to a long alliance between master and pupil, even after the latter had given up his ambition to become a professional painter for a career as a mechanical engineer. The artist's unusually conspicuous inscription, located just below Eagan's ear and reading, "To his friend and pupil, Thomas Eakins 1907" underscores this close relationship between teacher and student.

But the work also fits into a series of pictures of family, friends, and pupils that constitute the major corpus of the artist's oeuvre. Contemporaries were struck by a certain stiffness in Eakins' pictures and contrasted them with the animated portraits of the other great American portraitist of his time, John Singer Sargent. The portrait of Thomas Eagan is exemplary of the restraint Eakins achieved in his work. In keeping with his formula for head-and-shoulder portraits, he positioned his sitter against a neutral background to focus better on the face, turned in a three-quarter profile. No expression discloses the individual's inner feelings. The penetrating intelligence that the eyes convey creates an almost uncanny awareness of the mind that is housed within this static body. Eakins uses the tension between immobile posture and alert gaze to suggest the conflict engendered between the sitter as an object of visual inspection and the sitter as a human being whose inner self forever eludes scrutiny. It is this inner tension that makes Eakins' work a rare example in the Terra Foundation for the Arts collection of the power that realist portraiture could still have at a time when new pictorial tendencies began to explore the abstraction of the human figure.

61 x 50.8 cm
24 x 20 in.

Portrait of
Thomas J. Eagan

1907
Oil on canvas

Signed, dated, and
inscribed, c.r.:
"to his friend and pupil
Thomas Eakins 1907"

George Wesley **Bellows**

Columbus, Ohio 1882–1925 New York City

Nude Girl, Miss Leslie Hall, 1909

1. Quoted in Emma Bellows, et al., *The Paintings of George Bellows.* (New York: Alfred A. Knopf, 1929), viii.

2. Peyton Boswell Jr., *George Bellows.* (New York: Crown Publishers, 1942), 10.

In his short career George Wesley Bellows earned critical acclaim through participation in both vanguard exhibitions (such as the 1913 Armory Show) and those hosted by the comparatively conservative National Academy of Design. He also proved adept in multiple media, becoming an expert printmaker and illustrator. However, Bellows' best-known works remain his paintings, in particular the six forceful images of boxers including *Stag at Sharkey's*, 1909 (The Cleveland Museum of Art). Always in search of ideas amid the streets and docks of New York City, Bellows wrote that "good painting is the emotional heightening of form by the use of the powers, relations, and significance of colors . . . [and] anything, in fact, which has the power to hold human attention, may be the subject of a work of art."[1]

Structured by a series of triangles, *Nude Girl, Miss Leslie Hall* demonstrates the artist's predilection for working out a strict geometric scaffolding on which to hang his compositions. Faithful to the innovations of his teacher Robert Henri, Bellows pointedly refrained from idealizing his model; her apparently natural, self-protective pose seems to refute the alternately melodramatic or coquettish attitude of the traditional academic nude. With the contrast of pale rosy tints against a lush green backdrop, the artist celebrates the model's flesh and form, even as his confident brushstrokes roughen and rumple her silhouette, and her frank but deferential gaze is perhaps intended to suggest her position as a paid employee. This point was not lost on Bellows' American audience. In the decades immediately following his sudden death from a ruptured appendix, leading critics embraced what they saw as his attempt to democratize fine art through his unglamorous choice of subjects. The editor of *Art Digest*, Peyton Boswell Jr., for example, declared that, "[e]ntering the art arena in an era of pretty pictures, Bellows, with blunt contempt for the accepted way, broke open the doors of the proverbial Ivory Tower and invited the people to participate."[2]

To see the humane implications of Bellows' psychological portrayal of his model one need only turn to the mask-like countenance of John D. Graham's nude in *The Green Chair*, 1928 (p. 177), or the expressionless cipher of the dancer's face in Robert Henri's *Figure in Motion*, 1913 (p. 155).

152.4 x 106.7 cm
60 x 42 in.

Nude Girl,
Miss Leslie Hall

1909
Oil on canvas

Signed, l.r.: "Geo. Bellows,"
signed and inscribed with
various notations, on verso

George Wesley **Bellows**
Columbus, Ohio 1882–1925 New York City

The Palisades, 1909

In 1904, with earnings saved from playing semi-professional baseball, George Wesley Bellows left his home in Columbus, Ohio, to pursue a career in art in New York City. For the next several years he studied with the painter Robert Henri at the New York School of Art, eagerly absorbing both his teacher's tonalist approach to color and realist devotion to socially potent, primarily urban, subjects. The year 1909 brought Bellows' first artistic successes: the Pennsylvania Academy of the Fine Arts acquired his *North River*, 1908, a winter landscape like *The Palisades*; and he was elected a member of the National Academy of Design.

The Palisades combines flat, conspicuous surface texture with intricately calculated spatial depth. Bellows plays expertly with scale yet remains firmly within the bounds of realism. At first glance, wide brushstrokes, such as the one exuberant, frosty stroke marking the snow atop the cliffs across the river, belie the breadth of the scene. Similarly, the artist has created visual tension through

the initially surprising comparative size of the two figures strolling in relation to the nearby lamppost, or the enormous tree trunk on the left juxtaposed with the distant boathouse behind. It is only after the viewer explores each distinct area of the canvas that the landscape resolves into a coherent and balanced whole. Windblown steam from a tugboat and the suggestion of a train on the opposite shore provide the only relief from the crystalline stillness of the winter day.

Bellow's treatment of the bleak winter landscape in *The Palisades* is surprisingly masculine in contrast to the decorous and gentle winter depicted in John Twachtman's impressionist *Winter Landscape*, 1890–1900 (p. 119). Fellow urban realist George Luks mimics the rough brushwork of Bellows, but his high-keyed palette in *Knitting for the Soldiers: High Bridge Park*, about 1918 (p. 153) imbues the winter scene with a sensibility that conveys a hardiness of the female spirit.

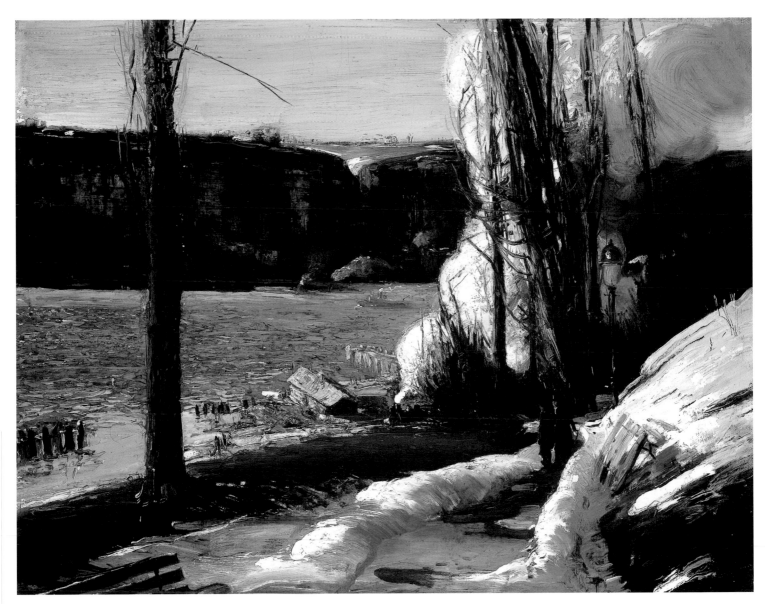

76.2 x 96.8 cm
30 x 38 1/8 in.

The Palisades

1909
Oil on canvas

Signed, l.l.:
"Geo. Bellows"

George Benjamin **Luks**

Williamsport, Pennsylvania 1867–1933 New York City

Knitting for the Soldiers: High Bridge Park, about 1918

Raised in the mining town of Shenandoah, Pennsylvania, George Benjamin Luks moved to Philadelphia in 1883. His art studies were intermittent, including a night class at the Pennsylvania Academy of the Fine Arts and brief enrollment in art academies in Düsseldorf, Munich, and Paris during an extended stay in Europe. When he returned to Philadelphia in 1894, he worked as an artist-reporter for the *Philadelphia Press* with such other artist-illustrators as Robert Henri, John Sloan (1871–1951), and William J. Glackens (1870–1938). After moving to New York City in 1896, Luks began to paint, depicting city life with the dark palette and blunt honesty of the circle of artists that became known as the Ashcan School. Luks was one of the Eight featured in an exhibition organized at the Macbeth Galleries by Henri in 1908.

Knitting for the Soldiers: High Bridge Park reveals a more genteel aspect of Luks' urban vision. In 1913 he moved from Greenwich Village to Upper Manhattan and turned his attentions from rough street life to the social activities in High Bridge Park, just minutes' walk from his studio. This gathering of women, each bent over her handiwork, was exhibited in 1918 simply as *Knitting for the Soldiers: High Bridge Park*, but in the fervor of the war effort, critics naturally assumed that the scarves and gloves were being made for soldiers. With a sharp reporter's eye, Luks records true-to-life details of costume and gesture. The women's garments are simple, yet fashionable enough to mark them as comfortably middle-class. They exchange neither a word nor a glance but work in silent camaraderie as if united in their endeavor.

Luks' vibrant palette marks a departure from his earlier dark tonality. With clear, yet nuanced colors, from the vivid yellow coat and red hat of the young woman at the left to the cool violet and blue shadows on the icy ground beneath the strollers, Luks captures the sensation of the brisk atmosphere and sparkling cold light of a winter's day. The high-keyed palette and unsentimental appreciation of mundane activities recall the scenes of modern life by the French impressionists. While never rejecting an urban point of view, Luks attained a more synthetic and balanced assimilation of European and American influence in his mature style.

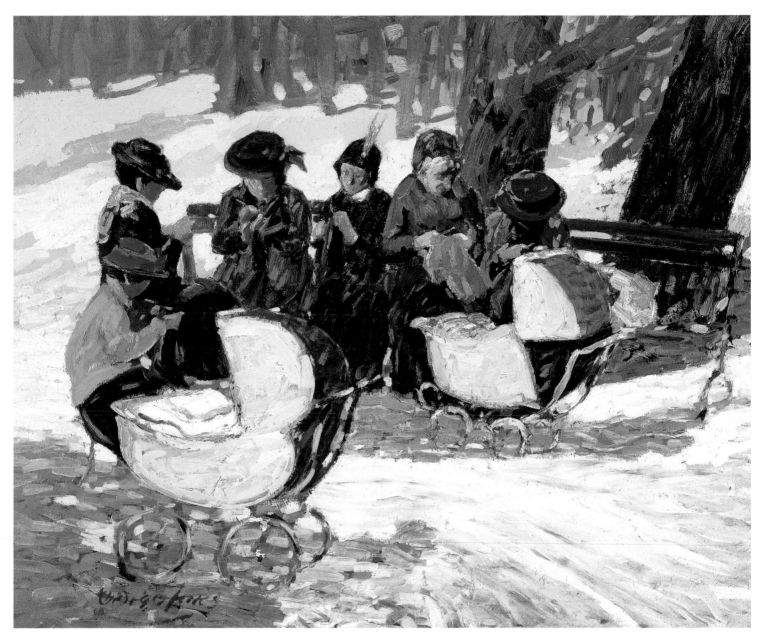

76.7 x 91.8 cm
30 3/16 x 36 1/8 in.

Knitting for
the Soldiers:
High Bridge Park

c. 1918
Oil on canvas

Robert **Henri**

Cincinnati, Ohio 1865–1929 New York City

Figure in Motion, 1913

1. Robert Henri. Compiled by Margery Ryerson, *The Art Spirit*. (Philadelphia: J. B. Lippincott Company, 1923), 39.

2. Ibid. 180.

"Exhibitions will never attract crowds or create any profound interest until there is in the works exposed evidence of a greater interest in the life we live."[1]

Though he studied at the Pennsylvania Academy of the Fine Arts, the Académie Julian, and the École des Beaux-Arts, Robert Henri came to be known for reacting against the conservatism of such established art institutions. His preeminence in pioneering an American "modernism" is indisputable. He organized and participated in such infamous independent exhibitions as *The Eight* of 1908 and the 1910 *Exhibition of Independent Artists* ("no jury, no prize"), as well as being a well-respected teacher and mentor of such artists as John Sloan (1871–1951), George Bellows, and George Luks. Henri's espousal of a personal approach to art was rooted in his belief that each idea for an object "must come of the artist's understanding of life and be a thing he greatly desires to say."[2]

Instrumental in establishing "urban realism" as a respectable subject matter for American artists, Henri turned to a more universal theme for his full-length *Figure in Motion*. He prepared this ambitious canvas for the famed *International Exhibition of Modern Art* of 1913—the Armory Show—where Henri hoped it would illustrate the competence and modernist vision of American artists at the time. Henri begins with the traditional subject of the nude human body, which he viewed as the most "beautiful and significant of the laws of the universe," but rejects an academic or idealized approach. The simple background, solidity of figure, rendering of gesture, color arrangement, and bravura brushwork demonstrate Henri's dicta as an artist and teacher, chronicled in his seminal book of 1923, *The Art Spirit*. Through such elements he sought to capture the "constant motion" of human life. Henri's expression of such modern concerns as time and the flux of being, however, proved too subtle, and in turn his painting was upstaged at the exhibition by the more avant-garde works of European artists, most notably Marcel Duchamp's *Nude Descending a Staircase, No. 2*.

Historically important for its inclusion in the Armory Show—one of five works by Henri exhibited there— and exceptional in his œuvre, *Figure in Motion* complements two late nineteenth-century depictions of Paris' urban scenes by Henri in the Terra Foundation for the Arts collection. It also serves as a counterpoint to the equally monumental and less idealized 1909 portrait by George Bellows, *Nude Girl, Miss Leslie Hall*, 1909 (p. 149).

Marcel Duchamp,
Nude Descending a Staircase No. 2,
1912, oil on canvas,
147.2 x 88.9 cm
(58 x 35 in.).
Philadelphia Museum of Art,
The Louise and Walter Arensberg Collection

196.2 x 94.6 cm *Figure in Motion* 1913 Signed, l.r.
77 1/4 x 37 1/4 in. Oil on canvas

Arthur Garfield **Dove**

Canandaigua, New York 1880–1946 Huntington, New York

Sails, 1911–1912

Between 1910 and 1911—perhaps a full year before the Russian painter Wassily Kandinsky (1866–1944) created his famous *Improvisations* (regarded by many as the first truly abstract European paintings)— an unknown American artist named Arthur Garfield Dove executed a landmark series of works in pastel that included *Sails*. Starkly geometric, full of motion, and saturated with brilliant color, the pastels were exhibited the following year in New York City under the banner *The Ten Commandments* by the charismatic photographer-dealer and Dove's lifelong friend, Alfred Stieglitz (1864–1946), at his New York gallery, 291. Although several works from the series have disappeared, it is known that all ten were lively and sensuous distillations of the fundamental shapes and

patterns the artist had perceived in nature. Fresh from a fifteen-month painting trip to France, Dove aimed to depict the movement and interrelationships of natural elements rather than their straightforward appearance. *The Ten Commandments*, in fact, marked perhaps the earliest application of recent European modernist experiments to the American landscape. Yet decades would pass before Dove, who at that time made his living as an illustrator and chicken farmer, was seen as a pioneer of American modernism.

Like other works in the series, *Sails* derives much of its tension and excitement from the juxtaposition of contrasting shapes and colors: angular sail-like shapes of pale yellow and rich brown sweep and spike across darker, rounder forms of blue and green in a fast-moving composition suggestive of powerful wind and heaving water. Though Dove had not abandoned all pictorial convention (the shapes are still layered from the foreground backward to produce an illusion of depth), he dispensed with a single horizon line in favor of dramatic, allover, tossing movement.

Arthur G. Dove, *Nature Symbolized #3: Steeple and Trees*, 1911–1912, pastel on board mounted on panel, 45.7 x 54.6 cm (18 x 21 1/2 in.). TFA, Daniel J. Terra Collection 1992.33

Remarkably, the Terra Foundation for the Arts collection holds another work from the important *Ten Commandments* series, *Nature Symbolized #3: Steeple and Trees*, 1911–1912. This work is particularly interesting in Dove's application of the language of cubism to the combined subject of both man-made and natural forms.

45.4 x 54.6 cm *Sails* 1911–1912 Signed, l.l.: "Dove"
17 7/8 x 21 1/2 in. Pastel on composition
 board mounted on panel

Arthur Garfield **Dove**

Canandaigua, New York 1880–1946 Huntington, New York

A Walk: Poplars, about 1912–1913

1. Quoted in Debra Bricker Balken et al., *Arthur Dove: A Retrospective*, exh. cat., (Andover, Mass.: Addison Gallery of American Art, 1998), 24.

Despite critical interest in his inventive *Ten Command-ments* series of 1910–1911, financial hardship and an unhappy family life made the following ten years artistically unproductive for Arthur Garfield Dove. In 1920, however, he met and fell in love with the painter Helen Torr, who provided the steadfast faith in his artistic ability that he had been lacking, and the pair began an ascetic but mutually supportive existence together aboard a houseboat. At forty, Dove had made a firm break with his past. From this point until his death in 1946, with the encouragement of his friend and dealer Alfred Stieglitz (1864–1946) and the innovative art collector Duncan Phillips, Dove continued his search for new ways to depict and celebrate the structural complexity and sensual experience of nature through color and form.

A Walk: Poplars exemplifies Dove's unique practice of conflating macro- and microscopic natural shapes to produce a fresh but archetypal abstract composition: the plantlike forms of saturated black, green, yellow, and blue might represent the anatomy of a single leaf or a whole landscape. Moreover, with its dominant central trunk and variety of implicitly biological shapes, *A Walk: Poplars* may reveal Dove's interest in exploring

sexuality through his art. Critics enthusiastically took up this theme during the 1920s and contrasted his phallic imagery with the "feminine" forms of another devoted painter of nature, Georgia O'Keeffe (1887–1986).

Dove's work continues a tradition of enduring reverence for nature evident throughout American landscape painting, irrespective of style or form. However, for Dove as for many modernists, neither belief in Manifest Destiny nor a metaphysical awareness of man's integrated place in nature could inspire novel depictions of water, land, and sea as they had a century before. Only sensual experience mattered, and in his art Dove aimed to replace old artistic theories with sheer exuberance. "[T]he reality of sensation alone remains," he wrote. "It is that in its essence which I wish to set down. It should be a delightful adventure."[1]

The stimulus of European modernism and a commitment to distilling formal elements directly from nature such as those found in Dove's explorations permeated the Stieglitz circle, inspiring Charles Sheeler's early nature experimentation in *Flower Forms*, 1917 (p. 163), and Max Weber's *Construction*, 1915 (p. 165).

54.9 x 45.4 cm
21 5/8 x 17 7/8 in.

A Walk: Poplars

c. 1912–1913
Pastel on silk mounted
on board

Helen **Torr**

Roxbury, Pennsylvania 1886–1967 Bayshore, New York

Purple and Green Leaves, n.d.

In 1906, Helen Torr won a scholarship to study art at the Pennsylvania Academy of the Fine Arts, where she studied under William Merritt Chase. Later, through her marriage to Arthur Dove and their friendship with avant-garde artists such as Alfred Stieglitz (1864–1946), Paul Strand (1890–1976) and Marsden Hartley, Torr participated in the development of a uniquely American brand of modernism during the 1920s. These artists rejected the materialism of daily life and drew inspiration directly from nature. Torr's own paintings demonstrate her achievements in this effort: flattened, luminous still lifes of shells, plant parts, and rocks, which can be read as landscapes.

Purple and Green Leaves is an excellent example of Torr's interpretation of the American landscape. The arched and inset frame of the painting, reminiscent of a stained-glass window, as well as the suggestion of light glowing from within the arrangement of leaves lend a quietness and sense of the sacred to the otherwise mundane objects depicted. Torr remained closely attuned to the details of her natural surroundings, noting nuances of weather in her diaries and collecting leaves and flowers while on walks. The rich palette of *Purple and Green Leaves* reflects Torr's sensitivity and devotion to natural color.

Her unobtrusive pictures have often been overshadowed by the expansive floral paintings of her fellow artist and friend Georgia O'Keeffe (1887–1986). Both artists shared the goal to infuse the minutiae of natural objects with concentrated personal feeling. O'Keeffe supported Torr who was sometimes hesitant in her pursuit of public recognition and arranged for her work to be exhibited at the Opportunity Gallery in 1927 with that of other women artists. Such a public showing of her work, however, was rare in her lifetime; in fact, Torr's first solo exhibition did not occur until 1972, five years after her death.

Daniel J. Terra had a particular admiration for the work of women artists, purchasing examples of twenty-four American women artists for his collection, including Lilla Cabot Perry, Mary Cassatt, and Georgia O'Keeffe.

Georgia O'Keeffe, *Red Amaryllis*, 1937, oil on canvas, 30.5 x 25.7 cm (12 x 10 1/8 in.). TFA, Gift of Henrietta Roig C1984.1

51.4 x 38.7 cm
20 1/4 x 15 1/4 in.

*Purple and Green
Leaves*

n.d.
Oil on copper mounted
on board

Charles Rettew **Sheeler**
Philadelphia 1883–1965 Dobbs Ferry, New York

Flower Forms, 1917

Throughout a career that spanned four decades, Charles Rettew Sheeler distinguished himself as both a painter and a photographer, creating modernist canvases and black-and-white photographs that celebrated distinctly American architecture— Pennsylvania barns, New York City skyscrapers, and industrial landscapes. A Philadelphia native, Sheeler studied at the Pennsylvania Academy of the Fine Arts under William Merritt Chase from 1903 to 1906. His 1909 trip to Paris, however, introduced him to the radical early-twentieth-century French art of Paul Cézanne (1839–1906), Henri Matisse (1869–1954), and the cubism of Pablo Picasso (1881–1973) and provided a decisive turning point in his artistic development. Sheeler moved to New York City in 1919 and became an active member of the avant-garde art scene, participating in the salons of modernist collectors Walter and Louise Arensberg and establishing friendships with Marcel Duchamp (1887–1968), Alfred Stieglitz (1864–1946), and the poet William Carlos Williams.

Charles Scheeler, *Bucks County Barn*, 1940, oil on canvas, 46.7 x 72.1 cm (18 3/8 x 28 3/8 in.). TFA, Daniel J. Terra Collection 1999.135

This early work, part of a series of large-scale botanical studies, was originally titled *Forms–Flowers* and was exhibited in a one-person show organized by the artist and dealer Marius de Zayas (1880–1961) at the Modern Gallery in New York in 1920. Sheeler believed that all nature had an underlying abstract structure that the artist should search for and expose. While the lighting and contrasts give the abstracted still life a dramatic, almost eerie quality, the limited palette of ochers, browns, and greens maintains a consistent allusion to nature. For some scholars there is a correspondence in Sheeler's 1918–1919 photographs of a nude model (presumably his future wife Katherine) between the fleshy torso, thighs, and bent knees and the pliant shapes and voluptuous contours of *Flower Forms*.

Research has shown the importance of *Flower Forms* in Sheeler's œuvre as the summation of the artist's earliest modernist explorations, thereby becoming his last fully realized abstract composition. This dramatic close-up of indeterminate organic forms that undulate and intertwine in a sensual rhythm contrasts dramatically with Sheeler's mature works, which are characterized by an emphasis on formal reduction, rigorous structure, geometry, and a precise rendering of forms achieved by a hard-edged painting style. Prized by two of America's most prestigious modern art collectors, John Quinn and Earl Horter, *Flower Forms* has been neither varnished nor lined, and it retains its original frame.

Flower Forms is a definitive early work by Sheeler and provides an interesting counterpoint to his precisionist subjects as seen in *Bucks County Barn*, 1940, a late painting in the Terra Foundation for the Arts collection.

59.1 x 48.6 cm
23 1/4 x 19 1/8 in.

Flower Forms

1917
Oil on canvas

Signed and dated, l.l.:
"Charles Sheeler 1917"

Max **Weber**

Belostok, Russia [now Bialystok, Poland] 1881–1961 Great Neck, New York

Construction, 1915

1. Max Weber, "The Fourth Dimension from a Plastic Point of View," *Camera Work* 31 (July 1910): 25.

Max Weber's art reflects the cosmopolitan spirit of American modernism. The son of a Jewish tailor, he was born in Russia and came with his family to the United States at the age of ten. They settled in Brooklyn, and Weber enrolled at the Pratt Institute, where he studied with Arthur Wesley Dow (1857–1922). After graduating in 1900, Weber taught art in Lynchburg, Virginia, and Duluth, Minnesota, but the progressive formal ideas he had begun to explore as a student led him to travel to Paris in 1905. Over the next three years Weber immersed himself in all the controversial issues of modern art, and he moved among a stimulating and diverse circle of artists and intellectuals that included the author Gertrude Stein, the painter Robert Delaunay (1885–1941), and the self-taught artist Henri Rousseau (1884–1910). Weber was profoundly influenced by the underlying structure of the paintings of Paul Cézanne (1839–1906) and the early cubists as well as the expressive art of Henri Matisse (1869–1954). In 1908 he enrolled in Matisse's newly opened atelier, and when he returned to the United States one year later, Weber had a good understanding of modernist experimentation.

In *Construction*, Weber explored one of the visual assertions of European formalism, that time opens a fourth dimension to optical analysis. He articulated his theory in the July 1910 issue of Alfred Stieglitz's (1864–1946) journal *Camera Work*, stating that this fourth dimension was sensed through a "consciousness" of the extension of "space-magnitude in all directions at all times," and that it was manifest through the three better-known spatial dimensions. In comparing it to the tonal color of music, Weber asserted that the fourth dimension could be perceived relative to the physical presence of objects, and as the "ideal measurement" it demanded the imaginative considerations of artists.[1] The jagged and swirling forms of *Construction* convey this sense of the inherent motion of forms through time, countering the stable serenity of the traditional approach to composition.

Weber was not alone in his investigation of modernism. In *Painting No. 50*, 1914–1915 (p. 169), Marsden Hartley explored rhythm through color and decorative form, while in *Sails*, 1911–1912 (p. 157), Arthur Dove bridged the formal distance between nature and the abstract. But Weber's adamant nonobjective approach proved daring among even the most advanced of American modernists and appeared as groundbreaking as the early cubist paintings of Pablo Picasso (1881–1973) or the atonal musical compositions of Igor Stravinsky.

58.1 x 70.8 cm
22 7/8 x 27 7/8 in.

Construction

1915

Oil on canvas

Signed and dated, l.r.:
"Max Weber 1915"

Lyonel **Feininger**
New York City 1871–1956

Denstedt, 1917

1. Quoted in Hans Hess, *Lyonel Feininger*. (New York: Harry N. Abrams, 1961), 78.

Although Lyonel Feininger was born and died in the United States and considered himself an American, he spent almost half a century in Europe, mostly in Germany. Allied with modernist art movements there, Feininger sought to distill essential truths through his ethereal visions of reality in his watercolors, prints, and oil paintings.

Denstedt reveals the influence not only of cubism but of Feininger's early training and work as a graphic artist. His work is characterized by the flattening and abstracting of objects into series of planar forms defined by sharp, angular lines and subtly modulated color. A sense of rhythm and counterpoint, legacy of the artist's intense early schooling in music, govern the works' arrangement. Feininger used this sensibility in his frequent treatment of archaic architecture and townscapes; like the Russian-born artist Marc Chagall (1887–1985), he infused his interpretations with nostalgia, fantasy, and mystery. In *Denstedt*, however, Feininger uses formal means to impose a sense of larger tragedy on an image of the German townscape.

Denstedt is a suburb of Weimar, an area Feininger began visiting in 1913 and continued to paint during the years of World War I. Punctuated by suggestions of windows, doorways, towers, and angled walls, *Denstedt* describes the physical experience as well as the visual reality of the townscape, unpopulated except for the shimmering figure of a striding, hatted man near the bottom edge. In this work of 1917, the nervous, jagged edges of fragmented forms and the unsettling intensity of the acidic colors evoke the specter of the ongoing war that was beginning to bring hardship to Germans on the home front, including Feininger himself. The year 1917 witnessed the added tragedy of outright conflict between Germany and the United States—the two nations with which the artist identified. In March of that year he wrote, "the terrible events in the world weigh on us and leave dark traces in my work."[1] An image of prosaic urbanism charged with disquietude, *Denstedt* seems to express the artist's personal distress over contemporary events.

While many works in the Terra Foundation for the Arts collection demonstrate the powerful artistic connections between the United States and France, Feininger's *Denstedt* exemplifies the less-recognized ties between German and American art. Daniel J. Terra's acquisition of the painting in 1988 demonstrated his concern for expanding the boundaries of the collection to include significant examples of early modernism.

87.3 x 118.4 cm
34 3/8 x 46 5/8 in.

Denstedt

1917
Oil on canvas

Signed and dated, u.l.:
"Feininger 17"

Marsden **Hartley**

Lewiston, Maine 1877–1943 Ellsworth, Maine

Painting No. 50, 1914–1915

1. Quoted in Roxana Barry, "The Age of Blood and Iron: Marsden Hartley in Berlin," *Arts Magazine*, 54, no. 2 (October 1979): 168.

After studying in Cleveland and New York City, Marsden Hartley exhibited his work in Alfred Stieglitz's (1864–1946) 291 Gallery as early as 1909. Thanks to Stieglitz, in 1912 Hartley was able to leave for Europe, living first in Paris (where he met Gertrude and Leo Stein) and later in Berlin (where he exhibited with members of the Blue Rider group). In 1914–1915, he executed a series of highly colored, abstract paintings inspired by Native American imagery and later by German army uniforms. Hartley returned to New York City in 1916, showing fifteen of his German works at 291. He was back in Europe between 1921 and 1929, painting remembered landscapes of New Mexico as well as Cézannesque views of Provence. In 1933–1934 he painted the mountains of Bavaria. Landscapes and portraits done by Hartley after 1918 are characterized by their thick brushwork and their monumental, simplified—almost archaic—construction.

Hartley's attraction to German expressionism dates from 1912, when he was still in Paris, thanks to his friendship with German sculptor Arnold Rönnebeck (1885–1947). He was therefore perfectly familiar with the spiritual theories of Wassily Kandinsky (1866–1944) and the Blue Rider group when he moved to Berlin in May 1913, showing with the group at the Neue Herbstsalon in September of that year. After his return from New York City, Hartley stopped briefly in Paris—where he admired the work of Robert Delaunay (1885–1941) at the Salon des Indépendants—before returning to Berlin, where war fever was beginning to mount. There he executed another series of paintings inspired by Native American imagery, a theme that probably allowed Hartley to devise a kind of national primitivism, a return to American sources. The series was titled Amerika, and certain works such as *Indian Fantasy* (North Carolina Museum of Art, Raleigh) and *American Indian Symbols* (private collection) contain teepees, eagles, canoes, and feather headdresses—probably seen in Berlin's ethnographic museum—that make it possible to identify the subject matter accurately. In others, such as *Painting No. 2 (Arrangement, Hieroglyphics)* at the Museum of Fine Arts in Boston, and *Painting No. 50*, shown here, the composition tends toward greater abstraction. Here canoe and eagle wings merge, and are affixed to the tip of the teepee like insect wings; the repeated motif of the tent, handled in broad washes of coarsely applied paint, henceforth functions only as a kind of central graphic element. The raw originality of Hartley's works stems from their flat construction, the almost childish simplicity of strictly symmetrical motifs, and the use of primary colors. As Hartley wrote to Stieglitz in May 1913, "I only know that when the thought 'golden triangle' comes into my mind— I 'see' that triangle—I have a real vision of it."[1]

In 1986, Daniel J. Terra bought a series of highly important modern paintings from the collection of Rolf Weinberg, including works by Marsden Hartley, Patrick Henry Bruce, and Stuart Davis. At the time, Daniel J. Terra sought to extend his collection into the first half of the twentieth century, with a view to moving the collection to a new site in downtown Chicago. The acquisition of Hartley's *Painting No. 50* was complemented by the 1994 purchase of a pastel from 1918, *New Mexico Landscape* (TFA 1994.19).

119.4 x 119.4 cm
47 x 47 in.

*Painting
No. 50*

1914–1915
Oil on canvas

Patrick Henry **Bruce**

Long Island, Virginia 1881–1936 New York City

Peinture (Painting), 1917–1918

1. Patrick Henry Bruce to Henri-Pierre Roché, March 17, 1928, quoted in William C. Agee and Barbara Rose, *Patrick Henry Bruce: American Modernist* (New York: The Museum of Modern Art, 1979), 222.

"I am doing all my traveling in the apartment on ten canvases. One visits many unknown countries in that way."[1]

It was only in 1902 that Patrick Henry Bruce—a descendant of American revolutionary hero Patrick Henry—moved to New York City to devote his life to painting. He studied at the New York School of Art under William Merritt Chase, then under Robert Henri, leader of the Ashcan school. Early in 1904, Bruce moved to Paris, where he exhibited at the official Salon and the Salon d'Automne that same year. When Edward Steichen (1879–1973) founded the New Society of American Artists in Paris in 1908, he was joined by John Marin, Max Weber, and, Bruce. Through Gertrude and Leo Stein, Bruce met Henri Matisse (1869–1954) in 1907 and Robert (1885–1941) and Sonia Delaunay (1885–1979) in 1912. His affinities with the Delaunays were soon reflected in his pre-war paintings of which few survive. Starting in 1917, his painting evolved anew, leading to his mature style. Influenced by Juan Gris' (1887–1927) purification of cubism and perhaps by the Italian metaphysical art seen in the Paris Salons from 1914 onward, Bruce produced a series of still lifes pared down to abstraction, all inevitably titled *Peinture* or *Nature morte* (Still Life). In these works, it would seem that the geometric patterns which Bruce endlessly combined, shifted, and re-colored derived from real objects that he continually re-arranged on a table.

The rules obeyed by all his still lifes are set out in this example, generally considered to be one of the earliest in the series. The ground of the canvas is decorated in vertical stripes of uneven width. Here they encounter three horizontal bands. In the foreground is a kind of table on which are placed pure volumes, formed by the intersection of two or three colors. A single color defines the surface of each object, with no modeling. Meanwhile, realistic perspective is denied through the absence of a vanishing point, imitating the technique of architectural drawings in which the back of objects appears at the same height as the front. The viewer's perception thus navigates between recognition of an abstract composition (structured as a function of the economy of the painted surface) and a temptation to position the eye in space (to identify and situate the objects in relation to one another); the physical layer of paint and the subtle arrangement of colors push in one direction, the volumetric impact in the other. This vacillation between an aesthetic eye that remains on the surface and a normal eye that seeks depth is what lends strength to Bruce's paintings. In addition, it was perhaps an elegant solution to the general vacillation in the inter-war period between a return to classicism and a loyalty to the avant-garde heritage. The paintings Bruce showed at the Salon d'Automne, the Salon des Indépendants, and the exhibition *L'Art Aujourd'hui* in 1925 generated no interest from either the general public or the avant-garde, which found them too decorative. In 1933 he destroyed all the paintings remaining in his studio, apart from twenty-six still lifes that he gave to Henri-Pierre Roché. Thus it was empty-handed that the proud artist left Paris in 1936 for New York City, where he lived with one of his sisters, and shortly afterward took his own life.

65.1 x 81.6 cm
25 5/8 x 32 1/8 in.

Peinture (Painting)

1917–1918
Oil and graphite on canvas

Inscribed upside down, on verso: "Ceci est un/Patrik [*sic*] Bruce/H P Roché"

Charles Henry **Demuth**
Lancaster, Pennsylvania 1883–1935

Welcome to Our City, 1921

1. Quoted in Emily Fanham, *Charles Demuth: Behind a Laughing Mask* (Norman: Oklahoma Press, 1971), 136.

Charles Henry Demuth studied at the Pennsylvania Academy of the Fine Arts from 1905 to 1910 under Thomas Anshutz (1851–1912), one of the main disciples of Thomas Eakins, then took courses from 1912 to 1914 at both the Académie Colarossi and the Académie Julian in Paris. That was where he met Gertrude and Leo Stein and, through them, Marcel Duchamp (1887–1968) and Marsden Hartley. The latter introduced Demuth to Alfred Stieglitz (1864–1946) on his return to New York City. Via Duchamp, Demuth also made contact with the Dada circle around Walter and Louise Arensberg. During this early part of his career, the incisive draftsmanship of his watercolors, still lifes, and flower or figure studies recalled German expressionism, while their flat construction suggested the influence of Auguste Rodin's (1840–1917) watercolors. Starting in 1916, Demuth introduced more precise geometry into his architectural views through angular beams that swept the space like spotlights. These works were labeled "Precisionist," as were those by Charles Sheeler.

In 1919, a shift from watercolor to gouache and then to oil paint enabled Demuth to give more opaque and solid volume to the shapes of the buildings of his hometown of Lancaster, Pennsylvania, which he repeatedly painted. The ironic or off-beat titles he gave to these paintings could be related to the Dada absurdity of his friends Francis Picabia (1879–1953) and Marcel Duchamp.

Demuth completed *Welcome to Our City* in Lancaster, on return from his final trip to Paris in August–November 1921; he had visited Europe one last time, knowing he was suffering from diabetes. His condition forced him to cut short his trip, and once back in Lancaster he wrote to Alfred Stieglitz: "What work I do will be done here; terrible as it is to work in this 'our land of the free.' . . . Together we will add to the American scene. . . ."[1]

This painting features the main dome of the Lancaster courthouse. The lower space weaves architectural elements together in a cubist manner, stressing their lines and planes. Above, the V-shaped lines of force encounter the curves of the dome, lending great dynamism to the composition. In the upper left corner, against a kind of black ground, letters appear. As in cubist works, the presence of lettering within representational space brutally reasserts the two-dimensional nature of the surface. If we nevertheless seek to decipher a meaning from the letters, potential permutations offer a privately ironic or Dada contrast to the solemnity of the title ("this is shit").

Welcome to Our City, originally in Alfred Stieglitz's personal collection, is one of three works by Demuth in the Terra Foundation for the Arts collection, along with *Rue du Singe qui Pêche*, 1921 (TFA 1999.44) and *Seven Plums in a Chinese Bowl*, 1923.

Charles Demuth, *Seven Plums in a Chinese Bowl*, 1923, watercolor and graphite on paper, 25.4 x 35.6 cm (10 x 14 in.). TFA, Daniel J. Terra Collection 1992.4

63.8 x 51.1 cm
25 1/8 x 20 1/8 in.

Welcome to Our City 1921
 Oil on canvas

Signed, l.l.:
"C. Demuth/1921"

Stuart **Davis**

Philadelphia 1894–1964 New York City

Super Table, 1925

Stuart Davis' mother was a sculptor, his father was art director of the *Philadelphia Press*, and his friends included John Sloan (1871–1951), George Luks, and Robert Henri. Having studied painting under Henri from 1909 to 1912, Davis' work remained close to the social realism of the Ashcan school until he discovered the European avant-garde at the Armory Show of 1913, where he exhibited five watercolors. Between 1915 and 1919, his paintings displayed the chromatic intensity and simplification typical of fauvist art. After the war, Davis became one of the American advocates of cubism, notably the work of Fernand Léger (1881–1955). He sojourned in Paris from June 1928 to August 1929.

Super Table could be seen as one of the potential outcomes of Davis' various reflections on modernism in art during the 1920s. Although influenced by theories on color, such as that of Hardesty G. Maratta, and form, notably Jay Hambidge's "dynamic symmetry"—popular in Henri's circle—Davis was wary of an overly strict application of theory.

The first thing we notice about the painting is a subject that directly alludes to synthetic cubism, especially a series of *Guéridons* (Pedestal Tables) by Georges Braque (1882–1963), which Davis probably saw in art magazines. Similarly, the combination of different viewpoints and the resulting distortion of planes points to the same influence. The rigorously symmetrical

balance that underpins this large canvas is obtained through a system of stacking the various motifs from the widest to the narrowest, from the simplest to the most elaborate. Meanwhile, the wholeness of the motifs, plus the almost mechanical application of paint (devoid of any traces of the brush), bring this work into the contemporary sphere of Purism. The challenge to conventional space is stressed by a use of color relatively independent of form, in an unusual palette of secondary colors. It was only two years later that Davis would paint his first *Eggbeater*, an abstract work that won praise from Fernand Léger during Davis' trip to Paris in 1928. Nevertheless, Davis' rejection of a strict progression from figuration to abstraction became apparent in the 1930 *Eggbeater No. 5* (Museum of Modern Art, New York), when he returned to the cubist motif of the pedestal table. Starting in the 1930s, the originality of Davis' œuvre crystallized around his use of subjects from contemporary American life, expressed through intense colors and two-dimensional forms, within complex compositions of great dynamism.

This monumental canvas, formerly owned by Rolf Weinberg, is the only work by Davis currently in the Terra Foundation for the Arts collection, except for *Rue des Rats*, 1929 (TFA 1996.68), a lithograph from Davis' Paris period, purchased in 1996 as part of a set of engravings and lithographs.

122.2 x 86.7 cm
48 1/8 x 34 1/8 in.

Super Table

1925
Oil on canvas

Signed, l.r.: "Stuart Davis,"
inscribed, on verso,
top of stretcher:
"Table Stuart Davis"

John D. **Graham** (Ivan Dambrowski)

Kiev, Russia [now Kiev, Ukraine] 1881–1961 London

The Green Chair, 1928

1. Quoted in Eleanor Green, *John Graham: Artist and Avatar* (Washington, D.C.: The Phillips Collection, 1987), 96.

2. Ibid., 38.

"Fewer and fewer people understand my Words and my Teaching, pretty soon no one and [I] will remain suspended alone, in a Frozen Zone. There are men whom few understand, there are men whom no one understands until future generation and there are men whom no one, Ever, understands or will understand."[1]

Born Ivan Dambrowski in Kiev, Russia, where he received a law degree, held public office, and served in the military, John Graham immigrated to the United States in 1920, settling in New York City and enrolling at the Art Students League two years later. A well-respected intellectual admired for his fluency in many languages and his knowledge of historical and contemporary theory, Graham kept company with such prominent art figures as Stuart Davis and later gave support to younger artists including Willem de Kooning (1904–1997) and Arshile Gorky (1905–1948). During his lifetime Graham also enjoyed the patronage of individuals such as Duncan Phillips and Etta and Claribel Cone, whose notable collections included the art of both the European and American avant-garde. In 1937 Graham published his seminal text *System and Dialectics of Art*, which espoused the expression of art in pure form and which became influential in the development of abstract expressionism.

Graham began painting at the age of thirty-six, and his 1928 canvas *The Green Chair* exemplifies his preoccupation, even at an early stage in his career, with formalist concerns. *The Green Chair* reflects his belief that "art is always a discovery, revelation, penetrating emotional precision, space and color organization."[2] Completed during a sojourn to Paris, the painting is one in a series of monumental nudes—many of which were exhibited in Graham's one-man show at the Galerie Zborowski in 1928—and is a testament to Graham's growing reliance on the female figure for artistic expression. In the work, the abstracted yet highly modeled nude female figure strikes a pose in classic profile, her mask-like face—a result of Graham's interest in and collection of African sculpture—a twist on the traditional depiction of the nude based on European models. Additionally, the work's title grants precedence to the color of the chair. Eschewing overt meaning, Graham's stylized forms, abstracted and compressed but still reading as three-dimensional shapes in space, are intended to elicit archetypal associations on a spiritual level. Graham continued to use the human figure throughout his artistic career as a point of departure, subsuming its importance yet never fully dissolving its form, as would a younger generation of artists including Graham's protégé Jackson Pollock (1912–1956).

Graham's role as art supporter, prolific writer, collector, art advisor, and artist is similar in profile to that of Albert E. Gallatin (1882–1952), whose abstract work *Room Space*, 1937–1938 (TFA 1999.56) is also in the Terra Foundation for the Arts collection. Gallatin's infamous Gallery of Living Art—opened in 1927 in New York City—showcased contemporary works of abstraction, examples of the ideas and objects that also interested Graham.

100.3 x 73.3 cm
39 1/2 x 28 7/8 in.

*The Green
Chair*

1928
Oil on canvas

Signed, dated, and
inscribed, u.l.:
"Graham Paris 1928"

John **Marin**

Rutherford, New Jersey 1870–1953 Cape Split, Maine

Brooklyn Bridge, on the Bridge, 1930

1. John Marin, in the foreword to his 1913 exhibition at 291 as quoted in John I. H. Baur, *John Marin's New York* (New York: Kennedy Galleries, 1981).

After working briefly as an architect, John Marin enrolled in the Pennsylvania Academy of the Fine Arts in Philadelphia and the Art Students League in New York City. He traveled to Paris in 1905 to study, especially etching. Marin stayed in Europe for five years and learned the visual vocabulary of Paul Cézanne (1839–1906) and cubism. On his return to New York City, he became an active member of the avant-garde circle surrounding the photographer Alfred Stieglitz (1864–1946), who was his lifelong dealer. In 1913 Marin exhibited ten watercolors at the Armory Show and had a solo exhibit at Stieglitz's gallery 291. After 1914 Marin summered in Maine, devoted to painting the sea and the rugged northern coast, and wintered in New York City. During his long and prolific career, he enjoyed a reputation as an important American artist and exhibited almost every year.

Marin loved the rhythm and energy of New York City in the 1910s and 1920s and often sketched as he wandered its streets. His early depictions of "my city" (as he referred to New York) appear naturalistic or expressionistic, while his later scenes introduce greater distortion and abstraction to better represent the intensity of the city. Along with the Woolworth Building, the Brooklyn Bridge became one of Marin's favorite subjects, and he painted it numerous times between 1912 and 1930. In *Brooklyn Bridge, on the Bridge*, two dominant elements counterbalance each other—the massive rectangular form of the bridge in the center with its pierced Gothic-style arches, and the round, bursting form of the sun to the right. The faceted geometric shapes and short parallel, and zigzag lines demonstrate Marin's interest in the shifting planes and deconstructed space of cubism and futurism. Diagonal lines and jagged forms add visual rhythm and encourage the viewer's gaze to move quickly around the work, just as visitors to New York follow the frenzy of the city.

Marin frequently spoke about the forces of the city and compared the constant motion he saw in the streets to the sounds of musical instruments. In 1913, in the preface to the gallery 291 exhibition catalogue, he wrote, "While these powers are at work pushing, pulling, sideways, downwards, upwards, I can hear the sound of their strife and there is great music being played. And so I try to express graphically what a great city is doing. Within the frames there must be a balance, a controlling of these warring, pushing, pulling forces. This is what I am trying to realize."[1] The dynamic composition of *Brooklyn Bridge, on the Bridge*, painted almost twenty years after this statement was written, realizes Marin's vision of the city. Its angular forms and uncertain perspective resemble many of Marin's other Brooklyn Bridge watercolors and prints, including *Brooklyn Bridge, No. 6*, 1913.

John Marin,
Brooklyn Bridge, No. 6,
1913, etching and drypoint,
27.3 x 22.4 cm
(10 3/4 x 8 13/16 in.).
TFA, Daniel J. Terra Collection
1995.15

55.2 x 67.9 cm
21 3/4 x 26 3/4 in.

Brooklyn Bridge,
on the Bridge

1930
Watercolor on paper

Signed and dated, l.r.:
"Marin 30"

Rockwell **Kent**

Tarrytown Heights, New York 1882–1971 Au Sable Forks, New York

Summer, Greenland, about 1932–1933

1. Quoted in Constance Martin, *Distant Shores: The Odyssey of Rockwell Kent*, exh. cat. (Berkeley: University of California University Press in association with the Norman Rockwell Museum, 2000), 30.

Rockwell Kent was a man of many talents and ideas whose versatility led to different vocations: artist, architect, carpenter, writer, freethinker, and non-conformist. He produced works in a wide variety of media and styles. In addition to painting in oil, he worked assiduously in the graphic arts—drawing cartoons for magazines, producing architectural renderings, designing advertisements and bookplates, and illustrating books to support his family of five children. He is perhaps best known for his powerful illustrations for the 1930 edition of Herman Melville's *Moby Dick*. Above all, however, the role that best defined Rockwell Kent was that of explorer. A modern Ulysses, Kent's travels took him to remote, climatically harsh, and sparsely inhabited regions like Alaska, Newfoundland, Tierra del Fuego, and Greenland in search of "the spirit-stirring glamour of the terrible."[1]

Summer, Greenland exemplifies Kent's skill at creating works of visual vitality and subtle social commentary. The cloudless sky, a pale gold tinged with blue, radiates a diffuse light that makes it difficult to decipher what time of day is depicted; the wan sky is suggestive of both the decline of the day and the continuous

daylight of a Greenland summer. The light from above sends long and deep shadows over the lichen-covered territory, creating a strong contrast in values. At the center of the work is a church-like structure— a community house, one of many built throughout Greenland by the government of Denmark to establish the Danish presence and to "educate" the indigenous population. The building is rendered in a deeply saturated red that calls attention to itself as the visual focus of the scene. The painting thus celebrates the eternal grandeur of nature against which man and his work appear insignificant, while also referring to the intrusive presence of an alien culture in a world where previously peace and contentment had reigned undisturbed.

Dated between the years 1932 and 1933, *Summer, Greenland* was most likely begun during Kent's 1931 trip and finished later at his studio in upstate New York, which was his habit with many of the Greenland paintings. This work echoes the bleakly alien but sublime landscapes by artists in the collection such as Frederic Edwin Church and William Bradford (1823–1892).

36.8 x 61 cm
28 x 44 in.

Summer, Greenland c. 1932–1933
Oil on canvas adhered
to panel

Signed, l.l.:
"Rockwell Kent";
inscribed: "To D…"

Reginald **Marsh**

Paris 1898–1954 Dorset, Vermont

Pip and Flip, 1932

New York City—vulgar, chaotic, and teeming with life—provided the urban realist painter Reginald Marsh with endless artistic inspiration throughout his career from the 1920s to the 1950s. Whether he worked in egg tempera, oil paint, Chinese ink, intaglio, or watercolor, the spectacle of humanity fascinated him. Marsh sought to depict life's seamy theater as he found it in the mobs on the subway, the shop girls on Fourteenth Street, the bums on the Bowery, the performers at burlesque houses, the taxi-dancers at dime-a-dance joints, and the throngs at Coney Island's beaches, amusement parks, and sideshows.

Unlike many of his subjects, Marsh was born into a wealthy family and educated at elite schools. After a brief sojourn in Europe, he studied at the Art Students League and kept a space at the Fourteenth Street Studio Building. During the Depression, while the majority of Americans struggled financially, Marsh had a modest income working as an illustrator for the *Daily News*, the *New Yorker*, and *Vanity Fair*, and an even bigger inheritance to live on.

This painting of Pip and Flip, freakish twins from Peru who performed in a Coney Island circus sideshow, is an early and superb example of Marsh's preferred subject and technique. An excellent draftsman, Marsh appreciated how the translucent layers of egg tempera—a medium introduced to him by Thomas Hart Benton (1889–1975) and one he employed throughout the 1930s—revealed his linear drawing beneath the color. Giant posters in the background advertise the bizarre carnival attractions, while an unruly crowd streams past in the foreground, creating a frieze of interconnected bodies. Space is compressed in this shallow stage-like arrangement—a distinctive feature of Marsh's compositions.

Marsh loved depicting the swirl of the crowd, and a dominant theme in his art was the voluptuous female form. The full figured "Marsh girl" was a spectacle of flesh and strident sexuality, evidenced by the scantily clad women on display. The parallel rhythm of women's legs in the center foreground combines with the energetic drawing to create a sexual undercurrent. The arabesque arms of two exotic dancers frame one of the twins as she rises above the crowd, her presence undetected by the mass of humanity below her.

During the 1930s many American artists turned away from the influence of European modernism and cultivated a style and subject that better reflected the mood of the Great Depression. Marsh's urban realist aesthetic found its counterpart in the regionalist or American Scene works by Grant Wood (1892–1942), Edward Hopper, and Thomas Hart Benton. *Pip and Flip*, along with other works by Marsh in the Terra Foundation for the Arts collection, exemplifies the disorientation and displacement of American social life during the Depression.

122.6 x 122.6 cm
48 1/4 x 48 1/4 in.

Pip and Flip

1932
Tempera on paper
mounted on canvas

Signed and dated, l.r.:
"Reginald/Marsh '32"

Walt **Kuhn**

Brooklyn, New York 1877–1949 White Plains, New York

Clown with Drum, 1942

An illustrator, printer, painter, sculptor, and art advisor to such collectors as John Quinn and Lillie Bliss, the versatile Walt Kuhn was also an avid supporter and promoter of contemporary art. Overseas in 1912 as executive secretary for the newly established Association of American Painters and Sculptors, Kuhn combed exhibition spaces in cities such as Cologne, Munich, Berlin, and Paris for art of the European avant-garde. The loans procured from this trip, together with notable examples of American art, formed the renowned *International Exhibition of Modern Art*—the 1913 Armory Show. Consisting of over 1,300 objects, the exhibition served as a watershed in the history of American art, bringing diverse trends in European modernism to the American public.

Kuhn's early interest in modernism slowly shifted, however, and by the early 1920s his focus was local; he created figurative work depicting the subjects around him in New York City. It is for this later work that Kuhn is best known, specifically his renderings of vaudeville actors and circus performers (about this time as well, Kuhn was writing, directing and designing stage productions for local and touring venues). His 1929 canvas *The White Clown*, first exhibited at the New York City exhibition *Paintings by Nineteen Living Americans*, heralded his mature style and drew comments of admiration for its economical use of form, masterful composition, and subtlety of color.

Clown with Drum is a remarkable example of Kuhn's noted subject matter that often earned him comparison to the French artist Henri de Toulouse-Lautrec (1864–1901). Joe Pascucciello, a local "bag-puncher," served as model and is portrayed in Kuhn's preferred style: instead of the big ring and the bright lights of the performance space, the viewer is given a glimpse behind the scene, a sensitive rendering from a privileged position shared by the artist. Critics often complimented Kuhn's refined depiction of the emotion of a subject, which sublimated the commonplace and conveyed a sense of compressed tension. His painting process was methodical: he followed preliminary drawings with watercolor sketches (occasionally oil sketches), and then applied background paint to tacked canvas and brought in his model. After completing the painting, Kuhn adjusted the canvas until he found the desired placement of the figure, then stretched and framed it; if the work was considered successful, he signed and dated it.

Seated with hands clenched and just barely fitting within the picture space, the clown evinces a potential of action and exemplifies Kuhn's expression of a psychological state of being through a "wonderfully ordinary" subject that became his trademark.

154.6 x 105.1 cm
60 7/8 x 41 3/8 in.

Clown
with Drum

1942
Oil on canvas

Signed and dated, l.r.:
"Walt Kuhn/1942"

Edward **Hopper**

Nyack, New York 1882–1967 New York City

Dawn in Pennsylvania, 1942

1. Edward Hopper, Record Book, II, p. 97, quoted in Gail Levin, *Edward Hopper: A Catalogue Raisonné* (New York: Whitney Museum of American Art, 1995), vol. 3, 294.

After initial training as an illustrator, from 1900 to 1906 Edward Hopper studied at the Chase School under such prestigious teachers as William Merritt Chase, Robert Henri, and Kenneth Hayes Miller (1876–1952). He then made three trips to Paris between 1906 and 1910, interspersed with visits to London, Amsterdam, Berlin, and Madrid. Yet it was not the avant-garde Hopper was seeking, but rather Dutch painting and impressionism. On returning to New York City, he made a living as a commercial illustrator, and took up engraving in 1915. A successful show of his watercolors at the Frank K. M. Rehn Gallery in New York City in 1924 enabled him to devote himself totally to painting. Hopper subsequently divided his time between New York and New England. Even though he has been labeled a painter of "the American scene," his style developed without any true link to either a national movement or a European avant-garde; it was characterized by introverted individuals, pictured alone within vast, highly constructed spaces painted as broad patches of lurid colors of highly contrasting luminosity.

In his record book, Hopper describes *Dawn in Pennsylvania*: "Platform concrete & floor of trunk cart—pale Nile green. Buildings beyond—gray. Roof of platform nearly black, girders under roof—black. Train rusty blackish brown. Tracks upper surface—burnt sienna dull. Rusty stains at left end of platform. The surface of concrete that turns down to track below—foreground—left corner. Sky—in angle between train & roof of building beyond—a luminous Chinese blue, paler below. Sky mostly covered with dark clouds—blackish dull blue purple."[1]

Although the terms initially seem flatly descriptive, like figures aligned in an account book, it provides a potential key for deciphering the painting. First of all, the order of description: Hopper begins with the most neutral and most central surfaces—ground and roof, one pale, the other dark—providing the general structure of the illusionist space that hollows the painting. Then come lateral elements: train, buildings, slope of the platform, and sky, all flanking this central hollow. Next we note the extreme precision of the terms used to describe shades of color: the luxuriant delicacy of the words themselves is striking—pale Nile green, rusty blackish brown, luminous Chinese blue. An entire play of colors and an entire conception of their arrangement emerge from an apparently dull and monochrome painting.

This painting is highly typical of Hopper's mature œuvre. The wide shape of the canvas, the contrasts of light and dark that structure it, and the central hollow all evoke a theatrical stage, and provoke similar effects—the audience waits in the darkness, eternally, for the show of artifice to begin. Everything creates a sense of endless suspense: the station as site of transit, dawn as a time of transition, the wide vista that urges train and cart, both partly out of frame, to lurch into movement.

61.9 x 112.4 cm
4 3/8 x 44 1/4 in.

*Dawn in
Pennsylvania*

1942
Oil on canvas

Signed, l.r.:
"Edward Hopper"

4

Appendix

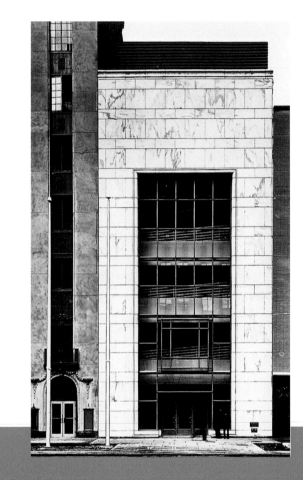

Terra Museum of American Art, Chicago

The documentation section of this catalogue, arranged alphabetically by artist's name, is as accurate and comprehensive as possible, thanks to the research efforts of numerous people, especially Laura Kalas. It is provided as a basis for future research on the collection. A selection of two or three bibliographic references follow each artist's name. These books and articles are among the most recent or important works on the artist (not the work of art) and are meant as a starting point for general research. Provenance listings provide names of previous owners and (whenever possible) cities and dates. In the case of exhibitions, the citation consists of the title (when known), the first venue, and the dates of presentation. Exhibitions with multiple venues are identified by [traveling exh.] and list only the first venue (in most cases, the organizer). When a catalogue was published to accompany an exhibition, it is indicated at the end of the citation by [catalogue]. Frequently cited exhibitions held at Terra Museum of American Art, and Musée d'Art Américain Giverny are identified by the name of the museum followed by a date and letter. A detailed list of these exhibitions can be found on this page.

Several abbreviations have been adopted: DJT Collection for Daniel J. Terra Collection, Chicago; TFA for Terra Foundation for the Arts Collection, Chicago.

Frequently Cited Exhibitions

Terra Museum of American Art, Chicago

Terra Museum of American Art 1987
A Proud Heritage: Two Centuries of American Art, April 21–June 21
[catalogue]

Terra Museum of American Art 1995
Attitudes Toward Nature,
September 30, 1995–April 21, 1996

Terra Museum of American Art 1996a
American Treasures: Chase, Whistler, and the Prendergasts,
April 27, 1996–January 5, 1997

Terra Museum of American Art 1996b
Visions of a Nation: Exploring Identity through American Art,
August 10, 1996–January 12, 1997

Terra Museum of American Art 1997a
Domestic Bliss: Family Life in American Art,
April 12–June 22

Terra Museum of American Art 1997b
American Artists and the French Experience,
April 12–August 27

Terra Museum of American Art 1997c
Selected Works from the Collections: Two Hundred Years of American Art,
April 12–August 27

Terra Museum of American Art 1997d
American Artists and the Paris Experience, 1880–1910,
November 22, 1997–March 8, 1998

Terra Museum of American Art 2000a
Figures and Forms: Selections from Terra Foundation for the Arts Collection,
May 11–July 9

Terra Museum of American Art 2000b
New Faces, New Places: Recent Additions to the Terra Foundation for the Arts Collections,
October 14–December 31

Terra Museum of American Art 2001a
On Process: Studio Themes,
January 13–March 4

Terra Museum of American Art 2001b
Selections from the Permanent Collection: Two Centuries of American Art,
March 10–July 8

Terra Museum of American Art 2001c
Selections from the Permanent Collection: American Moderns,
July 14–October 7

Terra Museum of American Art 2001d
(Re)Presenting Women,
October 16, 2001–January 13, 2002

Musée d'Art Américain Giverny, France

Musée d'Art Américain Giverny 1992
Lasting Impressions: American Painters in France, 1865–1915, June 1–October 31, 1992 [catalogue]. This exhibition was re-created, in part, during the seasons (April 1–October 31) of 1993, 1994, and 1995.

Musée d'Art Américain Giverny 1997
An American Glance at Paris,
April 1–October 31 [catalogue]

Musée d'Art Américain Giverny 1998
Giverny: An American Impression,
April 1–November 1

Musée d'Art Américain Giverny 1999
The City and the Country: American Perspectives, 1870–1920,
April 1–October 31 [catalogue]

Musée d'Art Américain Giverny 2000a
Waves and Waterways: American Perspectives, 1850–1900,
April 1–October 31 [catalogue]

Musée d'Art Américain Giverny 2000b
American Moderns, 1900–1950,
July 25–October 31 [catalogue]

Musée d'Art Américain Giverny 2001a
The Extraordinary and the Everyday: American Perspectives, 1820–1920,
April 1–November 30 [catalogue]

Musée d'Art Américain Giverny 2001b
Giverny in All Seasons, April 1–November 30

Washington **Allston**

- Bjelajac, David. *Washington Allston, Secret Societies and the Alchemy of Anglo-American Painting*. New York and Cambridge: Cambridge University Press, 1997.
- Gerdts, William H., and Theodore E. Stebbins, Jr. *"A Man of Genius": The Art of Washington Allston (1779–1843)*. Boston: Museum of Fine Arts, 1979.

Lorenzo and Jessica, 1832 (p. 52–53)
TFA 2000.3

Provenance
Patrick T. Jackson, 1832–46; Mrs. Patrick T. Jackson, 1850–53; Ellen Jackson, 1869–81 (daughter of Mrs. Patrick T. Jackson); Arthur T. Cabot (nephew of Ellen Jackson); Estate of Mrs. Arthur T. Cabot; John Moors Cabot (nephew of Mrs. Arthur T. Cabot), Elizabeth von Wentzel; Hirschl & Adler Galleries, New York; TFA, 2000.
Exhibitions
- Annual Exhibition of the Athenaeum Gallery, Boston Athenaeum, Boston, 1832, no. 247; 1846, no. 9; 1850, no. 84; 1852, no. 174; 1857, no. 231; 1863, no. 172; 1869, no. 369.
- *An Exhibition of Pictures Painted by Washington Allston*, Harding's Gallery, Boston, 1839 [catalogue].
- *Exhibition of the Works of Washington Allston*, Museum of Fine Arts, Boston, June–Oct. 1881, no. 210.
- *A Man of Genius: The Art of Washington Allston (1779–1843)*, Museum of Fine Arts, Boston, Dec. 12, 1979–Feb. 3, 1980 [traveling exh., catalogue].
- *Boston in the Age of Neo-Classicism: 1810–1840*, Hirschl & Adler Galleries, New York, Nov. 27, 1999–Feb. 5, 2000 [catalogue].
- Terra Museum of American Art 2000b.
- Musée d'Art Américain Giverny 2001a.

John James **Audubon**

- Ford, Alice. *John James Audubon: A Biography*. New York: Abbeville Press, 1987.
- Peterson, Roger Tory, and Virginia Marie Peterson. *Audubon's Birds of America: The Audubon Society Baby Elephant Folio*. New York: Abbeville Press, 1990.

The Birds of America, vol. 1, 1827–1838 (p. 56–57), TFA 1984.3.1

Provenance
Dr. John C. Merriam, President of the Carnegie Institution of Washington; National Academy of Sciences, Washington, D.C., Nov. 25, 1936; Smithsonian Institution, Washington, D.C. (on loan from National Academy of Sciences), Aug. 26, 1946; Sotheby's, London, Feb. 1, 1984, lot 1; Berry-Hill Galleries, New York (agent), DJT Collection, 1984; TFA, 1984.
Exhibitions
- Terra Museum of American Art 1987.
- Terra Museum of American Art 2001b.

George Wesley **Bellows**

- Doezema, Marianne. *George Bellows and Urban America*. New Haven, Conn.: Yale University Press, 1992.
- Quick, Michael, et al. *The Paintings of George Bellows*. New York: Harry N. Abrams, 1992.
- Setford, David. "George Bellows: Love of Winter." *American Art Review* 10, no. 4 (July–Aug. 1998): 150–57.

Nude Girl, Miss Leslie Hall, 1909 (p. 148–149), TFA 1999.5

Provenance
Estate of Emma S. Bellows (wife of the artist); H. V. Allison & Co., New York; Collection of Merton and Barbara Shapiro, 1975; Christie's, New York, May 26, 1999, lot 79; TFA, 1999.

Exhibitions
- National Arts Club Galleries, New York, 1910.
- *Paintings by George Bellows*, Art Students League of Columbus, Columbus, Ohio, 1912
- *George Bellows*, H. V. Allison & Co., New York, May 1–26, 1962.
- Terra Museum of American Art 2000a.
- Musée d'Art Américain Giverny 2000b.
- Terra Museum of American Art 2001a.
- Terra Museum of American Art 2001d.

The Palisades, 1909 (p. 150–151)
TFA 1999.10

Provenance
Quinnipiack Club, New Haven, Conn., until 1981; Vose Galleries, Boston; Private collection, Providence, R.I., 1981; Vose Galleries, Boston; DJT Collection, 1983; TFA, 1999.
Exhibitions
- *The Paintings of George Bellows*, Los Angeles County Museum of Art, Los Angeles, Calif., Feb. 16–May 10, 1992 [traveling exh., catalogue].
- Terra Museum of American Art 1997c.
- Musée d'Art Américain Giverny 1999.
- Musée d'Art Américain Giverny 2000a.
- Terra Museum of American Art 2001b.
- Terra Museum of American Art 2001c.

John Leslie **Breck**

- Corbin, Kathryn. "John Leslie Breck, American Impressionist." *Antiques* 134 (Nov. 1988): 1142–49.
- Gerdts, William H. *Monet's Giverny: An Impressionist Colony*. New York: Abbeville Press, 1993.

Morning Fog and Sun, 1892 (p. 124–125)
TFA 1999.19

Provenance
Mr. Edward T. Rice, 1899 (believed to be artist's step-uncle); Thomas Rice Varick, Manchester, N.H., by 1909; Margaret Codaire Sproul-Bolton, Manchester, N.H., 1940s; Rum Hill Antiques, Concord, N.H. (agent), Sotheby's, New York, Nov. 29, 1990, lot 56; Berry-Hill Galleries, New York (agent), DJT Collection, 1991; TFA, 1999.

John Leslie **Breck** (continued)

Exhibitions
– Exhibition, J. Eastman Chase Gallery, Boston, Jan. 1893, no. 2 (as *Morning Fog and Sun*).
– *Memorial Exhibition of Paintings by John Leslie Breck*, St. Botolph Club, Boston, May 1899, no. 1 (as *Haystacks at Giverny*).
– *Memorial Exhibition of Paintings by John Leslie Breck*, National Arts Club, New York, Feb.–Mar. 1900, no. 1 (as *Sun and Fog*).
– Musée d'Art Américain Giverny 1992.
– Terra Museum of American Art 1997b.
– Terra Museum of American Art 1997d.
– Musée d'Art Américain Giverny 1999.

John George **Brown**

– Burns, Sarah. *Pastoral Inventions: Rural Life in Nineteenth-Century American Art and Culture.* Philadelphia: Temple University Press, 1989.
– Hoppin, Martha J. *Country Paths and City Sidewalks: The Art of J. G. Brown.* Springfield, Mass.: George Walter Vincent Smith Art Museum, 1989.

The Cider Mill, 1880 (p. 84–85)
TFA 1992.19

Provenance
Private collection; Vose Galleries, Boston, 1984; DJT Collection, 1984; TFA, 1992.
Exhibitions
– *Life in Nineteenth-Century America*, Terra Museum of American Art, Evanston, Ill., Sept. 11–Nov. 15, 1981 [catalogue].
– Exhibition, Vose Galleries, Boston, Fall 1984 [catalogue].
– *Domestic Bliss: Family Life in American Painting, 1840–1910*, The Hudson River Museum, Yonkers, N.Y., May 18–July 14, 1986 [traveling exh., catalogue].
– Terra Museum of American Art 1987.
– *Country Paths and City Sidewalks: The Art of J. G. Brown*, George Walter Vincent Smith Art Museum, Springfield, Mass., Mar. 19–May 21, 1989 [traveling exh., catalogue].
– *The Apple of America: The Apple in Nineteenth-Century American Art*, Berry-Hill Galleries, New York, May 5–June 26, 1993 [catalogue].
– Terra Museum of American Art 1996b. Musée d'Art Américain Giverny 1999 [traveling exh.].

Patrick Henry **Bruce**

– Agee, William C., and Barbara Rose. *Patrick Henry Bruce, American Modernist.* New York: The Museum of Modern Art, 1979.

Peinture, 1917–1918 (p. 170–171)
TFA 1999.21

Provenance
Henri-Pierre Roché, Paris, 1933; Rose Fried Gallery, New York; Charles Simon, New York, c. 1949–50; Peter H. Davidson & Co., New York; Mr. and Mrs. Rolf Weinberg, Zurich, Switzerland, 1978; DJT Collection, 1986; TFA, 1999.
Exhibitions
– *Three American Pioneers of Abstract Art: Morgan Russell, Stanton Macdonald-Wright, Patrick Henry Bruce*, Rose Fried Gallery, New York, Nov. 20–Dec. 30, 1950 [catalogue].
– *Twentieth-Century American Art from Fried's Collections*, Whitney Museum of American Art, New York, July 27–Sept. 27, 1977 [catalogue].
– *Patrick Henry Bruce—American Modernist*, The Museum of Fine Arts, Houston, Tex., May 31–June 29, 1979 [traveling exh., catalogue].
– Rot konstruiert *und* Super Table: *Eine Schweizer Sammlung moderner Kunst*, Kunstmuseum, Winterthur, Switzerland, Mar. 2–Apr. 13, 1980 [catalogue].
– Terra Museum of American Art 1987.
– Terra Museum of American Art 1997c.
– Terra Museum of American Art 2000a.
– Musée d'Art Américain Giverny 2000b.
– Terra Museum of American Art 2001b.
– Terra Museum of American Art 2001c.

Dennis Miller **Bunker**

– Ferguson, Charles B. *Dennis Miller Bunker (1861–1890) Rediscovered.* New Britain, Conn.: The New Britain Museum of American Art, 1978.
– Gammell, R. H. Ives. *Dennis Miller Bunker.* New York: Van Rees Press, 1953.
– Hirschler, Erica. *Dennis Miller Bunker: American Impressionist.* Boston: Museum of Fine Arts, 1994.

Brittany Town Morning, Larmor, 1884 (p. 86–87), TFA 1991.1

Provenance
Sotheby Parke-Bernet, New York, Apr. 28, 1977, lot 153; Spanierman Gallery, New York, 1978; Mr. and Mrs. Ralph Spencer, 1978; Spanierman Gallery, New York; TFA, 1991.
Exhibitions
– *Dennis Miller Bunker Exhibition*, Noyes & Blakeslee Gallery, Boston, 1885, no. 10.
– *Sixtieth Annual Exhibition*, National Academy of Design, New York, Apr. 16–May 16, 1885, no. 192.
– *Dennis Miller Bunker (1861–1890) Rediscovered*, New Britain Museum of Art, New Britain, Conn., Apr. 1–May 7, 1978 [traveling exh., catalogue].
– *In Nature's Ways: American Landscape Painting of the Late Nineteenth Century*, Norton Gallery of Art, West Palm Beach, Fla., Feb. 21–Apr. 12, 1987 [traveling exh., catalogue].
– *The Spencer Collection of American Art: An Exhibition of Works for Sale*, Spanierman Gallery, New York, June 13–29, 1990 [catalogue].
– Musée d'Art Américain Giverny 1992.
– *Dennis Miller Bunker: American Impressionist*, Museum of Fine Arts, Boston, Jan. 13–June 4, 1995 [traveling exh., catalogue].
– Musée d'Art Américain Giverny 1998.
– Musée d'Art Américain Giverny 1999.
– Musée d'Art Américain Giverny 2001a.

Mary Stevenson **Cassatt**

– Barter, Judith A., ed. *Modern Woman.* New York: Abrams; Chicago: The Art Institute of Chicago, 1998.
– Breeskin, Adelyn Dohme. *Mary Cassatt: A Catalogue Raisonné of the Oils, Pastels, Watercolors, and Drawings.* Washington, D.C.: Smithsonian Institution Press, 1970.
– Mathews, Nancy Mowll, and Barbara Stern Shapiro. *Mary Cassatt: The Color Prints.* New York: Abrams, 1989.
– Pollock, Griselda. *Mary Cassatt, Painter of Modern Women.* New York: Thames and Hudson, 1998.

Woman Bathing, 1890–1891 (p. 126–127)
TFA 1996.87

Provenance
Mrs. Thomas A. Scott (gift from artist to second cousin); descended in family to Edgar Scott (grandson of Mrs. Thomas A. Scott); Christie's, New York, Apr. 29, 1996, lot 80; Margo Pollins Schab, Inc., New York (agent), TFA, 1996.
Exhibitions
– Exhibition (first solo exhibition), Galerie Durand-Ruel, Paris, 1891 (as one of *Set of Ten*).
– Musée d'Art Américain Giverny 1997.
– Terra Museum of American Art 1997d.
– Musée d'Art Américain Giverny 2001a.

Summertime, c. 1894 (p. 128–129)
TFA 1988.25

Provenance
Ambroise Vollard, 1906; Private collection, Paris, 1940; Brigadier Général M. C. Troper, Paris, 1940; descended in family to daughter of Brigadier Général M. C. Troper, 1985; Coe Kerr Gallery, New York, 1985; DJT Collection, 1985; TFA, 1988.
Exhibitions
– *American Impressionism*, Coe Kerr Gallery, New York, Nov. 7–Dec. 7, 1985 [catalogue].
– Terra Museum of American Art 1987.
– Musée d'Art Américain Giverny 1992.
– *Mary Cassatt: Modern Woman*, The Art Institute of Chicago, Oct. 10, 1998–Jan. 10, 1999 [traveling exh., catalogue].
– Musée d'Art Américain Giverny 2000a.
– Terra Museum of American Art 2001b.
– Terra Museum of American Art 2001d.

La Tasse de thé (The Cup of Tea),
1897 (p. 130–131), TFA 1999.24

Provenance
Durand-Ruel, Paris, 1897; Durand-Ruel,
New York, 1898–1942; Coe Kerr Gallery,
New York; DJT Collection, 1986; TFA, 1999.
Exhibitions
– Exhibition, Durand-Ruel, New York, 1903,
no. 21.
– *44th Annual Exhibition*, American Watercolor
Society, New York, 1911, no. 102.
– Exhibition, Durand-Ruel, New York, 1926,
no. 2.
– *Mary Cassatt*, Baltimore Museum of Art,
Baltimore, Md., Nov. 28, 1941–Jan. 11, 1942,
no. 29.
– Terra Museum of American Art 1987.
– Musée d'Art Américain Giverny 1992.
– *Mary Cassatt at a Glance*, Musée d'Art
Américain Giverny, Apr. 2–Oct. 31, 1996.
– Terra Museum of American Art 1997b.
– Terra Museum of American Art 1997d.
– *Mary Cassatt: Modern Woman*, The Art
Institute of Chicago, Oct. 10, 1998–Jan. 10,
1999 [catalogue].

William Merritt **Chase**

– Atkinson, D. Scott, and Nicolai Cikovsky, Jr.
*William Merritt Chase: Summers at
Shinnecock 1891–1902*. Washington, D.C.:
National Gallery of Art, 1987.
– Gallati, Barbara Dayer. *William Merritt Chase*.
New York: Harry N. Abrams, 1995.

Spring Flowers (Peonies), c. 1889
(p. 110–111), TFA 1999.32

Provenance
Potter Palmer, Chicago, c. 1897; Vincent
Bendix, Chicago; Parke-Bernet Galleries,
New York, May 29, 1942, lot 31, (as *White
Peonies*); J. A. Fenger, Long Island, New York;
Parke-Bernet Galleries, New York, May 18–20,
1950, lot 329 (as *Lady with Flowers*); State
Supreme Court Justice and Mrs. Louis
A. Valente, New York; descended in family;
Sotheby's, New York, May 27, 1993, lot 32
(as *Peonies*); Berry-Hill Galleries, New York
(agent), DJT Collection, 1993; TFA, 1999.

Exhibitions
– *Works of William M. Chase*, The Art Institute
of Chicago, Nov.–Dec. 1897, no. 66.
– *Inter-State Annual Exposition of Chicago,
Seventeenth Annual Exhibition*, Gallery C,
Exposition Building, Chicago, Sept. 4–Oct. 19,
1889 [catalogue].
– Loan Exhibition, University of Notre Dame,
South Bend, Ind., 1935–1942
(as *White Peonies*).
– Terra Museum of American Art 1995.
– Terra Museum of American Art 1996a.
– Terra Museum of American Art 1997c.

Hall at Shinnecock, 1892 (p. 112–113)
TFA 1988.26

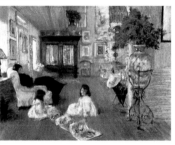

Provenance
Mrs. Arthur White Sullivan, Glen Head,
Long Island, N.Y.; Miss Margaret Mallory,
Santa Barbara, Calif., by 1954; Newhouse
Galleries, New York, 1985; Hirschl & Adler
Galleries, New York, 1985; DJT Collection,
1985; TFA, 1988.
Exhibitions
– Exhibition, The Art Institute of Chicago,
Nov. 23–Dec. 25, 1897, no. 49
(as *The Japanese Book*).
– *Loan Exhibition of Paintings by William
Merritt Chase*, The Metropolitan Museum
of Art, New York, Feb. 19–Mar. 18, 1917,
no. 27.
– *Exhibition of Paintings by William Merritt
Chase N.A., 1849–1916*, Newhouse Galleries,
New York, Feb. 28–Mar. 25, 1933, no. 21.
– *William M. Chase, 1849–1916: A Selected
Retrospective Exhibition of Paintings*,
American British Art Center, New York,
Nov. 9 Dec. 4, 1948, no. 17.
– *Chase Centennial Exhibition*, 1949,
John Herron Art Museum, Indianapolis, Ind.,
Nov. 1–Dec. 11, 1949, no. 37 [catalogue].
– *Impressionism and Its Influence in American
Art*, Toledo Museum of Art, Toledo, Ohio,
Jan. 3–Jan. 31, 1954 [traveling exh.].
– *The First West Coast Retrospective Exhibition
of Paintings by William Merritt Chase
(1849–1916)*, The Art Gallery, University
of California, Santa Barbara, Calif.,
Oct. 6–Nov. 8, 1964 [traveling exh.,
catalogue].
– *William Merritt Chase Retrospective Exhibition*,
Henry Art Gallery, University of Washington,
Seattle, Wash., Oct. 2, 1983–Jan. 29, 1984
[traveling exh., catalogue].
– Terra Museum of American Art 1987.
– *William Merritt Chase: Summers at
Shinnecock, 1891–1902*, National Gallery
of Art, Washington, D.C., Sept. 6–Nov. 29,
1987 in cooperation with the Terra Museum
of American Art, Chicago, Dec. 13, 1987–
Feb. 28, 1988 [catalogue].
– Terra Museum of American Art 1996a.
– Terra Museum of American Art 1997a.
– Terra Museum of American Art 2001a.

Frederic Edwin **Church**

– Carr, Gerald L. *Frederic Edwin Church:
The Icebergs*. Dallas: Dallas Museum of Art,
1980.
– Kelly, Franklin, ed. *Frederic Edwin Church*.
Washington, D.C.: National Gallery of Art,
1989.
– Mitchell, Timothy. "Frederic Church's
The Icebergs: Erratic Boulders and Time's Slow
Changes." *Smithsonian Studies in American
Art* (Fall 1989): 3–23.

The Iceberg, c. 1875 (p. 76–77)
TFA 1993.6

Provenance
William C. Osborn, New York, by Jan. 1875;
descended in family; Berry-Hill Galleries,
New York; TFA, Feb. 1993.
Exhibitions
– Ladies' Reception, Union League Club,
New York, Winter 1875, no. 26 [catalogue].
– *Hudson River School Days*, Berry-Hill Galleries,
New York, Nov. 18, 1992–Jan. 9, 1993.
– Terra Museum of American Art 1995.
– Terra Museum of American Art 1997c.
– Musée d'Art Américain Giverny 2000a.
– *In Search of the Promised Land: Frederic
Edwin Church and Exploration*, Berry-Hill
Galleries, New York, Apr. 25–June 30, 2000
[traveling exh., catalogue].
– *Ships at Sea: Sailing Through Summer*,
Terra Museum of American Art, Chicago,
June 6–Aug. 26, 2001.

Thomas **Cole**

– Miller, Angela. *The Empire of the Eye:
Landscape Representation and American
Cultural Politics, 1825–1875*. Ithaca,
New York: Cornell University Press, 1993.
– Myers, Kenneth John. "Art and Commerce
in Jacksonian America: The Steamboat *Albany*
Collection." *Art Bulletin* 82, no. 3
(Sept. 2000): 503–28.
– Truettner, William H., and Alan Wallach.
Thomas Cole: Landscape into History.
New Haven, Conn.: Yale University Press,
1994.

*Landscape with Figures: A Scene from
"The Last of the Mohicans,"* 1826
(p. 54–55), TFA 1993.2

Provenance
James Alexander Stevens, late Fall 1826
(commissioned by); D. T. Vail; Christie's,
New York, May 26, 1988, lot 25; Berry-Hill
Galleries, New York, 1988; TFA, Feb. 1993.
Exhibitions
– The Gallery at Earle's, James Earle's frame
shop, Philadelphia, 1827.
– Exhibition of the Steamboat *Albany* Collection,
Albany, New York, main cabin steamboat,
April 1827–c. 1843–44.
– Annual Art Exhibition (1858–1862), sponsored
by the Troy Young Men's Association, Troy,
New York, 1858 (as *Death of Uncas—Forest
and Mountain Scenery*); 1859 (as *Death
of Uncas*).
– *Hudson River School Days*, Berry-Hill Galleries,
New York, Nov. 18, 1992–Jan. 9, 1993.
– Terra Museum of American Art 1997c.
– Terra Museum of American Art 2000b.
– Musée d'Art Américain Giverny 2001a.

John Singleton **Copley**

– Prown, Jules David. *John Singleton Copley*,
2 vols. Cambridge: Harvard University
Press, 1966.
– Rebora, Carrie, et al. *John Singleton Copley
in America*. New York: The Metropolitan
Museum of Art, 1995.

*Portrait of Mrs. John Stevens
(Judith Sargent, Later Mrs. John
Murray),* 1770–1772 (p. 42–43)
TFA 2000.6

Provenance
Judith Sargent Stevens Murray (the sitter);
descended in Sargent family; Mr. and Mrs.
John T. Sargent; Berry-Hill Galleries, New York;
TFA, 2000.
Exhibitions
– Terra Museum of American Art 2000b.
– Terra Museum of American Art 2001d.

Charles Courtney **Curran**

– Gerdts, William H. *Down Garden Paths: The Floral Environment in American Art.* Cranbury, N.J.: Associated University Presses, 1983.
– Keny, James M., and Nanette V. Maciejunes. *Triumph of Color and Light: Ohio's Impressionists and Post-Impressionists.* Columbus, Ohio: Columbus Museum of Art, 1994.

Lotus Lilies, 1888 (p. 98–99)
TFA 1999.35

Provenance
Edwin Lefevre; Robert Skinner, Bolton, Mass., Oct. 20, 1978, lot 20; Bryan Olifant, New York; Jeffrey R. Brown Fine Arts, North Amherst, Mass., 1979; DJT Collection, 1980; TFA, 1999.
Exhibitions
– Exhibition, Paris Salon, Paris, 1890 (as *Lotus Lilies of Lake Erie, United States of America*; Honorable Mention).
– *Thirteenth Exhibition of the Society of American Artists*, Paris, Apr. 27–May 23, 1891, no. 63 [catalogue].
– *American Impressionism*, Henry Art Gallery, University of Washington, Seattle, Wash., Jan. 3–Mar. 2, 1980 [traveling exh., catalogue].
– *Life in Nineteenth-Century America*, Terra Museum of American Art, Evanston, Ill., Sept. 11–Nov. 15, 1981.
– *Down Garden Paths: The Floral Environment in American Art*, The Montclair Art Museum, Montclair, N.J., Oct. 1–Nov. 30, 1983 [traveling exh., catalogue].
– Terra Museum of American Art 1987.
– *1888: Frederick Layton and His World*, Milwaukee Art Museum, Milwaukee, Wis., Apr. 8–Aug. 28, 1988 [catalogue].
– *Triumph of Color and Light: Ohio's Impressionists and Post Impressionists*, Columbus Museum of Art, Columbus, Ohio, Feb. 6–May 15, 1994 [traveling exh., catalogue].
– Terra Museum of American Art 1997c.
– Musée d'Art Américain Giverny 2000a.
– Terra Museum of American Art 2001b.
– Terra Museum of American Art 2001d.

Stuart **Davis**

– Hills, Patricia. *Stuart Davis*. New York: Harry N. Abrams, 1996.
– Rylands, Philip, ed. *Stuart Davis*. Milan: Electa, 1997.
– Sims, Lowery Stokes, et al. *Stuart Davis, American Painter*. New York: The Metropolitan Museum of Art, 1991.

Super Table, 1925 (p. 174–175)
TFA 1999.37

Provenance
Mrs. Stuart Davis, New York, 1964; Borgenicht Gallery, New York; Mr. and Mrs. Rolf Weinberg, Zurich, Switzerland; Berry-Hill Galleries, New York; DJT Collection, 1986; TFA, 1999.
Exhibitions
– *International Exhibition of Modern Art*, arranged by the Société Anonyme for The Brooklyn Museum, Brooklyn, N.Y., Nov.–Dec. 1926.
– *Marsden Hartley, Stuart Davis*, Cincinnati Modern Art Society, Cincinnati, Ohio, Oct. 24–Nov. 24, 1941.
– *Stuart Davis*, Museum of Modern Art, New York, 1945 [catalogue].
– *Stuart Davis*, Walker Art Center, Minneapolis, Minn., Mar. 30–May 19, 1957 [traveling exh., catalogue].
– *Stuart Davis*, National Collection of Fine Arts, Washington, D.C., May 28–July 5, 1965 [traveling exh., catalogue].
– *Stuart Davis: Art and Art Theory*, The Brooklyn Museum, Brooklyn, N.Y., Jan. 21–Mar. 19, 1978 [traveling exh., catalogue].
– *Zwei Jahrzehnte amerikanische Malerei, 1920–1940*, Kunsthalle, Düsseldorf, Germany, June 10–Aug. 12, 1979 [catalogue].
– Rot konstruiert *und* Super Table: *Eine Schweizer Sammlung moderner Kunst, 1909–1939*, Kunstmuseum, Winterthur, Switzerland, Mar.12–Apr. 13, 1980 [catalogue].
– Terra Museum of American Art 1987.
– *Stuart Davis, American Painter*, The Metropolitan Museum of Art, New York, Nov. 23, 1991–Feb. 16, 1992 [traveling exh., catalogue].
– Terra Museum of American Art 2000a.
– Musée d'Art Américain Giverny 2000b.
– Terra Museum of American Art 2001b.
– Terra Museum of American Art 2001c.

Charles Henry **Demuth**

– Eiseman, Alvord L. *Charles Demuth*. New York: Watson-Guptill Publications, 1982.
– Fahlman, Betsy. *Charles Demuth of Lancaster*. Philadelphia: The Philadelphia Museum of Art, 1983.
– Farnham, Emily. *Charles Demuth: Behind a Laughing Mask*. Norman, Okla.: Oklahoma Press, 1971.
– Haskell, Barbara. *Charles Demuth*. New York: The Whitney Museum of American Art, 1987.

Welcome to Our City, 1921 (p. 172–173)
TFA 1993.3

Provenance
Georgia O'Keeffe, New York, 1935 (inherited); The Downtown Gallery, New York; Max Miller, Miami Beach, Fla., 1952; descended in family until 1992; Sotheby's, New York, Dec. 3, 1992, lot 153; Berry-Hill Galleries, New York (agent), TFA, 1993.
Exhibitions
– *Recent Paintings by Charles Demuth*, The Daniel Gallery, New York, Dec. 1922–Jan. 1923, no. 1.
– *Charles Demuth*, Whitney Museum of American Art, New York, Oct. 15, 1987–Jan. 17, 1988 [traveling exh., catalogue].
– Terra Museum of American Art 1996b.
– Musée d'Art Américain Giverny 1999 [traveling exh.].
– Terra Museum of American Art 2000a.
– Musée d'Art Américain Giverny 2000b.

Thomas Wilmer **Dewing**

– Hobbs, Susan A. *The Art of Thomas Wilmer Dewing: Beauty Reconfigured*. Washington, D.C.: Smithsonian Institution Press; Brooklyn, N.Y.: The Brooklyn Museum of Art, 1996.
– *From Realism to Symbolism: Whistler and His World*. New York: Columbia University Press; Philadelphia: The Philadelphia Museum of Art, 1971.

Portrait of a Lady Holding a Rose, 1910–1915 (p. 132–133), TFA 1999.46

Provenance
Montross Gallery, New York; Mr. and Mrs. Charles F. T. Seaverns, Hartford, Conn., by 1936; Mrs. Charles F. T. Seaverns, Hartford, Conn.; Mr. Appleton Seaverns, Hartford, Conn., by 1956; Parke-Bernet Galleries, New York, Dec. 6, 1956, lot 172; Mr. Nelson C. White, Waterford, Conn., by 1963–82; Private collection 1983; Hirschl & Adler Galleries, New York; DJT Collection, 1985; TFA, 1999.
Exhibitions
– *Paintings in Hartford Collections*, Wadsworth Atheneum, Hartford, Conn., Jan. 22–Feb. 20, 1936 (as *Woman in Green*).
– *Thomas Dewing 1851–1938*, a Loan Exhibition, Durlacher Brothers, New York, Mar. 26–Apr. 30, 1963.
– *American Art from Alumni Collections*, Yale University Art Gallery, New Haven, Conn., Apr. 25–June 16, 1968 (as *Lady in Green*) [catalogue].
– *From Realism to Symbolism: Whistler and His World*, Department of Art History of Columbia University, New York in cooperation with The Philadelphia Museum of Art, Philadelphia, Apr. 15–May 23, 1971 (as *Lady in Green*) [traveling exh., catalogue].
– *The Arts of the American Renaissance*, Hirschl & Adler Galleries, New York, Apr. 11–May 31, 1985 [catalogue].
– Terra Museum of American Art 1987 (as *Portrait of a Lady in Green*).
– *Face to Face: Portraits from the Collections of Terra Museum of American Art*, Terra Museum of American Art, Chicago, Oct. 8, 1994–Apr. 2, 1995.
– *The Art of Thomas Wilmer Dewing: Beauty Reconfigured*, The Brooklyn Museum, Brooklyn, N.Y., Mar. 21–June 9, 1996 [traveling exh., catalogue].
– Terra Museum of American Art 1997c.
– Terra Museum of American Art 2000a.
– Musée d'Art Américain Giverny 2001a.

A Walk: Poplars, c. 1912–1913
(p. 158–159), TFA 1999.47

Portrait of Thomas J. Eagan, 1907
(p. 146–147), TFA 1998.1

Arthur Garfield **Dove**

– Bricker Balken, Debra, et al. *Arthur Dove:
A Retrospective*. Cambridge, Mass.: MIT Press;
Andover, Mass.: Addison Gallery of American
Art, 1998.
– Cohn, Sherrye. *Arthur Dove: Nature as
Symbol*. Ann Arbor, Mich.: UMI Research
Press, 1985.
– Haskell, Barbara. *Arthur Dove*. San Francisco:
San Francisco Museum of Art, 1974.

Sails, 1911–1912 (p. 156–157)
TFA 1993.10

Provenance
"291," New York; Anderson Galleries auction,
1922 (as *Moving Boats*); Philip L. Goodwin,
New York, 1922; TFA, 1993.
Exhibitions
– Exhibition (first solo exhibition), "291,"
New York, Feb. 27–Mar. 12, 1912.
– Group Exhibition, Society of Independent
Artists, 1917, no. 92 (as *Nature Symbolized, 1*).
– *Pioneers of Modern Art in America*,
Whitney Museum of American Art, New York,
Apr. 2–May 12, 1946 [catalogue].
– *Arthur Dove: A Retrospective*, The Phillips
Collection, Washington, D.C., Sept. 20,
1997–Jan. 4, 1998 [traveling exh., catalogue].
– Musée d'Art Américain Giverny 2000b.

Provenance
The Downtown Gallery, New York;
Paul Rosenfeld, New York, 1950;
The Downtown Gallery, New York;
Edith Gregor Halpert; Sotheby Parke-Bernet,
New York, Mar. 14–15, 1973, lot 48;
William Zierler Gallery, New York, 1973;
ACA Galleries, New York; Dr. and Mrs. Fouad
A. Rabiah, Flint, Mich., 1978; DJT Collection,
1982; TFA, 1999.
Exhibitions
– *Arthur G. Dove—A Retrospective Exhibition*,
White Art Museum, Cornell University, Ithaca,
N.Y., Nov. 1954 [catalogue].
– *Arthur G. Dove—A Retrospective Exhibition*,
University of California, Los Angeles Art
Galleries, Los Angeles, Calif., May 1–June 15,
1959 [traveling exh., catalogue].
– *Edith G. Halpert Collections*, Munson-
Williams Proctor Institute, Utica, N.Y., 1960.
– *American Pioneer Artists*, University of Iowa,
Iowa City, Iowa, 1962.
– *The Decade of the Armory Show 1910–1920*,
Whitney Museum of American Art, New York,
Feb. 27–Apr. 14, 1963 [traveling exh.,
catalogue].
– *American Modernism: The First Wave,
Painting from 1903 to 1933*, Rose Art
Museum, Brandeis University, Waltham, Mass.,
Oct. 4–Nov. 10, 1963.
– *Twentieth-Century Painting and Sculpture*,
Washington Gallery of Modern Art,
Washington, D.C., Sept. 17–Oct. 24, 1965
[traveling exh., catalogue].
– *Roots of Abstract Art in America*, Smithsonian
Institution, Washington, D.C., Dec. 2, 1965–
Jan. 9, 1966 [catalogue].
– *Arthur Dove: The Years of Collage*, J. Millard
Tawes Fine Arts Center, University of Maryland
Art Gallery, College Park, Md., Mar. 13–
Apr. 19, 1967 [catalogue].
– *Edith Gregor Halpert Memorial Exhibition*,
National Collection of Fine Arts, Smithsonian
Institution, Washington, D.C., Apr. 7–June 25,
1972 [catalogue].
– *Arthur Dove*, San Francisco Museum of Art,
San Francisco, Calif., Nov. 21, 1974–Jan. 5,
1975 [traveling exh., catalogue].
– *Twentieth-Century American Drawing:
Three Avant-garde Generations*, Solomon
R. Guggenheim Museum, New York,
Jan. 23–Mar. 23, 1976 [traveling exh.,
catalogue].
– *Art of the Twenties*, Flint Institute of Arts,
Flint, Mich., Nov. 16, 1978–Jan. 21, 1979
[catalogue].
– Terra Museum of American Art 1987.
– Terra Museum of American Art 1995.

Robert Spear **Dunning**

– Gerdts, William H., and Russell Burke.
American Still-Life Painting. New York:
Praeger Publishers, 1971.
– Weintraub, Linda, ed. *Art What Thou Eat:
Images of Food in American Art*. Mount Kisco,
N.Y.: Moyer Bell Limited, 1991.

Still Life with Fruit, 1868 (p. 80–81)
TFA 1999.49

Provenance
Charles Augustus and Ella Hays Myers;
William Henry Hays Myers (son of Charles
Augustus and Ella Hays Myers); William Henry
Hays Myers, Jr., since 1935 (grandson
of William Henry Hays Myers); Berry-Hill
Galleries, New York, July 1984; DJT Collection,
1984; TFA, 1999.
Exhibitions
– Terra Museum of American Art 1987.
– *Regional American Painting to 1920*,
Greenville County Museum of Art, Greenville,
S.C., Nov. 6–Dec. 30, 1990 [catalogue].
– Terra Museum of American Art 1996b.
– Terra Museum of American Art 2000a.
– Terra Museum of American Art 2000b.
– Terra Museum of American Art 2001b.

Thomas **Eakins**

– Foster, Kathleen. *Thomas Eakins Rediscovered:
Charles Bregler's Thomas Eakins' Collection
at the Pennsylvania Academy of the Fine Arts*.
New Haven, Conn.: Yale University Press,
1997.
– Goodrich, Lloyd. *Thomas Eakins*, 2 vols.
Washington, D.C.: National Gallery of Art;
Cambridge: Harvard University Press, 1982.
– Johns, Elizabeth. *The Heroism of Modern Life*.
Princeton, N.J.: Princeton University Press,
1983.
– Sewell, Darrel, et al. *Thomas Eakins*.
Philadelphia: The Philadelphia Museum of Art;
New Haven, Conn.: Yale University Press,
2001.

Provenance
Thomas J. Eagan, Conshohocken, Pa.
(the sitter); M. Knoedler & Co, New York;
Thomas Mellon Evans; Christie's, New York,
May 21, 1988, lot 33; TFA, 1998.
Exhibitions
– *A Loan Exhibition of the Works of Thomas
Eakins, 1844–1944, Commemorating the
Centennial of his Birth*, M. Knoedler & Co.,
New York, June–July 1944 [traveling exh.,
catalogue].
– *Thomas Eakins Centennial Exhibition,
1844–1944*, Department of Fine Arts,
Carnegie Institute, Pittsburgh, Pa.,
Apr. 26–June 1, 1945, no. 38.
– *19th and 20th Century American Paintings
from Private Collections*, Whitney Museum
of American Art, New York, June–Sept. 1972,
no. 22.
– Terra Museum of American Art 2000b.
– Terra Museum of American Art 2001a.
– Terra Museum of American Art 2001b.

Lyonel **Feininger**

– Faas, Martin. *Feininger im Weimarer Land*.
Apolda, Germany: Kunsthaus Apolda
Avantgarde, 1999.
– Hess, Hans. *Lyonel Feininger*. New York:
Harry N. Abrams, 1961.
Joachimides, Christos M., et al. *German Art
in the Twentieth Century: Paintings and
Sculpture 1905–1985*. Munich, Germany:
Prestel-Verlag, 1985.

Denstedt, 1917 (p. 166–167)
TFA 1988.27

Provenance
Estate of the artist; Marlborough Gallery,
London, Rome, and Zurich; Private collection,
Japan; Mr. Leonard Lauder, New York;
Berry-Hill Galleries, New York, Nov. 1986;
TFA, 1986.

.../...

196

Lyonel **Feininger** (continued)

Exhibitions
- *Lyonel Feininger*, Marlborough-Gerson Gallery, New York, Apr.–May, 1969 [catalogue].
- *German Art in the Twentieth Century; Painting and Sculpture: 1905-1985*, Royal Academy of Arts, London, Oct. 11–Dec. 22, 1985 [traveling exh., catalogue].
- Terra Museum of American Art 1987.
- *Lyonel Feininger: von Gelmeroda nach Manhattan*, Neue Nationalgalerie, Berlin, Germany, July 3–Oct. 11, 1998 [traveling exh., catalogue].
- Musée d'Art Américain Giverny 2000b.
- Terra Museum of American Art 2001b.
- Terra Museum of American Art 2001c.

Erastus Salisbury **Field**

- Black, Mary C. "Erastus Salisbury Field." In *American Folk Painters of Three Centuries*. New York: Hudson Hills Press, 1980.
- *Erastus Salisbury Field, 1805-1900*. Springfield, Mass.: Museum of Fine Arts, 1984.

Portrait of a Woman Said to Be Clarissa Gallond Cook, in Front of a Cityscape, c. 1838–1839 (p. 48–49)
TFA 2000.4

Provenance
Private collection, New York; Hirschl & Adler Galleries, New York; TFA, 2000.
Exhibitions
- Terra Museum of American Art 2000a.
- Terra Museum of American Art 2000b.
- Terra Museum of American Art 2001b.

Frederick Carl **Frieseke**

- Kilmer, Nicholas. *Frederick Carl Frieseke: The Evolution of an American Impressionist*. Savannah, Ga.: Telfair Museum of Art, 2001.

Lady in a Garden, c. 1912 (p. 144–145)
TFA 1999.52

Provenance
Kay Kukes, Bloomfield Hills, Mich.; Berry-Hill Galleries, New York; DJT Collection, 1982; TFA, 1999.
Exhibitions
- Exhibition, Macbeth Galleries, New York, 1915 (as *The Striped Gown*).
- *Special Paintings by Frederick Frieseke*, Cincinnati Museum of Art, Cincinnati, Ohio, Jan. 1921 (as *In the Garden*).
- *Solitude: Inner Visions in American Art*, Terra Museum of American Art, Evanston, Ill., Sept. 25–Dec. 30, 1982 [catalogue].
- *An International Episode: Millet, Monet, and their North American Counterparts*, The Dixon Gallery and Gardens, Memphis, Tenn., Nov. 21, 1982–Jan. 2, 1983 (only final week) [traveling exh., catalogue].
- *Down Garden Paths: The Floral Environment in American Art*, The Montclair Art Museum, Montclair, N.J., Oct. 1–Nov. 30, 1983 [traveling exh., catalogue].
- *The Seasons: American Impressionist Painting*, Madison Art Center, Madison, Wis., Dec. 8, 1984–Feb. 3, 1985.
- Terra Museum of American Art 1987.
- *American Painters in France*, Terra Museum of American Art, Chicago, June 14–Sept. 3, 1989.
- *Frederick C. Frieseke: Women in Repose*, Berry-Hill Galleries, New York, May 2–June 23, 1990 [catalogue].
- *American Impressionism*, Fondazione Thyssen-Bornemisza, Villa Favorita, Lugano-Castagnola, Switzerland, July 22–Oct. 28, 1990 [catalogue].
- Musée d'Art Américain Giverny 1992.
- Terra Museum of American Art 1997b.
- Terra Museum of American Art 1997d.
- *Giverny: Inside and Out*, Musée d'Art Américain Giverny, Apr. 1–Oct. 31, 2000.

Sanford Robinson **Gifford**

- Avery, Kevin J., et al. *American Paradise: The World of the Hudson River School*. New York: The Metropolitan Museum of Art, 1987.
- Novak, Barbara. "The Double-Edged Axe." *Art in America* 1 (Jan.–Feb. 1976): 45–50.
- Sweeney, J. Gray. "The Nude of Landscape Painting: Emblematic Personification in the Art of the Hudson River School." *Smithsonian Studies in American Art* (Fall 1989): 42–65.

Hunter Mountain, Twilight, 1866 (p. 70–71), TFA 1999.57

Provenance
James Wallace Pinchot, New York; Governor Gifford Pinchot, Pa., 1907; Douglas Collins, Longmeadow, Mass., 1946; Vose Galleries, Boston; The Lano Collection, Washington, D.C.; DJT Collection, 1983; TFA, 1999.
Exhibitions
- *Forty-first Annual Exhibition*, National Academy of Design, New York, 1866, no. 360 (as *Hunter Mountain, Twilight*) [catalogue].
- *Exposition Universelle*, Paris, 1867, no. 18 (as *Le Crépuscule sur le mont Hunter*) [catalogue].
- Loan Exhibition, Society of Decorative Arts, New York, 1878 (as *Hunter Mountain*).
- *Gifford Memorial Meeting of the Century Club*, Century Club, New York, 1880.
- *Memorial Collection of Works of the Late Sanford R. Gifford*, The Metropolitan Museum of Art, New York, 1880, no. 20 (as *Hunter Mountain, Catskill Mountains*) [catalogue].
- *Memorial Catalogue of Paintings of Sanford Robinson Gifford*, The Metropolitan Museum of Art, New York, 1881, no. 417 [catalogue].
- *Sanford Robinson Gifford: 1823–1880*, University of Texas Art Museum, Austin, Tex., Oct. 25–Dec. 13, 1970, no. 35 (as *Twilight on Hunter Mountain*) [traveling exh., catalogue].
- *The American Frontier: Images and Myths*, Whitney Museum of American Art, New York, June 26–Sept. 16, 1973 [catalogue].
- *Themes in American Painting*, Grand Rapids Art Museum, Grand Rapids, Mich., Oct. 1–Nov. 30, 1977 [catalogue].
- *American Light: The Luminist Movement, 1850–1875*, National Gallery of Art, Washington, D.C., 1980 (as *Twilight on Hunter Mountain*) [catalogue].
- *Solitude: Inner Visions in American Art*, Terra Museum of American Art, Evanston, Ill., Sept. 25–Dec. 30, 1982.
- *American Paradise: The World of the Hudson River School*, The Metropolitan Museum of Art, New York, Oct. 4, 1987–Jan. 3, 1988 [catalogue].
- Terra Museum of American Art 1997c.
- Musée d'Art Américain Giverny 1999 [traveling exh.].
- Musée d'Art Américain Giverny 2001a.

John D. **Graham**

- Green, Eleanor. *John Graham: Artist and Avatar*. Washington, D.C.: The Phillips Collection, 1987.

The Green Chair, 1928 (p. 176–177)
TFA 1999.60

Provenance
Private collection; Berry-Hill Galleries, New York; DJT Collection, 1990; TFA, 1999.
Exhibitions
- Terra Museum of American Art 2000a.
- Terra Museum of American Art 2001a.
- Terra Museum of American Art 2001d.

Marsden **Hartley**

- Haskell, Barbara. *Marsden Hartley*. New York: Whitney Museum of American Art, 1980.
- Hartley, Marsden, and Susan Elizabeth Ryan. *Somehow a Past: The Autobiography of Marsden Hartley*. Cambridge: MIT Press, 1997.
- Robertson, Bruce. *Marsden Hartley*. New York: Harry N. Abrams, 1995.

Painting No. 50, 1914–1915 (p. 168–169)
TFA 1999.61

Provenance
Martha Jackson Gallery, New York; Private collection, New York; Peter H. Davidson & Co., New York; Mr. and Mrs. Rolf Weinberg, Zurich, Switzerland; Berry-Hill Galleries, New York; DJT Collection, 1986; TFA, 1999.

Exhibitions

- *Marsden Hartley*, Munchener Graphik-Verlag, Berlin, Germany, Oct. 1915.
- *Marsden Hartley*, Little Galleries of the Photo Secession "291", New York, Apr. 4–22, 1916.
- *Marsden Hartley: The Berlin Period*, Martha Jackson Gallery, New York, Jan. 3–29, 1955.
- *The Martha Jackson Collection*, Seibu, Tokyo, Japan, 1971.
- *Immagine Per La Citta*, Accademia di belle arte e Palazzo Reale, Genova, Italy, Apr. 8–June 11, 1972.
- *The Private Collection of Martha Jackson*, University of Maryland Art Gallery, College Park, Md., June 22–Sept. 30, 1973 (as *Painting no. 49*) [traveling exh., catalogue].
- *Second Williams College Alumni Loan Exhibition*, Hirschl & Adler Galleries, New York, Apr. 1–24, 1976 (as *Painting no. 49*) [traveling exh., catalogue].
- Rot konstruiert *und* Super Table: *Eine Schweizer Sammlung moderner Kunst 1909–1939*, Kunstmuseum, Winterthur, Switzerland, Mar. 2–Apr. 13, 1980 [catalogue].
- Terra Museum of American Art 1987.
- Terra Museum of American Art 1997c.
- Musée d'Art Américain Giverny 2000b.
- Terra Museum of American Art 2001a.
- Terra Museum of American Art 2001b.
- Terra Museum of American Art 2001c.

Frederick Childe **Hassam**

- Adelson, Warren, et al. *Childe Hassam, Impressionist.* New York: Abbeville Press, 1999.
- Hiesinger, Ulrich W. *Childe Hassam: American Impressionist.* Munich, Germany, and New York: Prestel, 1994.
- Larkin, Susan G. *The Cos Cob Art Colony: Impressionists on the Connecticut Shore.* New York: National Academy of Design; New Haven, Conn.: Yale University Press, 2001.

Une Averse, Rue Bonaparte, 1887
(p. 100–101), TFA 1993.20

Provenance
Milch Galleries, New York; Mrs. Arthur D. Whiteside; Mr. and Mrs. Cecil D. Lipkin, Boston; Harry T. Spiro, New York; Hirshl & Adler Galleries, New York; Private collection, Wichita, Kans.; Mrs. Gloria Manney, New York; Berry-Hill Galleries, New York (agent), TFA, 1993.

Exhibitions

- Exhibition, Painting Section, Paris Salon, France, Spring 1887, no. 1181.
- Exhibition, Goupil & Co., Paris, 1887.
- *American Paintings and Sculpture*, American Art Galleries, Madison Square South, New York, Dec., 1887, no. 140 (as *A Shower—Rue Bonaparte, Paris*).
- *Fifty-Eighth Annual Exhibition*, Pennsylvania Academy of the Fine Arts, Philadelphia, Feb. 16–Mar. 29, 1888, no. 156 (as *A Shower—Rue Bonaparte, Paris*).
- *Eighth Annual Exposition*, Saint Louis Exposition, Saint Louis, Mo., Sept. 2–Oct. 17, 1891, no. 138 (as *A Cab Stand— Rue Bonaparte, Paris*).
- *Retrospective Exhibition*, Society of American Artists, New York, Dec. 5–25, 1892, no. 164 (as *La Rue Bonaparte, Paris*).
- World's Columbian Exposition, Chicago, 1893, no. 833 (as *Cab Station, Rue Bonaparte, Paris*).
- *Catalogue of Oil Paintings, Water Colors, and Pastels by Childe Hassam*, American Art Galleries, New York, Feb. 6–7, 1896, no. 100 (as *La Rue Bonaparte*).
- *Childe Hassam 1859–1935*, Hirschl & Adler Galleries, New York, Feb. 18–Mar. 7, 1964.
- *Childe Hassam: A Retrospective Exhibition*, The Corcoran Gallery of Art, Washington, D.C., Apr. 30–Aug. 1, 1965 [traveling exh., catalogue].
- *Impressionistes Américains*, Musée du Petit Palais, Paris, Mar. 31–May 20, 1982, organized by Smithsonian Institution Traveling Exhibition Service, Washington, D.C. [traveling exh., catalogue].
- *Revisiting the White City: American Art at the 1893 World's Fair*, National Museum of American Art, Smithsonian Institution, Washington, D.C., Apr. 16–Aug. 15, 1993 [catalogue].
- Musée d'Art Américain Giverny 1992 (only Apr. 1–Oct. 30, 1994; Apr. 1–Sept. 24, 1995).
- *Impressions of France: Monet, Renoir, Pissarro, and Their Rivals*, Museum of Fine Arts, Boston, Oct. 4, 1995–Jan. 14, 1996 [catalogue].
- Musée d'Art Américain Giverny 1997.
- Terra Museum of American Art 1997d.
- Musée d'Art Américain Giverny 1998.
- Musée d'Art Américain Giverny 1999 [traveling exh.].
- Terra Museum of American Art 2001b.

Columbian Exposition, Chicago,
1892 (p. 102–103)
TFA 1992.38

Provenance
Ernest Hickok, Summit, N.J.; Hirschl & Adler Galleries, New York, 1978; DJT Collection, 1978; TFA, 1992.

Exhibitions

- *Life in Nineteenth-Century America*, Terra Museum of American Art, Evanston, Ill., Sept. 1–Nov. 15, 1981 [catalogue].
- Terra Museum of American Art 1987.
- *The Fair View: Representations of the World's Columbian Exposition of 1893*, The University of Michigan Museum of Art, Ann Arbor, Mich., Oct. 30–Dec. 31, 1993 [traveling exh.].
- Terra Museum of American Art 1996b.
- Terra Museum of American Art 2000a.
- Musée d'Art Américain Giverny 2001a.

Martin Johnson **Heade**

- Novak, Barbara. *Nature and Culture: American Landscape and Painting, 1825–1875.* New York: Oxford University Press, 1980.
- Novak, Barbara, and Timothy A. Eaton. *Martin Johnson Heade: A Survey 1840–1900.* West Palm Beach, Fla.: Eaton Ferie AA, 1996.
- Stebbins, Theodore E., Jr. *The Life and Work of Martin Johnson Heade: A Critical Analysis and Catalogue Raisonné.* New Haven, Conn.: Yale University Press, 2000.
- Wilmerding, John, ed. *American Light: The Luminist Movement, 1850–1875.* Washington, D.C.: National Gallery of Art, 1980.

Newburyport Marshes: Approaching Storm, 1865–1870 (p. 64–65)
TFA 1999.68

Provenance
Purchased from an exhibition in the early 1880s; descended in family to grandson of the original buyer; Dr. Douglas M. Sirkin, Williamsville, N.Y., 1978–83; Adams Davidson Galleries, Washington, D.C.; Taggart, Jorgensen and Putman Gallery, in association with Robert Weimann III, Washington, D.C., Oct. 1983; DJT Collection, 1984; TFA, 1999.

Exhibitions
- *A New World—American Landscape Painting, 1839–1900*, Nationalmuseum, Stockholm, Sweden, Sept. 18–Nov. 23, 1986 [traveling exh.].
- Terra Museum of American Art 1987.
- Terra Museum of American Art 1997c.
- Musée d'Art Américain Giverny 1999 [traveling exh.].
- Musée d'Art Américain Giverny 2000a.
- Terra Museum of American Art 2001b.

Still Life with Apple Blossoms in a Nautilus Shell, 1870 (p. 66–67)
TFA 1999.7

Provenance
Estate of Eugene Sussel, Baltimore, Md., Sotheby's, New York, Sept. 23, 1993, lot 24; Jordan-Volpe Gallery, New York, 1993; Sotheby's, New York, May 27, 1999, lot 122; TFA, 1999.

Exhibitions
- *Martin Johnson Heade*, Whitney Museum of American Art, New York, 1969, no. 22.
- *American Art*, Jordan-Volpe Gallery, New York, 1994.
- *Martin Johnson Heade, A Survey: 1840–1900*, Eaton Fine Art, West Palm Beach, Fla., Dec. 1996–Feb. 1997 [catalogue].
- *The Paintings of Martin Johnson Heade*, Museum of Fine Arts, Boston, Sept. 29, 1999–Jan. 16, 2000 [traveling exh., catalogue].
- Terra Museum of American Art 2000b.
- Terra Museum of American Art 2001b.

Robert **Henri**

– Homer, William Innes. *Robert Henri and His Circle*. Ithaca, N.Y.: Cornell University Press, 1969.
– Perlman, Bernard B. *Robert Henri: His Life and Art*. New York: Dover Publications, 1991.

Figure in Motion, 1913 (p. 154–155)
TFA 1999.69

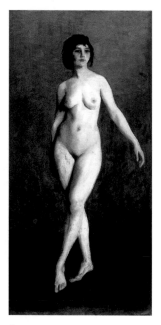

Provenance
Mr. and Mrs. John LeClaire, New York; Berry-Hill Galleries, New York (agent), DJT Collection, 1984; TFA, 1999.
Exhibitions
– *The International Exhibition of Painting and Sculpture* (The Armory Show), The Association of American Painters and Sculptors, The Armory of the Sixty-ninth Regiment, New York, Feb. 17–Mar. 15, 1913 [traveling exh.].
– *The 1913 Armory Show in Retrospect*, Mead Arts Building at Amherst College, Amherst, Mass., Feb. 17–Mar. 17, 1958 [catalogue].
– *The 1913 Armory Show—50th Anniversary Exhibition*, The Munson-Williams-Proctor Institute, Utica, N.Y., Feb. 17–Mar. 31, 1963 [traveling exh., catalogue].
– *Three Centuries of the American Nude*, The New York Cultural Center, New York, May 9–July 13, 1975, no. 67 [traveling exh.].
– Terra Museum of American Art 1987.
– *Painters of a New Century: The Eight*, Milwaukee Art Museum, Milwaukee, Wis., Sept. 6–Nov. 3, 1991 [traveling exh., catalogue].
– *Henri's Disciples: William Glackens & John Sloan*, Museum of Art, Fort Lauderdale, Fla., Feb. 5–Apr. 2, 1995.
– Terra Museum of American Art 2000a.
– Terra Museum of American Art 2001d.

Edward **Hicks**

– Mather, Eleanore Price, and Dorothy Canning Miller. *Edward Hicks: His Peaceable Kingdoms and Other Paintings*. Newark, Del.: University of Delaware Press, 1983.
– Tatham, David. "Edward Hicks, Elias Hicks, and John Comly: Perspectives on the Peaceable Kingdom Theme." *The American Art Journal* 13, no. 2 (Spring 1981): 36–50.
– Weekley, Carolyn J. *The Kingdoms of Edward Hicks*. Williamsburg, Va.: The Colonial Williamsburg Foundation; New York: Harry N. Abrams, 1999.

A Peaceable Kingdom with Quakers Bearing Banners, c. 1827 (p. 44–45)
TFA 1993.7

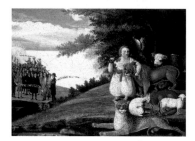

Provenance
Edith Gregor Halpert, American Folk Art Gallery, New York, Apr. 10, 1933; Bucks County Pennsylvania Antique Dealer; Holger Cahill and Dorothy Miller, New York, May 17, 1940–91; Joan Washburn Gallery, New York, 1991–93; Christie's, New York, Jan. 23, 1993, lot 386; Berry-Hill Galleries, New York; TFA, Feb. 1993.
Exhibitions
– *Edward Hicks, 1780–1849: A Special Exhibition Devoted to His Life and Work*, Abby Aldrich Folk Art Collection, Williamsburg, Va., Sept. 30–Oct. 30, 1960.
– *Three Self-Taught Pennsylvania Artists: Hicks, Kane, Pippin*, The Carnegie Institute, Pittsburgh, Pa., Oct. 21–Dec 4, 1966 [traveling exh., catalogue].
– *Edward Hicks: A Gentle Spirit*, Andrew Crispo Gallery, New York, May 15–July 27, 1975 [catalogue].
– Terra Museum of American Art 1995.
– Terra Museum of American Art 1996b.
– Terra Museum of American Art 1997c.
– *The Kingdoms of Edward Hicks*, The Abby Aldrich Rockefeller Center, Williamsburg, Va., Feb. 5–Sept. 5, 1999 [traveling exh., catalogue].
– Terra Museum of American Art 2000b.
– Musée d'Art Américain Giverny 2001a.

Winslow **Homer**

– Conrads, Margaret C. *Winslow Homer and the Critics: Forging a National Art in the 1870s*. Princeton: Princeton University Press; Kansas City, Mo.: The Nelson-Atkins Museum of Art, 2001.
– Cooper, Helen A. *Winslow Homer Watercolors*. Washington, D.C.: The National Gallery of Art, 1986.
– Kelly, Franklin, and Nicolai Cikovsky, Jr. *Winslow Homer*. Washington, D.C.: National Gallery of Art, 1995.

On Guard, 1864 (p. 88–89)
TFA 1994.11

Provenance
Samuel P. Avery, New York; Somerville Art Galleries, New York, Samuel P. Avery Sale, Mar. 20–21, 1871, no. 76; Allan Campbell Smidt, Greenwich, Conn.; Estate of Allan Campbell Smidt, Greenwich, Conn., 1935–36 (sale); Kenneth C. Faile, Greenwich, Conn.; descended in family; Christie's, New York, May 26, 1994, lot 31; Berry-Hill Galleries, New York (agent), TFA, 1994.
Exhibitions
– *Fifth Annual Exhibition*, Artist's Fund Society, New York, Nov.–Dec., 1864, no. 215.
– *Winslow Homer: Illustrator*, Smith College Museum of Art, Northampton, Mass., Feb. 1951, no. 2.
– Exhibition, Williams College Museum of Art, Williamstown, Mass., Mar. 1951.
– *Winslow Homer at a Glance*, Musée d'Art Américain Giverny, Apr. 1–Sept. 24, 1995.
– Terra Museum of American Art 1995.
– Terra Museum of American Art 1997a.
– Terra Museum of American Art 2000b.
– Musée d'Art Américain Giverny 2001a.

Apple Picking, 1878 (p. 90–91)
TFA 1992.7

Provenance
George S. Robbins, Conn.; descended in family; Mrs. Edward C. Robbins (Gertrude L.), Haverford, Pa. (daughter-in-law of George S. Robbins); Hirschl & Adler Galleries, New York, Jan. 1975; Margaret Lynch, Chestnut Hill, Mass.; Kennedy Galleries, New York, Apr. 1981; Mr. Richard Manoogian; Thomas Colville, Fine Paintings, New Haven, Conn.; TFA, 1992.
Exhibitions
– *American Art in Water-Colors. The Twelfth Annual Exhibition of the Water-Color Society*, National Academy of Design, New York, 1879, no. 234 (as *In the Orchard*).
– *Winslow Homer Watercolors*, National Gallery of Art, Washington, D.C., Mar. 2–May 11, 1986, no. 38 [traveling exh.].
– *Winslow Homer at a Glance*, Musée d'Art Américain Giverny, Apr. 1–Sept. 24, 1995.
– *Winslow Homer Retrospective*, National Gallery of Art, Washington, D.C., Oct. 15, 1995–Jan. 28, 1996 [traveling exh., catalogue].
– Musée d'Art Américain Giverny 1999 [traveling exh.].
– *Winslow Homer in the 1870s*, The Nelson-Atkins Museum of Art, Kansas City, Mo., Feb. 18–May 6, 2001.

Edward **Hopper**

– Bonnefoy, Yves, and Nicolas Cendo. *Edward Hopper*. Marseille, France: Musée Cantini, 1989.
– Levin, Gail. *Edward Hopper. A Catalogue*. New York: Whitney Museum of American Art, 1995.
– Lyons, Deborah, et al. *Edward Hopper and the American Imagination*. New York: Whitney Museum of American Art, 1995.

George **Inness**

– Cikovsky, Nicolai Jr. *George Inness*. New York: Harry N. Abrams; Washington, D.C.: National Museum of American Art, 1993.
– Ireland, LeRoy. *The Works of George Inness. An Illustrated Catalogue Raisonné*. Austin: University of Texas Press, 1965.
– Taylor, Eugene. "The Interior Landscape: George Inness and William James on Art from a Swedenborgian Point of View." *Archives of American Art Journal* 37 (1997): 2–10.

John Frederick **Kensett**

– Driscoll, John Paul, et al. *John Frederick Kensett: An American Master*. Worcester, Mass.: Worcester Art Museum; New York: W. W. Norton & Company, 1985.
– Sullivan, Mark W. "John F. Kensett at Newport: The Making of a Luminist Painter." *Antiques* (Nov. 1990): 1030–41.

A Garden in Nassau, 1885 (p. 92–93)
TFA 1994.10

Provenance
John S. Ames, Esquire, Boston; Copley Gallery, Boston; Christie's, New York, May 26, 1988, lot 95; Berry-Hill Galleries, New York, 1988; TFA, 1994.
Exhibitions
– *Exhibition of Works by Winslow Homer and John La Farge*, Museum of Fine Arts, Boston, June–Aug. 1936.
– *Winslow Homer Centenary Exhibition*, Whitney Museum of American Art, New York, Dec. 15, 1936–Jan. 15, 1937, no. 59 (as *Pickaninny and Palm Tree*) [catalogue].
– *Art in New England: Paintings, Drawings and Prints from Private Collections in New England*, Museum of Fine Arts, Boston, June 9–Sept. 10, 1939 (as *Pickaninny and Palm Trees*) [catalogue].
– *Winslow Homer at a Glance*, Musée d'Art Américain Giverny, Apr. 1–Sept. 24, 1995.
– *Winslow Homer Retrospective*, National Gallery of Art, Washington, D.C., Oct. 15, 1995–Jan. 28, 1996 [traveling exh., catalogue].
– Musée d'Art Américain Giverny 2001a.

Dawn in Pennsylvania, 1942 (p. 186–187)
TFA 1999.77

Provenance
Dr. and Mrs. James Hustead Semans, Durham, N.C.; Berry-Hill Galleries, New York; DJT Collection, 1986; TFA, 1999.
Exhibitions
– *Robert Henri and Five of his Pupils*, The Century Association, New York, Apr. 5–June 1, 1946 [catalogue].
– *Edward Hopper Retrospective Exhibition*, Whitney Museum of American Art, New York, Feb. 11–Mar. 26, 1950 [traveling exh., catalogue].
– *Edward Hopper*, Whitney Museum of American Art, New York, Sept. 29–Nov. 29, 1964 [traveling exh., catalogue].
– *IX Biennial. Edward Hopper and Environment USA: 1957–1967*, São Paulo, Brazil, 1967.
– *Edward Hopper: Art and Artist*, Whitney Museum of American Art, New York, Sept. 16, 1980–Jan. 18, 1981 [traveling exh., catalogue].
– *Solitude—Inner Visions in American Art*, Terra Museum of American Art, Evanston, Ill., Sept. 25–Dec. 30, 1982 [catalogue].
– Terra Museum of American Art 1987.
– *Edward Hopper*, Musée Cantini, Marseilles, France, June 23–Sept. 24, 1989 [traveling exh.].
– *Edward Hopper—Die Wahrheit des Sichtbaren/Edward Hopper und die Fotografie im 20. Jahrhundertz*, Museum Folkwang, Essen, Germany, June 28–Sept. 27, 1992.
– *Edward Hopper*, Schirn Kunsthalle, Frankfurt, Germany, Dec. 4, 1992–Feb. 14, 1993 [traveling exh., catalogue].
– *Questions about Four Paintings*, Westfalian Kunstverein, Munster, Germany, June 4–July 11, 1993.
– *Edward Hopper and the American Imagination*, Whitney Museum of American Art, New York, June 21–Oct. 15, 1995 [catalogue].
– Terra Museum of American Art 1996b.
– Terra Museum of American Art 1997c.
– Terra Museum of American Art 2000a.
– Musée d'Art Américain Giverny 2000b.
– Terra Museum of American Art 2001b.
– Terra Museum of American Art 2001c.

Summer, Montclair, 1877 (p. 78–79)
TFA 1999.78

Provenance
Mrs. George Inness, New York, 1904 (widow of the artist); R. C. Vose Galleries, Boston; Moulton & Ricketts Galleries, Chicago; S. C. Scotten Collection, Chicago; L. A. Clubb Collection, Okla.; Thurber Art Galleries, Chicago, 1926; Frank Vernon Nichols, Detroit, Mich., 1926; The Nichols Family, Detroit, Mich.; Thomas Colville Fine Paintings, New Haven, Conn.; DJT Collection, 1980; TFA, 1999.
Exhibitions
– *Loan Exhibition of Important Works by George Inness, Alexander Wyant, Ralph Blakelock*, Moulton & Ricketts Galleries, Chicago, Mar. 10–22, 1913.
– Terra Museum of American Art 1987.
– Terra Museum of American Art 1996b.
– Musée d'Art Américain Giverny 1999 [traveling exh.].

Near Newport, Rhode Island, 1872 (p. 74–75), TFA 1999.1

Provenance
Estate of the artist; Dr. William Diller, New York; descended in family; Malcolm McConnell (grandson of Dr. William Diller); Sotheby's, New York, Dec. 3, 1998, lot 146; TFA, 1999.
Exhibitions
– Musée d'Art Américain Giverny 2000a.
– Terra Museum of American Art 2001b.

Rockwell **Kent**

– Ferris, Scott R. and Ellen Pearce. *Rockwell Kent's Forgotten Landscapes*. Camden, Maine: Down East Books, 1998.
– Martin, Constance. *Distant Shores: The Odyssey of Rockwell Kent*. Berkeley, Calif.: University of California Press; Stockbridge, Mass.: Norman Rockwell Museum, 2000.

Summer, Greenland, c. 1932–1933 (p. 180–181), TFA 1998.2

Provenance
Christie's, New York, May 21, 1998, lot 167; TFA, 1998.
Exhibitions
– Musée d'Art Américain Giverny 2000b.

Walt **Kuhn**

- Adams, Philip Rhys. *Walt Kuhn, Painter: His Life and Work*. Columbus, Ohio: Ohio State University Press, 1978.
- *Walt Kuhn 1877–1949: A Memorial Exhibition*. Cincinnati, Ohio: Cincinnati Art Museum, 1960.

Clown with Drum, 1942 (p. 184–185)
TFA 1992.172

Provenance
Kuhn Estate; Maynard Walker, 1967; Mr. Philip Sills, Riverdale-on-Hudson, N.Y.; Sotheby's, New York, Dec. 3, 1992, lot 148; Berry-Hill Galleries, New York (agent), TFA, 1992.
Exhibitions
- *Whitney Annual*, Whitney Museum of American Art, New York, Dec. 24, 1942–Jan. 6, 1943.
- *Walt Kuhn 1877–1949*, Cincinnati Art Museum, Cincinnati, Ohio, 1960 [catalogue].
- *Walt Kuhn: Painter of Vision*, University of Arizona Art Gallery, Tucson, Ariz., Feb. 6–Mar. 31, 1966, no. 95 [catalogue].
- *Walt Kuhn, A Classic Revival*, The Amon Carter Museum, Fort Worth, Tex., Aug. 6–Sept. 10, 1978 [traveling exh.].
- Terra Museum of American Art 2000a.
- Musée d'Art Américain Giverny 2000b.
- Terra Museum of American Art 2001b.
- Terra Museum of American Art 2001c.

John **La Farge**

- Adams, Henry, et al. *John La Farge*. New York: Abbeville Press; Pittsburgh, Pa.: Carnegie Museum of Art, 1987.
- Yarnell, James L. *John La Farge in Paradise: The Painter and His Muse*. Newport, R.I.: William Vareika Fine Arts, 1995.

Paradise Valley, c. 1865 (p. 68–69)
TFA 1996.92

Provenance
Doll and Richards Gallery, Boston; Alice Sturgis Hooper, Boston; Private collection (by descent); Christie's, New York, May 23, 1996, lot 18; Adelson Galleries, New York (agent), TFA, 1996.
Exhibitions
- *Fifty-First Annual Exhibition*, National Academy of Design, New York, Spring 1876, no. 188 (as *New England Pasture Land*) [catalogue].
- Exhibition, Doll and Richards Gallery, Boston, August 1876.
- *Fourteenth Catalogue, Works of Art Exhibited*, Museum of Fine Arts, Boston, 1877, no. 178.
- *Exposition universelle*, Paris, Sept. 1878, no. 73 [catalogue].
- *Retrospective Exhibition of the Society of American Artists*, Society of American Artists, New York, Dec. 5–25, 1892, no. 203N.
- *Grosse Berliner Kunst-Ausstellung*, Berlin International Exposition, Berlin, Germany, May 1–Sept. 29, 1895, no. 961.
- Exhibition, Century Association, New York, Mar. 1896 (as *Paradise Valley, Newport, Rhode Island*).
- Exhibition, Bing Gallery, Paris, Summer 1896.
- *A Loan Collection of Pictures by Old Masters and Other Painters*, Copley Society, Copley Hall, Boston, 1903, no. 6 [catalogue].
- *Comparative Exhibition of Native and Foreign Art*, American Fine Arts Society, New York, Nov. 15–Dec. 11, 1904, no. 94.
- *La Farge Memorial Exhibition*, Museum of Fine Arts, Boston, Jan. 1–31, 1911.
- *Opening of the Howard Gardiner Cushing Memorial: Retrospective Exhibition of Newport Artists*, Newport Art Association, Newport, R.I., Aug. 1–15, 1920, no. 21.
- *Loan Exhibition of Paintings by John La Farge and His Descendants*, Wildenstein and Co., New York, Mar. 1931, no. 3.
- *An Exhibition of the Work of John La Farge*, The Metropolitan Museum of Art, New York, Mar. 23–Apr. 26, 1936 [catalogue].
- *Retrospective Exhibition of the Work of Artists Identified with Newport*, Newport Art Association, Newport, R.I., July 25–Aug. 15, 1936.
- *A Century of American Landscape Painting 1800–1900*, Whitney Museum of American Art, New York, Jan. 19–Feb. 25, 1938.
- *A Century of American Paintings and Sculpture*, Springfield Museum of Fine Arts, Springfield, Mass., Mar. 8–28, 1938.
- *Art in Our Time*, Museum of Modern Art, New York, 1939 [catalogue].
- *Survey of American Paintings*, Carnegie Institute, Pittsburgh, Pa., Oct. 24–Dec. 15, 1940.
- *Loan Exhibition in Honor of Royal Cortissoz and his 50 Years of Criticism in the New York Herald Tribune*, M. Knoedler & Co., New York, Dec. 1–10, 1941 [catalogue].
- *John La Farge*, Museum of Fine Arts, Boston, Feb. 24–Apr. 24, 1988, organized by The Carnegie Museum of Art, Pittsburgh, Pa. [catalogue].
- Musée d'Art Américain Giverny 1999 [traveling exh.].
- Terra Museum of American Art 2001b.

Fitz Hugh **Lane**

- Miller, David C. "The Iconology of Wrecked or Stranded Boats in Mid to Late Nineteenth-Century American Culture." In David C. Miller, ed. *American Iconology: New Approaches to Nineteenth-Century Art and Literature*. New Haven, Conn. and London: Yale University Press, 1993.
- Wilmerding, John, et al. *Paintings by Fitz Hugh Lane*. New York: Harry N. Abrams; Washington, D.C.: National Gallery of Art, 1988.
- Wilmerding, John, et al. *American Light: The Luminist Movement, 1850–1875, Paintings, Drawings, and Photographs*. New York: Harper and Row, Publishers; Washington, D.C.: National Gallery of Art, 1980.

Brace's Rock, Brace's Cove, 1864 (p. 62–63), TFA 1999.83

Provenance
Private collection, Maine; Barridoff Galleries, Portland, Maine; Lano Collection, Washington, D.C.; DJT Collection, 1983; TFA, 1999.
Exhibitions
- *A New World—American Landscape Painting 1839–1900*, Nationalmuseum, Stockholm, Sweden, Sept. 18–Nov. 23, 1986 [traveling exh.].
- *Paintings by Fitz Hugh Lane*, National Gallery of Art, Washington, D.C., May 15–Sept. 5, 1988 [traveling exh., catalogue].
- Terra Museum of American Art 1995.
- Musée d'Art Américain Giverny 2000a.
- Terra Museum of American Art 2001b.

George Benjamin **Luks**

- *George Luks, An American Artist*. Wilkes-Barre, Pa.: Sordoni Art Gallery, 1987.
- *George Luks, An Artistic Legacy*. New York: Owen Gallery, 1997.
- Trovato, Joseph S. and Ira Glackens. *George Luks, 1866–1933: An Exhibition of Paintings and Drawings Dating from 1889–1931*. Utica, N.Y.: Museum of Art, Munson-Williams-Proctor Institute, 1973.

Knitting for the Soldiers: High Bridge Park, c. 1918 (p. 152–153)
TFA 1999.87

Provenance
Descended in family of the artist until 1950; Parke-Bernet Galleries, New York, Apr. 5, 1950, lot 58; Jack E. and Zella B. Butler Foundation, New York; Christie's, New York, May 23, 1990, lot 185; Berry-Hill Galleries, New York (agent), DJT Collection, 1990; TFA, 1999.
Exhibitions
- Exhibition, Kraushaar Gallery, New York, 1918.
- *One Hundred Twenty-Sixth Annual Exhibition*, Pennsylvania Academy of the Fine Arts, Philadelphia, Jan. 25–Mar. 15, 1931.
- Exhibition, Rhode Island School of Design, Providence, R.I.
- *Metropolitan Lives: Ashcan Artists and Their New York*, National Museum of American Art, Washington, D.C., Nov. 15, 1995–Mar. 17, 1996 [traveling exh., catalogue].
- Musée d'Art Américain Giverny 1999 [traveling exh.].
- Terra Museum of American Art 2001b.
- Terra Museum of American Art 2001c.
- Terra Museum of American Art 2001d.

Frederick William **MacMonnies**

– Smart, Mary, and Adina E. Gordon. *A Flight with Fame: The Life and Art of Frederick MacMonnies with a Catalogue Raisonné of Sculpture and a Checklist of Paintings.* Madison, Conn.: Sound View Press, 1996.

Self-Portrait, 1896 (p. 134–135)
TFA 1992.46

Provenance
Descended in family; Marjorie MacMonnies Young (granddaughter of the artist); Post Road Gallery, Larchmont, N.Y., c. 1984; Berry-Hill Galleries, New York; DJT Collection, 1987; TFA, 1992.

Exhibitions
– *Frederick MacMonnies and the Princeton Battle Monument*, Princeton Art Museum, Princeton, N.J., Spring 1977.
– *Frederick William MacMonnies et Mary Fairchild MacMonnies: deux artistes Américains à Giverny*, Musée Alphonse-Georges Poulain, Vernon, France, June 18–Sept. 11, 1988.
– *Face to Face: Portraits from the Collections of the Terra Museum of American Art*, Terra Museum of American Art, Chicago, Oct. 4, 1994–Apr. 2, 1995.
– Terra Museum of American Art 1997d.
– *1900: Art at the Crossroads*, Royal Academy of Arts, London, Jan. 16–Apr. 3, 2000 [traveling exh., catalogue].
– *Mary and Frederick MacMonnies: An Interlude in Giverny*, Palmer Museum of Art, Pennsylvania State University, University Park, Pa., Oct. 24, 2000–Feb. 25, 2001 [traveling exh., catalogue].
– Terra Museum of American Art 2001a.

John **Marin**

– Fine, Ruth. *John Marin*. New York: Abbeville Press; Washington, D.C.: The National Gallery of Art, 1990.
– Melvin, Ronald McKnight. *Five American Masters of Watercolor*. Evanston, Ill.: Terra Museum of American Art, 1981.
– Reich, Sheldon. *John Marin: A Stylistic Analysis and Catalogue Raisonné*. Tucson: University of Arizona Press, 1970.

Brooklyn Bridge, on the Bridge, 1930 (p. 178–179), TFA 1999.95

Provenance
John Marin family; Kennedy Galleries, New York; DJT Collection, 1981; TFA, 1999.

Exhibitions
– *Brooklyn Bridge—75th Anniversary Exhibition*, The Brooklyn Museum, Brooklyn, N.Y., Apr. 29–July 27, 1958.
– *Selections from the Private Collection of Norma and John Marin, Jr.*, Montclair Art Museum, Montclair, N.J., Dec. 14, 1958–Jan. 4, 1959.
– *John Marin: The Etchings and Related Oils, Drawings, and Watercolors*, Cape Split Place, Addison, Maine, Aug. 1–Oct. 1, 1980.
– *Five American Masters of Watercolor*, Terra Museum of American Art, Evanston, Ill., May 5–July 12, 1981 [catalogue].
– *John Marin's New York*, Kennedy Galleries, New York, Oct. 11–Nov. 6, 1981 [catalogue].
– *American Masters of the Twentieth Century*, Oklahoma Art Center, Oklahoma City, Okla., May 7–June 20, 1982 [traveling exh., catalogue].
– *The Great East River Bridge 1883–1983*, The Brooklyn Museum, Brooklyn, N.Y., Mar. 19–June 19, 1983 [catalogue].
– Terra Museum of American Art 1987.
– *Selections and Transformations: The Art of John Marin*, National Gallery of Art, Washington, D.C., Jan. 28–Apr. 15, 1990 [catalogue].
– *The Modernist Tradition in American Watercolors: 1911–1939*, Mary and Leigh Block Gallery, Northwestern University, Evanston, Ill., Apr. 5–June 22, 1991 [catalogue].
– Terra Museum of American Art 1996b.
– Terra Museum of American Art 1997c.
– Musée d'Art Américain Giverny 1999.
– Musée d'Art Américain Giverny 2000b.

Reginald **Marsh**

– Cohen, Marilyn. *Reginald Marsh's New York: Paintings, Drawings, Prints and Photographs*. New York: Dover Publications and Whitney Museum of American Art, 1983.
– Garver, Thomas H. "Reginald Marsh and the City that Never Was." In *Reginald Marsh: A Retrospective Exhibition*. Newport Beach, Calif.: Newport Harbor Art Museum, 1972.
– Goodrich, Lloyd. *Reginald Marsh*. New York: Harry N. Abrams, 1972.

Pip and Flip, 1932 (p. 182–183)
TFA 1999.96

Provenance
Frank K. Rehn Gallery, New York; Huntington Hartford Collection (Gallery of Modern Art), New York, 1956; Parke-Bernet Galleries, New York, Apr. 7–8, 1971, lot 79; Bernard Danenberg Galleries, New York; Mr. & Mrs. George Arden, New York; ACA Galleries, New York; DJT Collection, 1980; TFA, 1999.

Exhibitions
– *Reginald Marsh*, Whitney Museum of American Art, New York, Sept. 21–Nov. 6, 1955 [traveling exh., catalogue].
– *Four Centuries of American Art*, Minneapolis Institute of Art, Minneapolis, Minn., Nov. 27, 1963–Jan. 19, 1964 [catalogue].
– *Paintings from the Huntington Hartford Collection*, Huntington Hartford Museum (Gallery of Modern Art), New York, 1964 [catalogue].
Exhibition, Norton Gallery of Art, West Palm Beach, Fla., 1965.
– *Pop Art and the American Tradition*, Milwaukee Art Center, Milwaukee, Wis., Apr. 8–May 9, 1965 [catalogue].
– *Reginald Marsh*, Bernard Danenberg Galleries, New York, July 29–Aug. 13, 1971 [catalogue].
– *Reginald Marsh: A Retrospective Exhibition*, Newport Harbor Art Museum, Newport Beach, Calif., Nov. 2–Dec. 10, 1972 [traveling exh., catalogue].
– *The Modern Spirit: American Painting 1908–1935*, Arts Council of Great Britain in association with the Edinburgh Festival Society and the Royal Scottish Academy, Edinburgh, Scotland, Aug. 20–Sept. 11, 1977 [traveling exh., catalogue].

– *Center Ring: The Artist, Two Centuries of Circus Art*, Milwaukee Art Museum, Milwaukee, Wis., May 7–June 28, 1981 [traveling exh., catalogue].
– *Reginald Marsh's New York*, Whitney Museum of American Art at Philip Morris, New York, June 29–Aug. 24, 1983 [traveling exh., catalogue].
– Terra Museum of American Art 1987.
– Terra Museum of American Art 2000a.
– Musée d'Art Américain Giverny 2000b.
– Terra Museum of American Art 2001b.
– Terra Museum of American Art 2001c.
– *Images from the World Between: The Circus in Twentieth-Century American Art*, Wadsworth Atheneum, Hartford, Conn. Oct. 9, 2001–Jan.6, 2002 [traveling exh.].

Thomas Buford **Meteyard**

– Gerdts, William H. *Lasting Impressions: American Painters in France 1865–1915*. Evanston, Ill.: Terra Foundation for the Arts, 1992.
– Kilmer, Nicholas. *Thomas Buford Meteyard (1865–1928): Paintings and Watercolors*. New York: Berry-Hill Galleries, 1989.

Giverny, Moonlight, c. 1890 (p. 114–115)
TFA 1989.24

Provenance
Robert Meteyard (son of the artist), Berry-Hill Galleries, New York, 1988; TFA, 1989.

Exhibitions
Thomas Buford Meteyard (1865–1928): Paintings and Watercolors, Berry-Hill Galleries, New York, Sept. 13–Oct. 7, 1989 [catalogue].
– Musée d'Art Américain Giverny 1992.
– Terra Museum of American Art 1997d.
– Musée d'Art Américain Giverny 1998.
– Musée d'Art Américain Giverny 1999.
– *Giverny: Inside and Out*, Musée d'Art Américain Giverny, Apr.1–Oct. 31, 2000.
– Musée d'Art Américain Giverny 2001b.

Thomas **Moran**

- Anderson, Nancy K., et al. *Thomas Moran*. New Haven, Conn.: Yale University Press; Washington, D.C.: The National Gallery of Art, 1997.
- Bedell, Rebecca Bailey. *The Anatomy of Nature: Geology and American Landscape Painting, 1825–1875*. Princeton: Princeton University Press, 2001.
- Kinsey, Joni Louise. *Thomas Moran and the Surveying of the American West*. Washington, D.C.: Smithsonian Institution Press, 1992.

Autumn on the Wissahickon, 1864
(p. 60–61), TFA 1999.99

Provenance
J. S. Martin; Mrs. Gamble Latrobe, Wilmington, Del.; Mrs. Richard Reese, Wilmington, Del.; Sotheby's, New York, Apr. 25, 1980, lot 33; Graham Gallery, New York; Hirschl & Adler Galleries, New York; Alexander Gallery, New York; Sotheby's, New York, May 25, 1994, lot 29; Berry-Hill Galleries, New York (agent), DJT Collection, 1994; TFA, 1999.
Exhibitions
- *Forty-Second Annual Exhibition*, Pennsylvania Academy of the Fine Arts, Philadelphia, Spring 1865, no. 636.
- Terra Museum of American Art 1995.
- Musée d'Art Américain, Giverny 1999.
- Musée d'Art Américain Giverny 2000a.
- Terra Museum of American Art 2001b.

Samuel Finley Breese **Morse**

- Crean, Hugh R. "Samuel F. B. Morse's *Gallery of the Louvre*: Tribute to a Master and Diary of a Friendship," *American Art Journal* 16, no. 1 (Winter 1984): 76–81.
- Staiti, Paul J. *Samuel F. B. Morse*. New York: Cambridge University Press, 1989.
- Tatham, David. "Samuel F. B. Morse's *Gallery of the Louvre*: The Figures in the Foreground," *The American Art Journal* 13, no. 4 (Fall 1981): 38–48.

Gallery of the Louvre, 1831–1833
(p. 50–51), TFA 1992.51

Provenance
George Clarke, Hyde Hall, Otsego Lake, Cooperstown, N.Y., July 1834; John Townsend, Albany, N.Y.; Julia Townsend Munroe, Syracuse, N.Y., 1875 (daughter of John Townsend); Syracuse University, Syracuse, N.Y., 1884–1892 (extended loan); Syracuse University, Syracuse, N.Y., 1892; DJT Collection, 1982; TFA, 1992.
Exhibitions
- Exhibition, New York, (corner of Pine Street and Broadway), Oct. 1833.
- Exhibition, Franklin Hall, New Haven, Conn., May 2–29, 1834.
- Exhibition (annual art exhibitions), Crouse College Art Gallery, Syracuse University, Syracuse, N.Y., 1890.
- *The Exhibition of Paintings by Samuel Finley Breese Morse*, The Metropolitan Museum of Art, New York, Feb.16–Mar. 23, 1932 [catalogue].
- Exhibition, Addison Gallery, Andover, Mass., 1939.
- *Pictures within Pictures*, Wadsworth Atheneum, Hartford, Conn., 1949.
- *125 Years of American Art*, Syracuse Museum of Fine Arts, Syracuse, N.Y., Sept. 16–Oct. 11, 1953, no. 7.
- Exhibition, The Carnegie Institute, Pittsburgh, Pa., 1957 [traveling exh.].
- *Paintings, Inventions, Daguerreotypes and Documents of Samuel F. B. Morse*, Vassar College Art Gallery, Poughkeepsie, N.Y., Feb. 24–Mar. 24, 1961.
- *Special New Year's Exhibition*, The Lowe Art Center, Syracuse University, Syracuse, N.Y., Dec. 27, 1961–Jan. 14, 1962.
- *Four Centuries of American Art*, The Minneapolis Institute of Arts, Minneapolis, Minn., Nov. 27, 1963–Jan. 19, 1964 [catalogue].
- Exhibition, The Lowe Art Center, Syracuse University, Syracuse, N.Y., Dec. 1966–Jan. 1967.
- Exhibition, The Morehead Museum, Montreal, Canada, June 8–July 30, 1967.
- *Nineteenth-Century America*, The Metropolitan Museum of Art, New York, Apr. 16–Sept. 7, 1970 [catalogue].
- *The Centennial Exhibition 1870–1970*, The Lowe Art Center, Syracuse University, Syracuse, N.Y., Oct. 11–Nov. 29, 1970.
- *American Self-Portraits*, National Portrait Gallery, Washington, D.C., Feb. 1–Mar. 15, 1974 [catalogue].
- Bi-Centennial Celebration Installation, Lowe Art Gallery, Syracuse University, Syracuse, N.Y., Feb.–May 1976.
- Exhibition, Lowe Art Gallery, University of Syracuse, Syracuse, N.Y., 1979.

- *Samuel F. B. Morse*, Grey Art Gallery and Study Center, New York University, New York, Sept. 14–Oct. 23, 1982 [catalogue].
- Exhibition, National Gallery of Art, Washington, D.C., Dec. 19–Feb. 13, 1983.
- *Works by Samuel F. B. Morse from the National Academy of Design*, Cheekwood Botanical Gardens and Fine Arts Center, Nashville, Tenn., June 11–June 26, 1983.
- *Samuel Morse's Gallery of the Louvre*, The Carnegie Institute, Pittsburgh, Pa., July 1–Aug. 8, 1983.
- *A New World: Masterpieces of American Painting, 1760–1910*, Museum of Fine Arts, Boston, Sept. 7–Nov. 13, 1983 [traveling exh., catalogue].
- *Samuel F. B. Morse's Gallery of the Louvre*, Terra Museum of American Art, Evanston, Ill. [traveling exh., 1984–88].
- Terra Museum of American Art 1987.
- Musée d'Art Américain Giverny 1992.
- Musée d'Art Américain Giverny 1997.
- Terra Museum of American Art 1997d.
- Musée d'Art Américain Giverny 2001a.

William Sidney **Mount**

- Frankenstein, Alfred. *William Sidney Mount*. New York: Harry N. Abrams, 1975.
- Johns, Elizabeth. *American Genre Painting: The Politics of Everyday Life*. New Haven, Conn.: Yale University Press, 1991.
- Johnson, Deborah J. William *Sidney Mount: Painter of Everyday American Life*. New York: The American Federation of Arts, 1998.

The Trap Sprung, 1844 (p. 58–59)
TFA 1992.52

Provenance
E. L. Carey, Esquire, Philadelphia; John Towne, Philadelphia, 1845; James Graham and sons, New York; Mr. W. Melville, Stony Brook, N.Y., c. 1955–56; The Museums at Stony Brook, Stony Brook, N.Y.; Christie's, New York, Dec. 9, 1983, lot 31; Berry-Hill Galleries, New York City (agent), DJT Collection, 1983; TFA, 1992.

Exhibitions
- *Tenth Annual Exhibition of the Artists' Fund Society of Philadelphia*, Pennsylvania Academy of the Fine Arts, Philadelphia, 1845, no. 80 (as *The Dead Fall*).
- *Twenty-ninth Annual Exhibition*, Pennsylvania Academy of the Fine Arts, Philadelphia, Spring 1852, no. 94. (as *The Dead Fall*).
- *William Sidney Mount*, Century Association, New York, Jan.–Feb. 1967.
- *Painter of Rural America: William Sidney Mount*, National Gallery of Art, Washington, D.C., Nov. 23, 1968–Jan. 5, 1969 [traveling exh., catalogue].
- *Mount Exhibition and Festival*, Suffolk Museum and Carriage House, Long Island, N.Y., July–Sept. 1972.
- *William Sidney Mount and American Genre Painting*, Executive Mansion, Albany, N.Y., May–June 1974.
- *An Exhibition of Paintings by William Sidney Mount (1807–1868) to Commemorate the Opening of the William Sidney Mount Gallery*, The Museums at Stony Brook, Long Island, N.Y., Oct. 1974–Apr. 1975.
- *Recollections of Early Days*, The Museums at Stony Brook, Long Island, N.Y., Mar.–July 1977.
- *The Creative Process*, The Museums at Stony Brook, Long Island, N.Y., June–Aug. 1978.
- *Silent Storytellers*, The Museums at Stony Brook, Long Island, N.Y., July 1–Oct. 1981.
- Terra Museum of American Art 1987.
- *Art of an Emergent Nation: American Painting 1775–1865*, University of Wisconsin Milwaukee Art Museum, Milwaukee, Wis., Feb. 14–Mar. 27, 1988 [catalogue].
- Terra Museum of American Art 1995.
- Terra Museum of American Art 1996b.
- Terra Museum of American Art 1997c.
- Terra Museum of American Art 2000b.
- Musée d'Art Américain Giverny 2001a.

Lilla **Cabot Perry**

- Martindale, Meredith. *Lilla Cabot Perry. An American Impressionist*. Washington, D.C.: The National Museum of Women in the Arts, 1990.

Autumn Afternoon, Giverny, n.d.
(p. 116–117), TFA 1999.106

Provenance
Estate of the artist; Hirschl & Adler Galleries, New York, by 1971; Dr. Philip Brewer, Columbus, Ga., Dec. 1980; Berry-Hill Galleries, New York, 1986; gifted to DJT Collection, 1986; TFA, 1999.

Exhibitions
- *An Exhibition of Paintings by Lilla Cabot Perry*, Braus Galleries, New York, 1922, no. 16.
- *Lilla Cabot Perry*, Hunter Gallery of Art, Chattanooga, Tenn., Oct. 10–Nov. 26, 1971, organized by Hirschl & Adler Galleries, New York [traveling exh., catalogue].
- Terra Museum of American Art 1987.
- *Lilla Cabot Perry: An American Impressionist*, The National Museum of Women in the Arts, Washington, D.C., Sept. 28, 1990–Jan. 6, 1991 [catalogue].
- *Giverny: Inside and Out*, Musée d'Art Américain Giverny, Apr. 1–Oct. 31, 2000.
- Musée d'Art Américain Giverny 2001b.

Ammi **Phillips**

- Holdridge, Barbara C., and Lawrence B. *Ammi Phillips: Portrait Painter 1788–1865*. New York: Clarkson N. Potter, 1968.
- Hollander, Stacy C. *Revisiting Ammi Phillips: Fifty Years of American Portraiture*. New York: Museum of American Folk Art, 1994.

Girl in a Red Dress, c. 1835 (p. 46–47)
TFA 1992.57

Provenance
Dorothy Jackson, 1930s; Christie's, New York, Jan. 26, 1985, lot 145; DJT Collection, 1985; TFA, 1992.
Exhibitions
- *Children in Red*, Museum of American Folk Art, New York, Dec. 10, 1985–Feb. 16, 1986.
- Terra Museum of American Art 1987.
- *Revisiting Ammi Phillips: Fifty Years of American Portraiture*, Museum of American Folk Art, New York, Jan. 15–Apr. 30, 1994 [traveling exh., catalogue].
- Terra Museum of American Art 1997a.
- Terra Museum of American Art 2000a.
- Terra Museum of American Art 2000b.
- Terra Museum of American Art 2001b.

Maurice Brazil **Prendergast**

- Clark, Carol, et al. *Maurice Brazil Prendergast, Charles Prendergast: A Catalogue Raisonné*. Munich, Germany: Prestel Verlag; Williamstown, Mass.: Williams College Museum of Art, 1990.
- Langdale, Cecily. *Monotypes by Maurice Prendergast in the Terra Museum of American Art*. Chicago: Terra Museum of American Art, 1984.
- Mathews, Nancy Mowll. *Maurice Prendergast*. Munich, Germany: Prestel Verlag; Williamstown, Mass.: Williams College Museum of Art, 1990.
- Wattenmaker, Richard J. *Maurice Prendergast*. New York: Harry N. Abrams; Washington, D.C.: National Museum of American Art, Smithsonian Institution, 1994.

Red Cape, 1891–1894 (p. 138–139)
TFA 1992.102

Provenance
Charles Prendergast, 1924; Mrs. Charles Prendergast, 1948; Kraushaar Galleries, New York, 1956; Peter Deitsch, New York, 1956; Christie's, New York, May 13, 1986, lot 260; Davis and Langdale, New York (agent), DJT Collection, 1986; TFA, 1999.
Exhibitions
- *Prendergast Monotypes*, Kraushaar Galleries, New York, May 7–31, 1956.
- *Permanent Collection: Maurice and Charles Prendergast*, Terra Museum of American Art, Chicago, Mar. 16–Apr. 21, 1991.
- *Maurice Brazil Prendergast at a Glance*, Musée d'Art Américain Giverny, Apr. 1–Oct. 31, 1993.
- Musée d'Art Américain Giverny 1997.
- Terra Museum of American Art 1997d.
- Terra Museum of American Art 2001a.

Opal Sea, 1907–1910 (p. 140–141)
TFA 1999.118

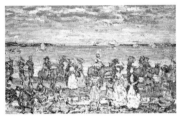

Provenance
Charles Hovey Pepper, Boston, Mass., 1910; Mrs. F. Bradshaw Wood, Gainesville, Fla. (granddaughter of Charles Hovey Pepper); Hunter Gallery, San Francisco, Calif., 1976; Dr. William Winter (?), La Jolla, Calif., 1976; Berry-Hill Galleries, New York, 1976; DJT Collection, 1976; TFA, 1999.
Exhibitions
- Exhibition, Boston Copley Gallery, Boston, Mass., 1911, no. 13.
- Exhibition, Beaux Arts Architects, 1911, no. 4.
- *Maurice Prendergast*, The Harvard Society for Contemporary Art, Cambridge, Mass., Feb.–June 1929, no. 13.
- *Maurice Prendergast Memorial Exhibition*, Whitney Museum of American Art, New York, Feb. 21–Mar. 22, 1934 [catalogue].
- *The Prendergasts: Retrospective Exhibition of the Work of Maurice and Charles Prendergast*, Addison Gallery of American Art, Andover, Mass., 1938 [catalogue].
- Exhibition, San Francisco Palace of the Legion of Honor, San Francisco, Calif., 1949 (as *Summer on the Beach*).
- *Maurice Prendergast: Art of Impulse and Color*, University of Maryland Art Gallery, College Park, Md., Sept. 1–Oct. 6, 1976 [traveling exh., catalogue].
- *American Paintings from the Collection of Daniel J. Terra*, Museum of Art, Pennsylvania State University, University Park, Pa., June 5–July 17, 1977 [catalogue].
- *American Impressionism*, Henry Art Gallery, University of Washington, Seattle, Wash., Jan. 3–Mar. 2, 1980 [traveling exh., catalogue].
- Terra Museum of American Art 1987.
- *Maurice Prendergast*, Williams College Museum of Art, Williamstown, Mass., Oct. 6–Dec. 16, 1990 [traveling exh., catalogue].
- *Maurice Brazil Prendergast at a Glance*, Musée d'Art Américain Giverny, Apr. 1–Oct. 31, 1993.
- Terra Museum of American Art 1997c.
- Musée d'Art Américain Giverny 2000a.
- *Selections from the Permanent Collection: Art and Craft, The Work of Charles and Maurice Brazil Prendergast*, Terra Museum of American Art, Chicago, Mar. 10–Sept. 16, 2001.

St. Malo, c. 1907 (p. 142–143)
TFA 1999.121

Provenance
Charles Prendergast, 1924; Mrs. Charles Prendergast, 1948; DJT Collection, 1984; TFA, 1999.
Exhibitions
- *Maurice Prendergast, Paintings, and Watercolors*, Kraushaar Galleries, New York, Nov. 13–Dec. 9, 1944.
- *American Impressionism*, Musée du Petit Palais, Paris, Mar. 30–May 30, 1982, organized by Smithsonian Institution Traveling Exhibition Service, Washington, D.C. [traveling exh., catalogue].
- Terra Museum of American Art 1987.
- *Maurice Brazil Prendergast at a Glance*, Musée d'Art Américain Giverny, Apr. 1–Oct. 31, 1993.
- Terra Museum of American Art 1996a.
- Musée d'Art Américain Giverny 2000a.

Theodore **Robinson**

- Baur, John I. H. *Theodore Robinson, 1852–1896*. Brooklyn: The Brooklyn Art Museum, 1946.
- Johnston, Sona. *Theodore Robinson, 1852–1896*. Baltimore: The Baltimore Museum of Art, 1973.

The Wedding March, 1892 (p. 120–121)
TFA 1999.127

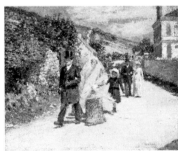

Provenance
George Bailey Wheeler, New York, by 1946; Wheeler Estate, 1955; Parke-Bernet Galleries, New York, Oct. 14–15, 1955, lot 119 (as *Going to Church*); Milch Art Gallery/Babcock Gallery/James Graham & Sons, New York, 1955–58; Mrs. John Barry Ryan, New York, 1958–78; Hirschl & Adler Galleries, New York, 1978; DJT Collection, 1978; TFA, 1999.

Theodore **Robinson** (continued)

Exhibitions

- *Theodore Robinson, American Impressionist*,
 Kennedy Galleries, New York, 1966
 [catalogue].
- *Nineteenth-Century America Paintings and
 Sculpture*, The Metropolitan Museum of Art,
 New York, Apr. 16–Sept. 7, 1972 [catalogue].
- *Eighteenth- and Nineteenth-Century American
 Art from Private Collections*, Whitney Museum
 of American Art, New York, May 1–June 10,
 1973 [catalogue].
- *Theodore Robinson*, Baltimore Museum of Art,
 Baltimore, Md., May 1–June 10, 1973
 [traveling exh., catalogue].
- *Impressionism, A Centenary Exhibition*,
 The Metropolitan Museum of Art, New York,
 Dec. 1974–Feb. 1975 [catalogue, but not
 included].
- *American Impressionism*, Henry Art Gallery,
 University of Washington, Seattle, Wash.,
 Jan. 3–Mar. 2, 1980 [traveling exh.,
 catalogue].
- *Americans in Brittany and Normandy:
 1860–1910*, Phoenix Art Museum, Phoenix,
 Ariz., Mar. 19–May 1, 1983 [traveling exh.,
 catalogue].
- Terra Museum of American Art 1987.
- *Bilder aus der Neuer Welt. Amerikanische
 Malerie des 18. und 19. Jahrhunderts*,
 Staatliche Museen Preussischer Kulturbesitz,
 Nationalgalerie, Orangerie des Schlosses,
 Charlottenburg, Berlin, Germany, Nov. 22,
 1988–Feb. 5, 1989 [traveling exh., catalogue].
- Musée d'Art Américain Giverny 1992.
- Terra Museum of American Art 1997b.
- Terra Museum of American Art 1997d.
- Musée d'Art Américain Giverny 1998.
- *First Exposure: The Sketchbooks and
 Photographs of Theodore Robinson*,
 Musée d'Art Américain Giverny,
 Apr. 1–July 16, 2000 [traveling exh., catalogue].
- Musée d'Art Américain Giverny 2001b.

John Singer **Sargent**

- Adelson, Warren, et al. *Sargent Abroad:
 Figures and Landscapes*. New York:
 Abbeville Press, 1997.
- Fairbrother, Trevor. *John Singer Sargent*.
 New York: Harry N. Abrams, 1994.
- Kilmurray, Elaine, and Richard Ormond, ed.
 John Singer Sargent. Boston: Museum
 of Fine Arts, 1999.
- Ormond, Richard, and Elaine Kilmurray.
 *John Singer Sargent: The Early Portraits,
 Complete Paintings*, I. New Haven, Conn.
 and London: Yale University Press, 1998.
- Ratcliff, Carter. *John Singer Sargent*.
 New York: Abbeville Press, 2001.

Breton Girl with a Basket, Sketch
for *The Oyster Gatherers of Cancale*,
1877 (p. 94–95), TFA 1999.129

Provenance
Parke-Bernet Galleries, New York, April 7–8,
1971, lot 30; DJT Collection, 1980; TFA, 1999.
Exhibitions
- *American Paintings from the Collection
 of Daniel J. Terra*, Museum of Art,
 The Pennsylvania State University, University
 Park, Pa., June 5–July 17, 1977 [catalogue].
- *Americans in Brittany and Normandy:
 1860–1910*, Phoenix Art Museum, Phoenix,
 Ariz., Mar. 19–May 1, 1983 [traveling exh.,
 catalogue].
- Terra Museum of American Art 1987.
- Musée d'Art Américain Giverny 1992.
- Terra Museum of American Art 1997b.
- Musée d'Art Américain Giverny 2000a.
- *Selections from the Permanent Collection:
 American Artists in France, 1860–1910*,
 Terra Museum of American Art, Chicago,
 Mar. 10–June 3, 2001.

A Parisian Beggar Girl, c. 1880
(p. 96–97), TFA 1994.14

Provenance
Paul and Ida Schulze family, Chicago,
c. early 1920s; Helen Schulze, 1929 or 1931
(daughter of Paul and Ida Schulze); descended
in family; Sotheby's, New York, May 25, 1994,
lot 66; Berry-Hill Galleries, New York (agent),
TFA, 1994.

Exhibitions
- *Memorial Exhibition of the Works of John
 Singer Sargent*, Museum of Fine Arts, Boston,
 Nov. 3–Dec. 27, 1925, no. 12 [catalogue].
- *John Singer Sargent Memorial Exhibition*,
 The Metropolitan Museum of Art, New York,
 Jan. 4–Feb. 14, 1926, no. 3.
- Exhibition, Dallas Museum of Fine Arts, Dallas,
 Tex., 1975, no. 9.
- *Lasting Impressions: American Painters
 in France, 1865–1915*, Musée d'Art Américain
 Giverny, Apr. 1–Oct. 31, 1995.
- Musée d'Art Américain Giverny 1997.
- Terra Museum of American Art 1997d.
- Musée d'Art Américain Giverny 1998.
- Musée d'Art Américain Giverny 1999
 [traveling exh.].
- Musée d'Art Américain Giverny 2001a.

Charles Rettew **Sheeler**

- Friedman, Martin. *Charles Sheeler*. New York:
 Watson-Guptill Publications, 1975.
- *The Elite and Popular Appeal of the Art
 of Charles Sheeler*. New York: James Maroney,
 1986.
- Troyen, Carol, and Erica E. Hirshler.
 Charles Sheeler: Paintings and Drawings.
 Boston: Museum of Fine Arts, 1987.

Flower Forms, 1917 (p. 162–163)
TFA 1987.33

Provenance
John Quinn, New York, Mar. 1920; sold by
the Estate of John Quinn, Feb. 9, 1927, lot 68;
Alex Liebermann, Philadelphia; Earl Horter,
Germantown and Philadelphia; Mrs. John Earle
Keim, Philadelphia; Mrs. Earl Horter,
Doylestown and Philadelphia; Berry-Hill
Galleries, New York; DJT Collection, 1986;
TFA, 1987.

Exhibitions
- *Abstract Painting in America*, Whitney
 Museum of American Art, New York,
 Feb. 12–Mar. 2, 1935, cat. 104.
- *Charles Sheeler: Paintings, Drawings,
 Photographs*, The Museum of Modern Art,
 New York, Oct. 4–Nov. 1, 1939 [catalogue].
- *Pioneers of Modern Art in America*, Whitney
 Museum of American Art, New York,
 Apr. 9, 1946–May 30, 1947 [traveling exh.,
 catalogue].
- *Charles Sheeler: A Retrospective Exhibition*,
 Art Galleries of the University of California,
 Los Angeles, Calif., Oct. 11, 1954–June 15,
 1955 [traveling exh., catalogue].
- *Charles Sheeler*, National Collection of Fine
 Arts, Smithsonian Institution, Washington,
 D.C., Oct. 10, 1968–Apr. 27, 1969
 [catalogue].
- *The Noble Buyer: John Quinn, Patron of the
 Avant-Garde*, Hirshhorn Museum and
 Sculpture Garden, Smithsonian Institution,
 Washington, D.C., June 15–Sept. 4, 1978
 [catalogue].
- *Reflections of Nature: Flowers in American Art*,
 Whitney Museum of American Art, New York,
 Mar. 1–May 20, 1984 [catalogue].
- *The Elite and Popular Appeal of the Art
 of Charles Sheeler*, The Woodmere Art Gallery,
 Chestnut Hill, Pa., Apr. 1986 [catalogue].
- Terra Museum of American Art 1987.
- *Charles Sheeler: Paintings, Drawings,
 Photographs*, Museum of Fine Arts, Boston,
 Oct. 13, 1987–Jan. 3, 1988 [traveling exh.].
- Terra Museum of American Art 2000a.
- Terra Museum of American Art 2001a.
- Terra Museum of American Art 2001b.
- Terra Museum of American Art 2001c.

Francis Augustus **Silva**

- Wilmerding, John. *American Marine Painting*.
 New York: Harry N. Abrams, 1987.

Ten Pound Island, Gloucester,
1871–1872 (p. 72–73), TFA 1999.137

Provenance
Private collection, Greenwich, Conn.;
Berry-Hill Galleries, New York; DJT Collection,
1984; TFA, 1999.

Exhibitions
- Terra Museum of American Art 1987.
- Musée d'Art Américain Giverny 2000a.
- *Ships at Sea: Sailing through Summer*,
 Terra Museum of American Art, Chicago,
 June 6–Aug. 26, 2001.

Henry Ossawa **Tanner**

– Boime, Albert. "Henry Ossawa Tanner: Subversion of Genre." *Art Bulletin* 75 (Sept. 1993): 415–42.
– Mosby, Dewey F. *Henry Ossawa Tanner*. Philadelphia: Philadelphia Museum of Art, 1991.
– *Across Continents and Cultures: The Art and Life of Henry Ossawa Tanner*. Kansas City, Mo.: The Nelson-Atkins Museum of Art, 1995.
– Woods, Naurice Frank Jr. *Insuperable Obstacles: The Impact of Racism on the Creative and Personal Development of Four Nineteenth-Century African-American Artists* (Ph.D. diss.). Cincinnati, Ohio: The Union Institute, 1993.

Les Invalides, Paris, 1896 (p. 136–137)
TFA 1999.140

Provenance
Private collection, France; Hirschl & Adler Galleries, New York, 1968; Mr. & Mrs. Salim Lewis, N.J., 1968; Mrs. Diana Bonnor Lewis Collection; Hirschl & Adler Galleries, New York, 1983; DJT Collection, 1983; TFA, 1999.
Exhibitions
– *The Art of Henry O. Tanner (1858–1937)*, Frederick Douglass Institute in collaboration with the National Collection of Fine Arts, Smithsonian Institution, Washington, D.C., July 23–Sept. 7, 1969 [traveling exh., catalogue].
– *Turn-of-the-Century: Paintings, Graphics, Photographs, 1890–1910*, Whitney Museum of American Art, New York, June 30–Oct. 2, 1977 [traveling exh., catalogue].
– Exhibition, Museum of Fine Arts, Boston, Robert Dawson Evans Memorial Wing Painting Reinstallation, Dec. 1, 1986–Mar. 31, 1987.
– Terra Museum of American Art 1987.
– *Henry Ossawa Tanner 1859–1937*, Philadelphia Museum of Art, Philadelphia, Jan. 20–Apr. 14, 1991 [traveling exh., catalogue].
– Musée d'Art Américain Giverny 1992.
– Terra Museum of American Art 1997b.
– Terra Museum of American Art 1997d.
– Musée d'Art Américain Giverny 1999 [traveling exh.].
– Musée d'Art Américain Giverny 2001a.

Edmund Charles **Tarbell**

– Pierce, Patricia J. *Edmund C. Tarbell and the Boston School of Painting (1889–1980)*. Hingham, Mass: Pierce Galleries, 1980.
– Doherty, Linda J., et al. *Impressionism Transformed: The Paintings of Edmund C. Tarbell*. Manchester, N.H.: Currier Gallery of Art, 2001.

In the Orchard, 1891 (p. 122–123)
TFA 1999.141

Provenance
– Mrs. E. C. Tarbell; Josephine Tarbell Ferrell; Dr. Albert Cannon; National Collection of Fine Arts, Washington, D.C.; Dr. Albert Cannon, Charleston, S.C.; Vose Galleries, Boston (partnership Ed Shein); Herbert M. and Beverly Gelfand, Beverly Hills, Calif., 1981; Berry-Hill Galleries, New York (agent), DJT Collection, 1992; TFA, 1999.
Exhibitions
– *Frank W. Benson and Tarbell*, St. Botolph Club, Boston, 1891.
– *Sixty-seventh Annual Exhibition*, National Academy of Design, New York, Apr. 4–May 14, 1892, no. 136.
– *World Columbian Exposition*, Chicago, 1893.
– *Winter Exhibition*, Worcester Art Museum, Worcester, Mass., 1898–99.
– Exhibition, Museum of Fine Arts School of Drawing & Painting, Boston, Spring–Summer 1899, no. 274; Feb.–May 1900; Winter 1900; May 1902; Winter 1902; Jan. 1903, no. 380; Mar. 1903.
– Exhibition, Durand-Ruel Galleries, New York, 1902.
– *Exhibition of Ten American Painters (1898–1918)*, Durand-Ruel Galleries, New York, 1903.
– *Eleventh Annual Exhibition of American Art*, Cincinnati Art Museum, Cincinnati, Ohio, May 21–July 11, 1904.
– *A Collection of Paintings by Edmund C. Tarbell*, Worcester Art Museum, Worcester, Mass., Apr. 21–May 7, 1905, no. 26.
– *Exhibition of Paintings by Edmund C. Tarbell*, Corcoran Gallery of Art, Washington, D.C., Jan. 8–29, 1908, no. 17.
– *Paintings by Edmund C. Tarbell*, Copley Society, Boston, May 1912, no. 63.
– *Exhibition of Paintings by Edmund C. Tarbell*, Corcoran Gallery of Art, Washington, D.C., Jan. 22–Feb. 13, 1916, no. 30.
– *Frank W. Benson, Edmund C. Tarbell: Exhibition of Paintings, Drawings, and Prints*, Museum of Fine Arts, Boston, Nov. 16–Dec. 15, 1938, no. 148 [catalogue].
– Exhibition, National Collection of Fine Arts, Washington, D.C., Mar. 1955.
– *Centennial Exhibition of Paintings by Edmund C. Tarbell N.A. (1862–1938)*, Smithsonian Institution, Washington, D.C., July 9–Aug. 19, 1962, no. 6.
– *American Impressionist Painting*, National Gallery of Art, Washington, D.C., July 1–Aug. 26, 1973 [traveling exh., catalogue].
– *Two American Impressionists: Frank W. Benson and Edmund C. Tarbell*, University Art Galleries, University of New Hampshire, Durham, N.H., Mar. 12–Apr. 26, 1979 [catalogue].

– *The Bostonians: Painters of an Elegant Age, 1870–1930*, Museum of Fine Arts, Boston, June 11–Sept. 14, 1986 [catalogue].
– *American Impressionism: Masterworks From Public and Private Collections in the United States*, Villa Favorita, Thyssen-Bornemisza Foundation, Lugano-Castagnola, Italy, July 22–Oct. 28, 1990 [catalogue].
– *Revisiting the White City: American Art at the 1893 World's Fair*, National Museum of American Art, Smithsonian Institution, Washington, D.C., Apr. 16–Aug. 15, 1993 [catalogue].
– *American Impressionism and Realism: The Painting of Modern Life, 1885–1915*, The Metropolitan Museum of Art, New York, May 10–July 24, 1994 [traveling exh., catalogue].
– *La Belle Epoque*, Nassau County Museum of Art, Roslyn Harbor, N.Y., June 11–Sept. 24, 1995 [catalogue].
– Musée d'Art Américain Giverny 1999 [traveling exh.].
– Terra Museum of American Art 2001b.
– *Edmund C. Tarbell: Impressionism Transformed*, Currier Gallery of Art, Manchester, N.H., Oct. 13, 2001–Jan. 7, 2002 [traveling exh., catalogue].

Helen **Torr**

– DePietro, Anne Cohen, et al. *Arthur Dove and Helen Torr: The Huntington Years*. Huntington, N.Y.: The Heckscher Museum, 1989.

Purple and Green Leaves, n.d. (p. 160–161), TFA 1999.142

Provenance
Private collection; John Berggruen Gallery, San Francisco, Calif.; Berry-Hill Galleries, New York; DJT Collection, 1984; TFA, 1999.
Exhibitions
– Group Exhibition, Opportunity Gallery, New York, 1927.
– *Dove-Torr Exhibition*, An American Place, New York, 1933.
– *Helen Torr*, Heckscher Museum, Huntington, N.Y., June 3–July 9, 1972 [traveling exh.].
– *Helen Torr*, Graham Gallery, New York, Mar. 25–May 17, 1980 [catalogue].
– Terra Museum of American Art 1987.
– Musée d'Art Américain Giverny 2000b.
– Terra Museum of American Art 2001b.
– Terra Museum of American Art 2001c.
– Terra Museum of American Art 2001d.

John Henry **Twachtman**

– Boyle, Richard. *John Twachtman*. New York: The Watson-Guptill Publications, 1979.
– Chotner, Deborah, et al. *John Twachtman: Connecticut Landscapes*. Washington, D.C.: National Gallery of Art, 1989.
– Peters, Lisa N. *John Henry Twachtman. American Impressionist*. Atlanta: High Museum of Art, 1999.

Winter Landscape, 1890–1900 (p. 118–119), TFA 1992.136

Provenance
Dr. Edward L. Partridge, New York; Sotheby's, New York, June 4, 1982, lot 58; Berry-Hill Galleries, New York (agent), DJT Collection, 1982; TFA, 1992.
Exhibitions
– Exhibition, The Brooklyn Museum, Brooklyn, N.Y., Dec. 1925–May 1926.
– Terra Museum of American Art 1987.

Max **Weber**

– North, Percy. *Max Weber: The Cubist Decade.1910–1920*. Atlanta: High Museum of Art, 1991.
– Werner, Alfred. *Max Weber*. New York: Harry N. Abrams, 1975.

Construction, 1915 (p. 164–165)
TFA 1987.31

Provenance
Estate of Max Weber; Berry-Hill Galleries, New York; DJT Collection, 1987; TFA, 1987.

Max **Weber** (continued)

Exhibitions

– *Max Weber, The Years 1906–1916,* Bernard Danenberg Galleries, New York, May 12–30, 1970 [traveling exh., catalogue].
– *Multiple Perspectives: Cubism in Chicago Collections,* The David and Alfred Smart Museum of Art, The University of Chicago, Oct. 6–Dec. 2, 1991.
– *Max Weber: The Cubist Decade, 1910–1920,* Albright-Knox Art Gallery, Buffalo, N.Y., Sept. 12–Oct. 26, 1992, organized by High Museum of Art, Atlanta, Ga. [traveling exh., catalogue].
– Terra Museum of American Art 1987.
– Terra Museum of American Art 1997c.
– Musée d'Art Américain Giverny 2000b.
– Terra Museum of American Art 2001b.
– Terra Museum of American Art 2001c.

James Abbott McNeill **Whistler**

– Enaud-Lechien, Isabelle. *Whistler et la France.* Paris: Herscher, 1995.
– Lochnan, Katherine A. *The Etchings of James McNeill Whistler.* New Haven, Conn: Yale University Press, 1984.
– MacDonald, Margaret. *James McNeill Whistler. Drawings, Pastels, and Watercolours: A Catalogue Raisonné.* New Haven, Conn.: Yale University Press, 1995.
– MacDonald, Margaret, et al. *The Paintings of James McNeill Whistler.* New Haven, Conn.: Yale University Press, 1980.

The Zattere: Harmony in Blue and Brown, 1879–1880 (p. 104–105)
TFA 1992.162

Provenance
Possibly Ross Winans, Baltimore, Md., (cousin of Whistler); Albert Rouiller Art Galleries, Chicago; Kennedy Galleries, New York; Marshall Field, Chicago, by 1915; Mrs. Diego Suarez, New York, by 1938; F. W. Woolworth, New York; M. Knoedler & Co., New York (agent); Private collection, Boston, 1963; M. Knoedler & Co., New York, 1985; DJT Collection, 1985; TFA, 1992.

Exhibitions

– *Venice Pastels,* The Fine Art Society, London, Jan.–Mar. 1881, no. 4.
– *Pastels, Etchings and Lithographs by Whistler,* Kennedy Galleries, New York, Nov. 1914, no. 63 (as *Little Riva, Venice*).
– *Whistler Pastels and Water Colours,* Carroll Carstairs, Jan. 12–Feb. 5, 1938, no. 4.
– *Trois siècles d'art aux États-Unis,* Musée du Jeu de Paume, Paris, May–June 1938, no. 180.
– Exhibition, New London, 1949, no. 51 (as *Little Riva*).
– *American Master Drawings and Watercolors,* American Federation for the Arts, New York, Sept. 1976–Apr. 1977 (as *The Little Riva in Opal*).
– *Notes, Harmonies, Nocturnes,* M. Knoedler & Co., New York, Nov. 30–Dec. 27, 1984, no. 81 [catalogue].
– Terra Museum of American Art 1987.
– *James Abbott McNeill Whistler at a Glance,* Musée d'Art Américain Giverny, Apr. 1–Sept. 18, 1994.
– *James McNeill Whistler: Retrospective Exhibition 1994–1995,* Tate Gallery, London, Oct. 12, 1994–Jan. 8, 1995.
– Terra Museum of American Art 1996a.
– Musée d'Art Américain Giverny 2000a.

Note in Red: The Siesta, 1882–1883 (p. 106–107), TFA 1999.149

Provenance
– D. C. Thompson, Goupil Gallery, London, 1889; Goupil Gallery, Paris, 1891; Sir George A. Drummond, Montreal, Dec. 21, 1891; Christie's, London, June 27, 1919, lot 166; A. Reid, Glasgow, Scotland; E. R. Workman, London; M. Knoedler & Co., New York, Jan. 15, 1924; Stevenson & Scott, New York, May 16, 1924; Scott & Fowles, New York, 1926; Hunt Henderson, New Orleans, La.; Tulane University, New Orleans, La., 1939 (bequeathed by Hunt Henderson); MacDonald Gallery, New York (agent), G. L. Winthrop, New York; Mrs. Mary Gay Sherrod; Gay and Clifton Leonhardt (children of Mrs. Mary Gay Sherrod) until 1982; Davis & Langdale Company, New York, 1982; DJT Collection, 1982; TFA, 1999.

Exhibitions

– *Notes—Harmonies—Nocturnes,* Dowdeswell Gallery, London, 1884, no. 17.
– *Annual Exhibition of Sketches,* Dublin Sketching Club, Dublin, Ireland, 1884, no. 236.
– *III Internationale Kunst-Austellung,* Koniglichen Glaspalast, Munich, Germany, 1888, no. 58 (as *Eine rote Stimmung* and listed by Whistler as *Une note rouge*).

– *Notes—Harmonies—Nocturnes,* H. Wunderlich & Co., New York, 1889 (as *Red Note– The Sofa*).
– Exhibition, Goupil Gallery (branch of London gallery), Paris, Sept. 1891.
– *Loan Collection: Oil Paintings, Water Colors, Pastels, & Drawings: Memorial Exhibition of Mr. J. McNeill Whistler,* Copley Society of Boston, Feb. 1904 (as *La Note Rouge*).
– *Memorial Exhibition of the Works of the Late James McNeill Whistler, First President of the International Society of Sculptors, Painters and Gravers,* New Gallery, London, Feb. 22–Apr. 15, 1905, no. 142 [catalogue].
– *Principal Pictures from the Collection of Sir George Drummond,* Barbizon House, London, 1919, no. 19.
– *Woman,* Terra Museum of American Art, Evanston, Ill., Feb. 21–Apr. 22, 1984 [catalogue].
– *Notes, Harmonies, and Nocturnes: Small Works by James McNeill Whistler,* M. Knoedler & Co., New York, Nov. 30–Dec. 27, 1984 [catalogue].
– Terra Museum of American Art 1987.
– *Whistler and His Circle,* Minnesota Museum of Art, St. Paul, Minn., Apr. 9–June 25, 1989 [catalogue].
– *Discerning Tastes: Montreal Collectors 1880–1920,* Montreal Museum of Fine Arts, Montreal, Canada, Dec. 8, 1989–Feb. 25, 1990 [catalogue].
– *James Abbott McNeill Whistler at a Glance,* Musée d'Art Américain Giverny, Apr. 1–Sept. 18, 1994.
– *James McNeill Whistler: Retrospective Exhibition,* Tate Gallery, London, Oct. 12, 1994–Jan. 8, 1995 [traveling exh., catalogue].
– Terra Museum of American Art 1996a.
– Terra Museum of American Art 2001a.
– Musée d'Art Américain Giverny 2001a.

Nocturne: Palaces, 1886 (p. 108–109)
TFA 1996.52

Provenance
Edward James; Margo Pollins Schab, New York, 1996; TFA, 1996.
Exhibitions
– Terra Museum of American Art 1996a.
– Terra Museum of American Art 2001a.

Robert **Wylie**

– Cariou, André. *Les Peintres de Pont-Aven.* Rennes, France: Éditions Ouest-France, 1994.
– Myers, Julia Rowland. "'Sympathy for Humanity:' Robert Wylie and His Paintings of Breton Life." *The American Art Journal* 28 (1997): 82–121.

The Breton Audience, c. 1870 (p. 82–83)
TFA 1992.166

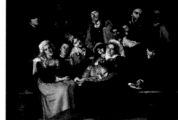

Provenance
John McCoy, Baltimore, Md.; Peabody Institute, Baltimore, Md., 1895–1963; Mr. Roland Hartman, New York, 1963–86; Post Road Gallery, Larchmont, N.Y., 1986; Berry-Hill Galleries, New York; DJT Collection, 1991; TFA, 1992.
Exhibitions
– *Adventure and Inspiration,* Hirschl & Adler Galleries, New York, 1988.
– Musée d'Art Américain Giverny 1992.
– Musée d'Art Américain Giverny 1999 [traveling exh.].
– Musée d'Art Américain Giverny 2001a.

Photograph Credits

The photographs reproduced in this book belong
to the Terra Foundation for the Arts, Chicago
unless otherwise indicated in the captions
accompanying the images. The following
photograph credits apply to all images for which
separate or additional credit is due. Every effort
has been made to trace individual copyright
holders, and any omissions are unintentional.

Giverny, Musée d'Art Américain Giverny
© Didier Brunner: p. 34
© Jean-François Lefèvre: p. 29, 30, 39, 41
© Nathalie Rateau: p. 31

Paris, Réunion des musées nationaux: p. 132

For works by Marcel Duchamp © 2002 Artists
Rights Society (ARS), New York/ADAGP,
Paris/Estate of Marcel Duchamp;
Lyonel Feininger © 2002 Artists Rights Society
(ARS), New York/DACS London;
John Marin © 2002 Estate of John Marin/Artists
Rights Society (ARS), New York;
Georgia O'Keeffe © 2002 Georgia O'Keeffe
Foundation.

© **Reichen et Robert**, architectes: p. 29, 31,
33–35, 39, 41
© **Catherine Proux**, architecte: p. 37